# FREEHAND FIGURE DRAWING FOR ILLUSTRATORS

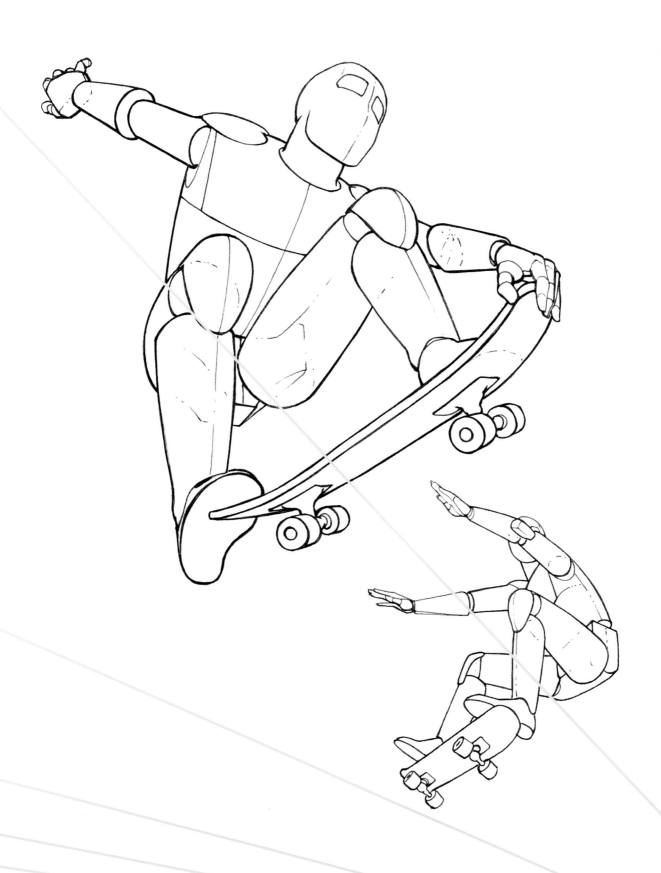

# FREEHAND FIGURE DRAWING FOR ILLUSTRATORS

## Mastering the Art of Drawing from Memory

## DAVID H. ROSS

WATSON-GUPTILL PUBLICATIONS
Berkeley

Library of Congress Cataloging-in-Publication Data
Ross, Dave (Graphic novel artist)
 Freehand figure drawing for illustrators : mastering the art of drawing
from memory / David H. Ross.—First Edition
    pages cm
1. Figure drawing—Technique. 2. Human figure in art. I. Title.
 NC765.R587 2015
 743.4--dc23
                        2014049539

Trade Paperback ISBN: 978-0-3853-4623-8
eBook ISBN: 978-0-3853-4624-5

Printed in China

Design by Kara Plikaitis

10 9 8 7 6 5

First Edition

DEDICATED TO

# W. Harold Ross

My father, who encouraged me to pursue a career
that would bring me happiness and fulfillment.

ACKNOWLEDGMENTS

I would like to thank my students for inspiration,
Design Source for technical support, and my wife, Judi Michelle,
for her dedication, patience, and encouragement.

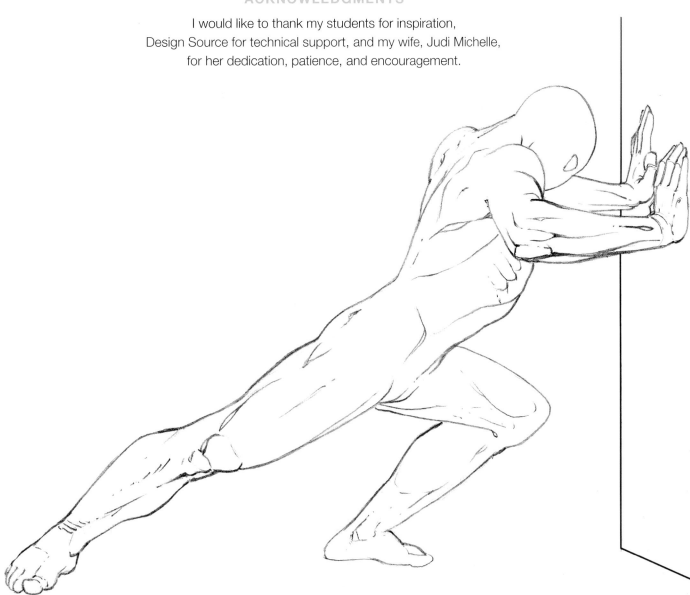

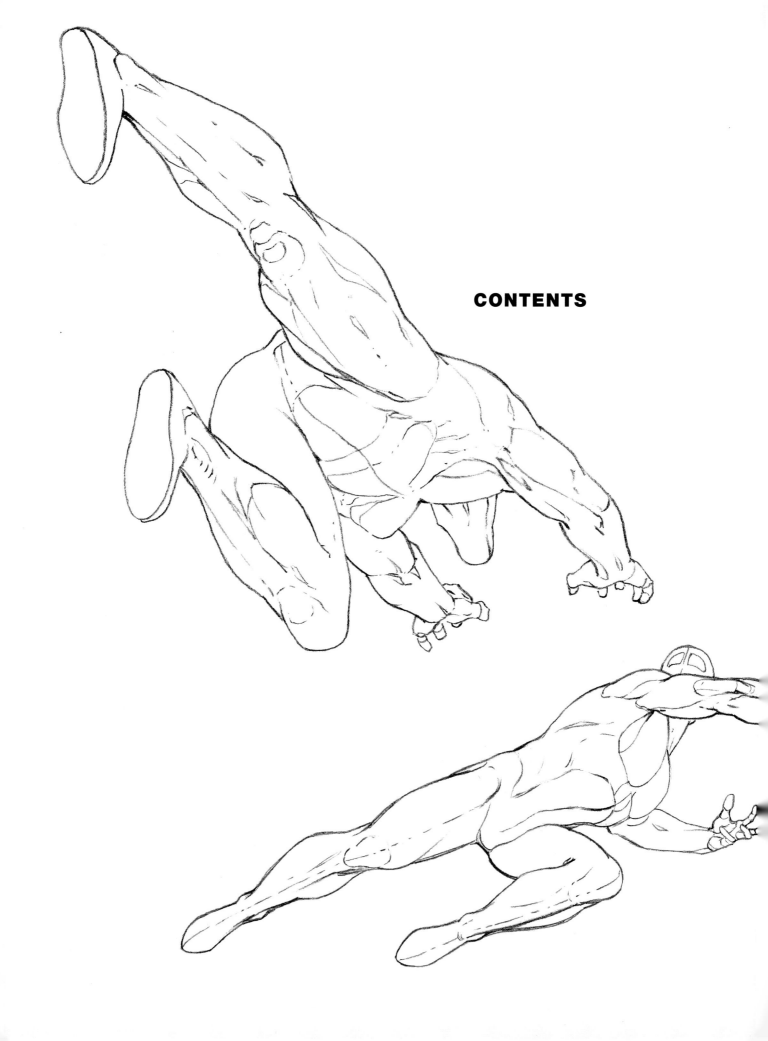

CONTENTS

FOREWORD BY ROY THOMAS  ix

INTRODUCTION  1

1  **A PERSPECTIVE PRIMER**  5

2  **INTRODUCING THE GLASS MANNEQUIN**  23

3  **THE STANDING FIGURE**  47

4  **THE WALKING AND RUNNING FIGURE**  65

5  **THE CROUCHING, SITTING, AND RECLINING FIGURE**  81

6  **DRAWING THE HEAD**  93

7  **DRAWING HANDS AND FEET**  115

8  **THE SKELETON**  143

9  **THE MUSCLES**  155

10  **DYNAMIC ACTION**  171

CONCLUSION  193

INDEX  194

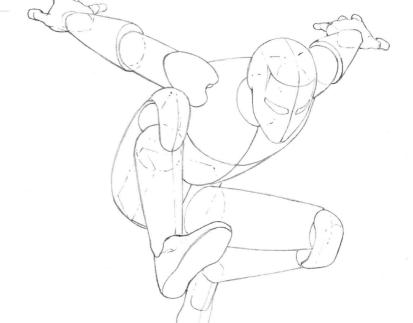

## FOREWORD

Boy, have you got the right book—by the right author/artist!

Dave Ross and I go way back, all the way to 1990, when fate tossed us together on a comic book for Marvel titled *Avengers West Coast*, with me as scripter and him as penciler. Almost from the start, and for the next four years, whenever I sat down to plot a story that featured the likes of Iron Man, Hawkeye, the Vision, Spider-Woman, U.S. Agent, and the rest of the Hollywood superhero contingent locked in battle with Ultron, the Hangman, Dr. Demonicus, et al., I could see the tale unfolding in my head as if already drawn by Dave, in that particular combination of high photorealism and exaggerated action that few comics artists have ever been able to pull off as well. And when I got the penciled pages of art back from him, ready for me to add dialogue and captions, I was never disappointed. The guy could draw—and he could tell a ripping good yarn, panel after panel, while doing it.

So now I look at the table of contents of this book—and the chapter headings are like a laundry list of the things Dave Ross is good at drawing: perspective (whether in a living room or in an alternate dimension); human figures standing, walking, running, crouching, sitting, and reclining—even figures that are flying, leaping, or getting knocked on their butts; the human head from all angles; hands and feet (and fists and kicks); the skeleton (even when it's hidden by skin); muscular anatomy (nobody does it better); and, yes, dynamic action.

What can I say? You're gonna be learning from the best!

—Roy Thomas

Roy Thomas has been a comic book writer, primarily for Marvel Comics and DC Comics, since 1965.

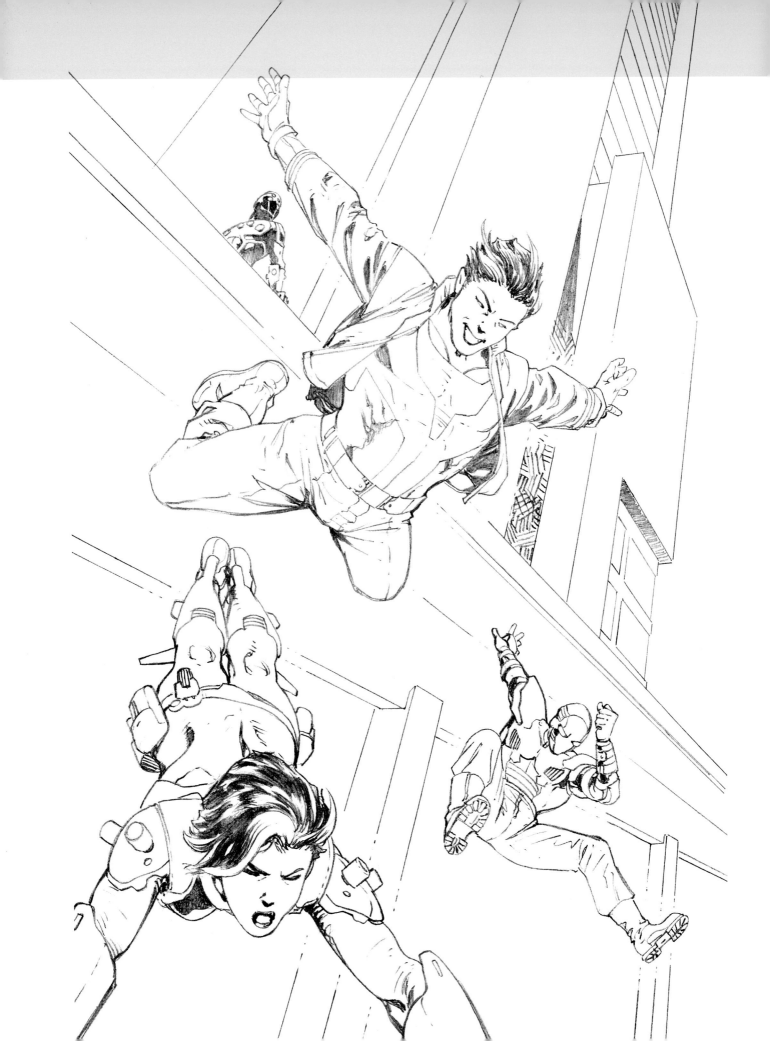

## INTRODUCTION

The term *freehand drawing* describes the practice of drawing from the imagination without the aid of a live model or photographic reference.

Freeing the artist from any dependency on such sources allows for maximum versatility—the artist is restricted only by his or her imagination or skill level. As it applies specifically to the human figure, it is the drawing of the body in any pose imaginable and from any angle—without the need for a reference.

*Freehand Figure Drawing for Illustrators* offers up a constructive approach to drawing the human form that can be traced back to the early 1900s. Illustrators of that era developed a system for blocking out the human figure using a *drawn mannequin*.

This book focuses on that drawn mannequin, putting it through its paces in ways that those early illustrators could not have foreseen. There are studies of standing, walking, and running figures, of course, but also leaping, dodging, and flying ones. Mannequins throwing punches and high kicking demonstrate the mechanics of motion and will help you to examine the limitations of the body's movement. The drawn mannequin is nothing more or less than a visualization tool—a simplified representation of the human body that enables the artist to block figures into place with proper proportions and posing. It is particularly useful when dealing with more complex camera angles (for example, the bird's-eye and worm's-eye views).

With a drawn mannequin, the artist doesn't have to deal with the details of specific anatomy, folds in clothing, or lighting and can focus on achieving a solid, well-constructed underdrawing (or mannequin), first.

The mannequin is transparent (which is why it's also known as a *glass mannequin*) to help the artists using it think of what they are drawing as three-dimensional or *in the round*. This is a crucial mind-set for artists to attain. They must think of everything they draw

as having *volume*—of occupying space—if they wish that sense to be conveyed to their audience. On an even more practical note: the mannequin's transparency allows the artist to locate the sometimes obscured connection of that far arm or leg to the trunk of the body.

Mannequins used in this book range from basic to intermediate to advanced. Each successive category introduces more human anatomy into the mannequin figures, enabling you to progress in stages. I have varied the mannequins throughout the book on a need-to-see basis. Earlier chapters contain a higher percentage of basic mannequins, while later ones such as those in chapter 10 are weighted toward the advanced model.

The first chapter of this book offers a primer in technical perspective. This is a necessary first step for those considering freehand drawing of any sort. The ability to visualize in three dimensions on the flat page or screen is indispensable to the process. The fundamentals outlined in chapter 1 will help instill in you a heightened sense of depth, which you can then apply directly to drawing the human figure.

Your ability to draw convincing poses—both in form and in gesture—will increase in direct proportion to your understanding of anatomy. The study of human anatomy is included in this book, both as sub sections in the chapters covering the head, hands, and feet, as well as in whole chapters devoted to the human skeleton (chapter 8) and the muscles (chapter 9). The skeleton is the foundation that shapes the body; however, it is the muscles that make the body "move." Ingrained anatomical knowledge is especially important for the freehand artist, since there is no actual model or other reference immediately at hand to guide you. If you can include muscle tone and bone-related landmarks in your freehand sketching, it will greatly add to your speed and versatility.

*Freehand Figure Drawing for Illustrators* is for anyone who has ever dreamed of picking up a pencil and drawing spontaneously from the imagination. That being said, it certainly does represent a valuable skillset for the professional artist whether working in the field of animation, cinematic storyboarding, concept art, or book and comic book illustration.

Beyond all other considerations, however, there is the simple satisfaction that can come from adopting the freehand approach. This is what drawing should be about, straight from the mind to the page with no stops or detours along the way!

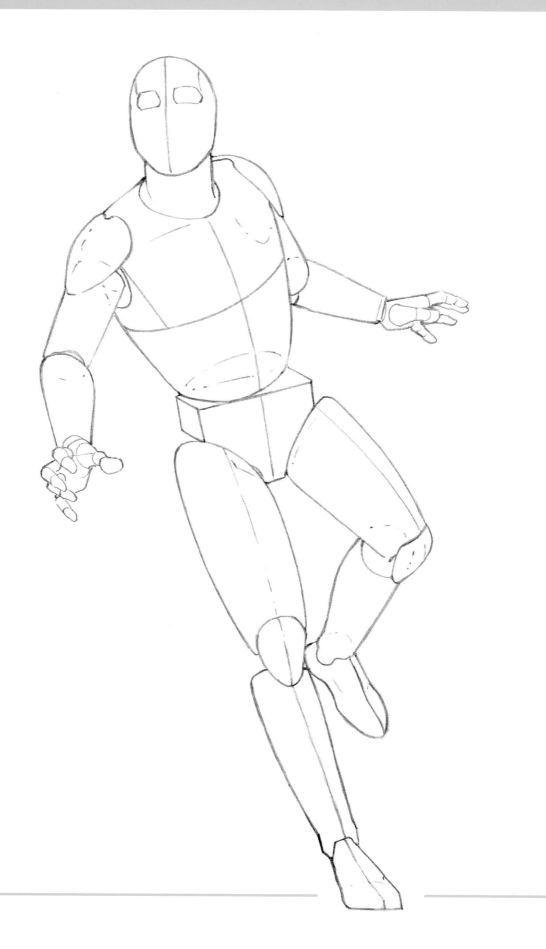

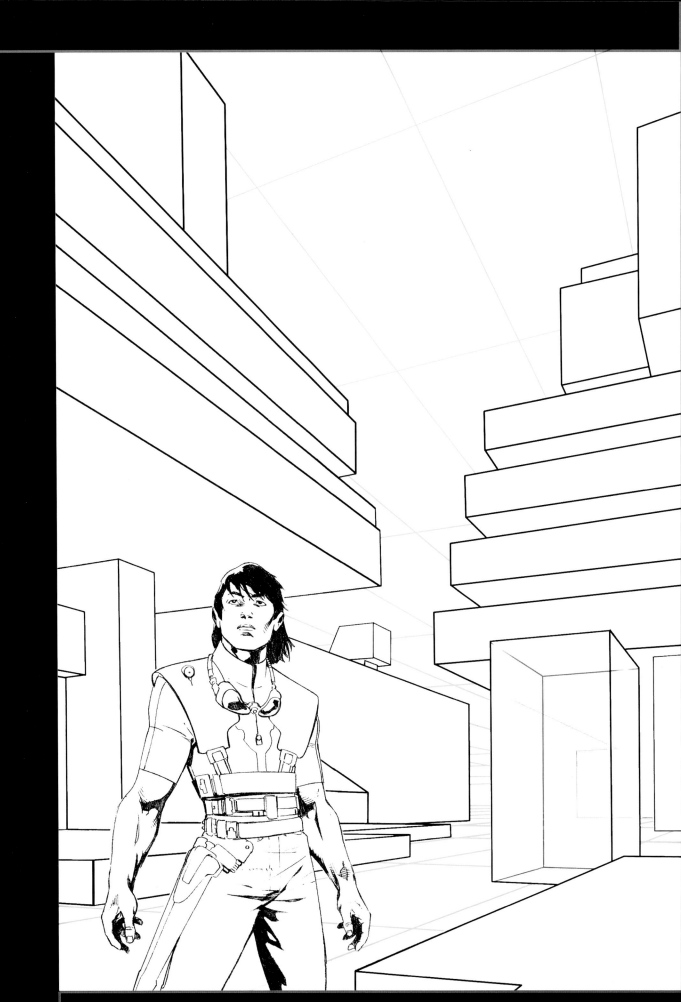

# A PERSPECTIVE PRIMER

This book begins not with a study of the figure, but with a primer on technical perspective. While this may seem odd, mastering perspective is an important first step in the process of learning to think in 3-D. To become versatile in freehand figure drawing, you need to develop an ability to both visualize and draw figures and their component parts from any and all angles; and that requires mastering *foreshortening* (see page 6). Developing a spatial sense will help with this task. There is no better way to awaken that ability than to learn and practice basic technical perspective.

# Perspective Terms

Before beginning this chapter, familiarize yourself with this list of frequently used terms relating to perspective and their definitions:

**HORIZON LINE (H-LINE):** The horizon line is defined as the imaginary line where the earth meets the sky. All elements in a scene diminish in size as they recede into the distance until they can no longer be seen. Both horizon lines and *vanishing points* are practical extrapolations of that visual fact.

**VANISHING POINTS (VPS):** Elements within a scene aligned along parallel lines recede into the distance toward a single focal point on the horizon line. This is referred to as a vanishing point since it represents the point at which those elements shrink completely out of sight.

**GRIDDED SPACE:** Refers to an image in which basic perspective has been established via a grid. The grid represents a floor or ceiling; however, you can also draw it to represent vertical planes (e.g., walls). Gridlines connect with the vanishing point or points that define the space.

**POINT OF VIEW (POV):** Refers to the positioning of the viewer relative to the scene viewed. POVs generally fall into three categories: eye-level views, high angles (also known as bird's-eye views), and low angles (also known as worm's-eye views). POVs are often referred to as camera angles. Of course—as these are illustrations—there are no actual cameras present.

> **Eye Level:** The most familiar of angles making the viewer feel as if he or she is standing on firm ground while taking in the scene.
>
> **High Angle or Bird's-Eye View:** Creates the impression of floating above the scene, looking down on it.
>
> **Low Angle or Worm's-Eye View:** Puts the viewer at floor level, or even under it.

I should note that while these angles may give the impression of the viewer floating above or dropping below the scene, the selection of POV is all about where the viewer is directed to look, not where they are.

You might draw a scene from the POV of someone lying on the ground, but if that person looks down on an object, then you must illustrate the scene from a high angle, or bird's-eye view. In the same way, you might draw a scene from the POV of a character standing on a high balcony; however, if the person is looking up, then a low angle, or worm's-eye view is needed.

**FORESHORTENING:** The visual distortion that occurs when observing an object from a radical angle, by which I mean that the object is viewed from an almost head-on front or back view. The resulting perspective shortens the length of the object severely, as it angles either toward or away from the viewer.

# Thinking in 3-D

In this chapter, I will introduce you to the concepts of one-, two-, and three-point perspective, encouraging the drawing of gridded space and the building of varied box forms within picture planes. Mastering these concepts will have practical benefits for augmenting your figure work. But the greatest value of this training comes from the cumulative effect of helping you develop an overall three-dimensional, or spatial, sense.

## ONE-POINT PERSPECTIVE

One-point perspective establishes a single focal point on the horizon line; the viewer is in direct or almost direct alignment with the environment. It is the simplest form of perspective. Yet, due to its directness, it can lead to the most dramatic results. Here's how to do it.

**Image Area**

When first building three-dimensional space on a flat page, define your final art area with borders. This is known as the *image area*.

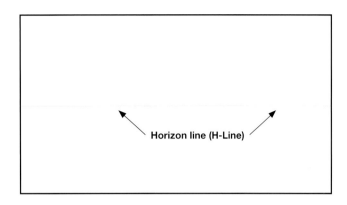

Next locate a *horizon line* relative to the image area. The horizon line establishes the height from which the scene is viewed. In this example, the horizon line bisects the space in the middle, of the image area, creating an eye-level POV.

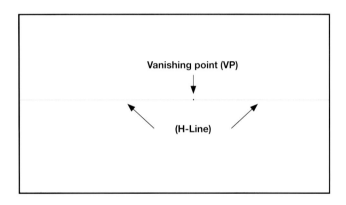

The positioning of one or more vanishing points on the horizon line determines the viewer's orientation with regard to the overall scene and establishes the degree of depth.

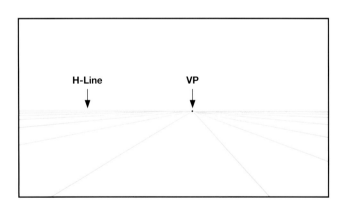

With a single VP placed on the H-Line, one set of grid lines radiates out across the image. Their spacing appears wider in the center of the image, but narrows exponentially toward the outer edges. In this example, the grid lines define one plane—the ground—or the floor plane in this example.

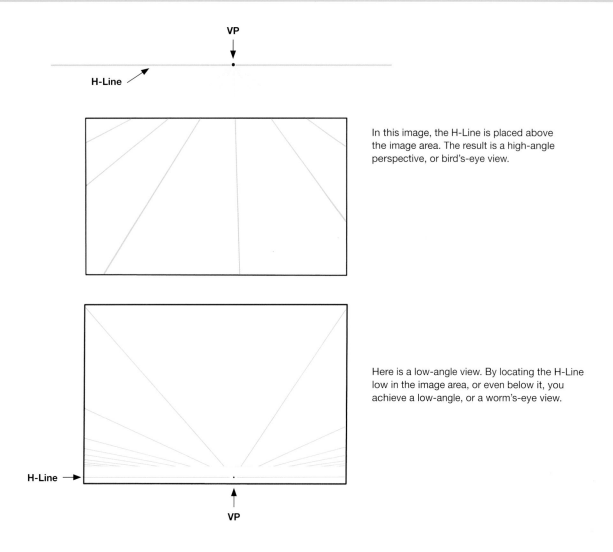

In this image, the H-Line is placed above the image area. The result is a high-angle perspective, or bird's-eye view.

Here is a low-angle view. By locating the H-Line low in the image area, or even below it, you achieve a low-angle, or a worm's-eye view.

## APPLYING THE GRID

The grid is an essential tool for visualizing three-dimensional space and will help you to place objects in proper perspective within the image.

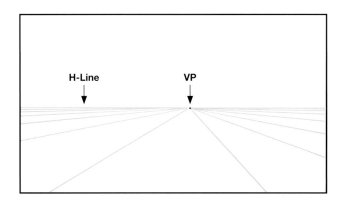

Return to the eye-level POV to complete the gridding process. Extend lines from the vanishing point forward to the foreground with the widest spacing between them at the center of the image. Be sure to narrow the gap between the lines as they get farther from the center.

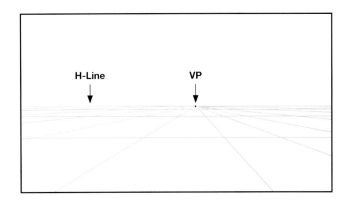

Add *crosslines*—the parallel lines that complete the grid. As they recede into the distance (i.e., as they approach the H-Line), the space between them narrows exponentially.

## TWO-POINT PERSPECTIVE

If you view a scene or a key object from a side angle, then you need two-point perspective to illustrate it.

Begin by placing two vanishing points—termed *vanishing point left (VPL)* and *vanishing point right (VPR)*—on a horizon line. Space them a good distance apart from each other. Locate both points outside your image area. Extend grid lines out from both points into and through the image area to establish a sense of space.

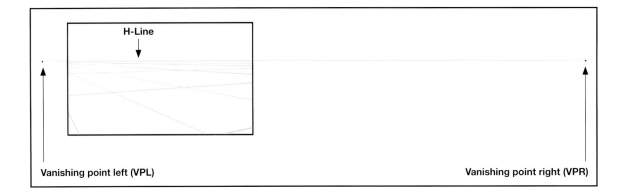

In this example, both vanishing points are located outside the actual image area. Note the proportional relationship between the size of the image area and the distance between the points.

## FORCED PERSPECTIVE

When vanishing points are located too close together, the resulting image appears distorted. This unnatural skewing is referred to as *forced perspective*. The two box forms below illustrate forced perspective. This type of distortion is neither good nor bad. You can use forced perspective to convey the impression of great scale—as if the viewer were up close to something very large. It is by nature visually dramatic and can easily be overused or used inappropriately. As the artist, you must control perspective, not the other way around.

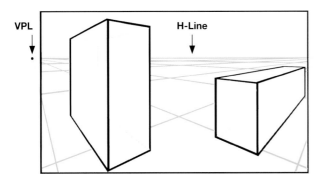

Note how close the vanishing points are to the image area.

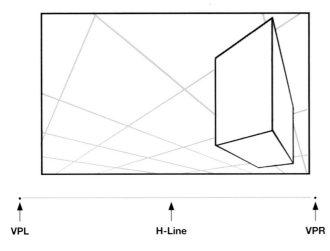

Here the points are placed on a horizon line below the image area, but are still unnaturally close to each other. The box form highlights the distortion, particularly at its upper right corner.

## NATURAL PERSPECTIVE

This approach to technical perspective seeks to re-create the impression of depth that you as the viewer experience through the lens of your eye—free of any distortion. In a two- or three-point perspective illustration, you may achieve this effect by spacing the vanishing points at a significant distance from each other, outside the image area.

**VPL**

**H-Line**

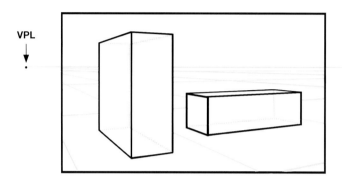

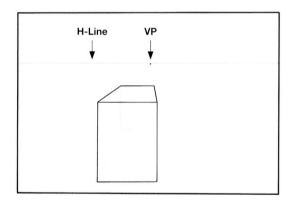

Align the box with a VP located almost directly behind it. Since the horizontal outlines defining the top and bottom of the box facing the viewer are parallel to the horizon line and to each other, no second point is required.

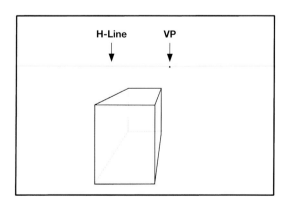

Shift the box's alignment to the vanishing point. It should now be located a little to one side. Note that the lines defining the top and bottom are still parallel to both the horizon line and each other. Technically, however, they should taper back to a very distant second vanishing point; the degree of taper is so slight that the unaided eye is unable to spot it. Therefore at this angle, there is no need to be concerned with drawing it.

**VPR**

Notice that the two box forms and the grid are all rendered in *natural perspective*. The VPL is quite close to the image area and the VPR is a good distance away from it. This relationship—between the size of the image area and the distance between the two VPs—serves as a useful guide for avoiding unintentional forced perspective.

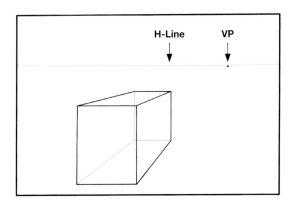

**H-Line**   **VP**

Note that the angle of displacement of the box from its VP is more evident here. Even though the horizontal outlines on the box are kept parallel to both the H-Line and each other, they can benefit from some tapering toward a second point.

**VPL**

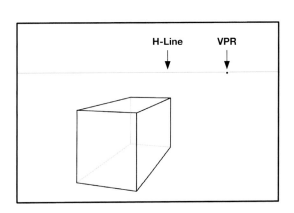

**H-Line**   **VPR**

Here, I re-created the box from the previous example above, with one difference. The horizontal lines now taper off to a second vanishing point, VPL. The original VP transforms into VPR. As a result, the box looks "truer," or in more realistic perspective.

## THREE-POINT PERSPECTIVE

Gentle high or low angles are typified by horizon lines that are either in or very close to the image area. It is better not to apply the third point in these instances. However, when illustrating strong high or low angles, you must switch to a three-point treatment in order to avoid distortion.

A third point positioned below the image is referred to as *vanishing point nadir* or *VPN*. The one that is located above the image is termed *vanishing point zenith* or *VPZ*.

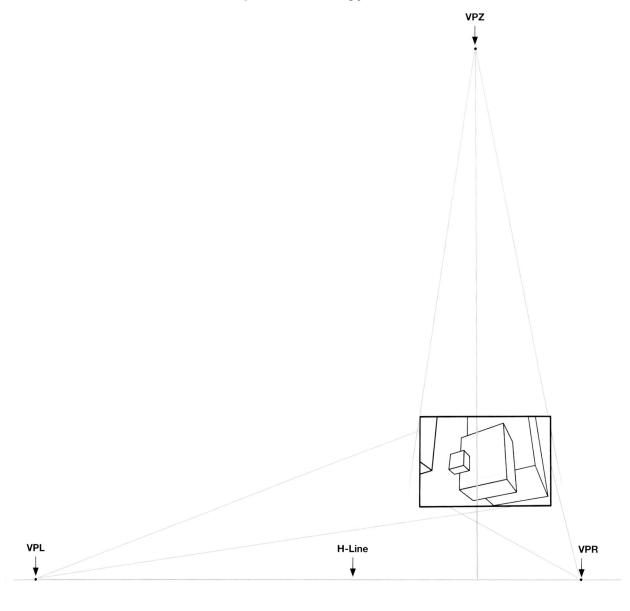

As with vanishing point placement in two-point perspective, establish a safe distance between the H-Line and your third vanishing point to avoid distortion. A simple way to do this? Measure the distance between VPL and VPR, and then apply that measurement vertically between the horizon line and the third point, as shown here.

**A bird's-eye view in three-point perspective:** In an image viewed from a high angle, place a third point well below the horizon line. As for the H-Line, position it well above the image area.

**A worm's-eye view in three-point perspective:** When viewing an image from a low angle, position a third point well above the image area. Set the H-Line significantly below the image area. Boxes built in this type of picture plane have vertical edge lines that taper up to the third VP.

## Assembling Box Forms

Practice drawing many picture planes with grids using a variety of perspectives and vanishing points, and add a range of box constructions to them. I recommend separating the grids from the boxes via color coding. Draw the grids in light blue pencil, as in the example below. Then, draw the boxes in black.

Try drawing all types of boxes—from high and low angles—using one-, two-, and three-point perspective. By varying the sizes and shapes of your boxes, you will soon find yourself creating three-dimensional space on a flat page. When you vary the proportions of the boxes, you can use them as the foundation blocks for drawing a wide range of objects.

Shape the space in your illustrations by drawing in box forms first.

## BUILDING FIGURES WITHIN BOXES

You can construct figures within basic box forms. This technique is particularly useful when planning poses from high or low angles, especially when those poses are essentially vertical in orientation.

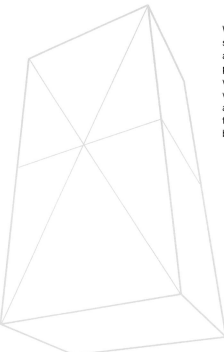

When preparing to construct a figure in a box, first subdivide the box. Using the plane angled most directly at the viewer, draw diagonal construction lines (using blue pencil) from corner to corner, forming an X. The point at which the lines intersect represents the *optical mid-point*— what looks to the eye to be the center, as opposed to the actual center. From that point, run a horizontal line around the box's circumference. This will accurately bisect the box in perspective.

Repeat for the top and bottom halves of the box, resulting in an accurately quartered box.

## USING THE QUARTERED BOX AS A GUIDE

Proportionally, the crotch represents the vertical midpoint of the average standing figure. So it's best to start by aligning it with the horizontal center of the box. The lower quarter line on the box lines up with the knees, while you can use the second from the top section to locate the breastline at the base of the chest.

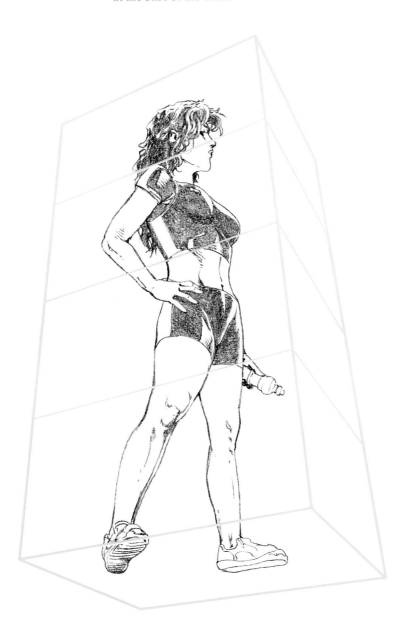

For this example, the camera angle is swung around, looking down at the quartered box. Note that both boxes—the one used here and the previous one—are drawn in three-point perspective. Follow the same procedure for quartering this box.

Here is a complete figure built within the high-angle box. Besides helping to keep track of the figure's proportions in perspective, the box form can also help reinforce the angle of the ground beneath the figure. This in turn aids you in placing the feet.

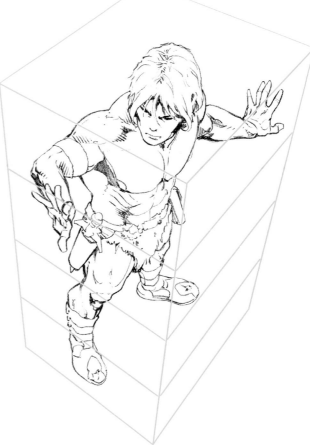

## EXERCISE: Building the Figure Within a Box

Now it's time for you to try it. Below and on the following page are two boxes drawn in perspective. Track back along the border lines of each box to find their vanishing points. Use those to first make each box appear transparent by drawing horizontal lines around the box's circumference. Then use the procedure outlined in the previous examples to quarter the boxes in diminishing perspective. With those subdivisions to guide you, build figures into the boxes.

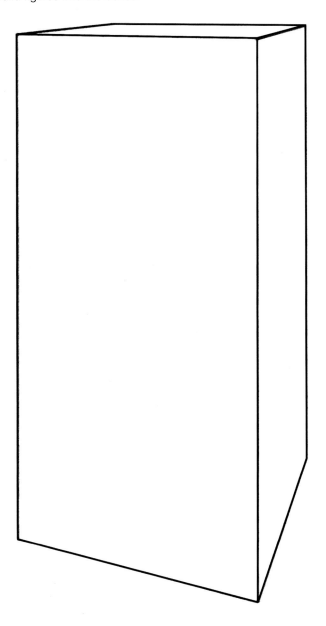

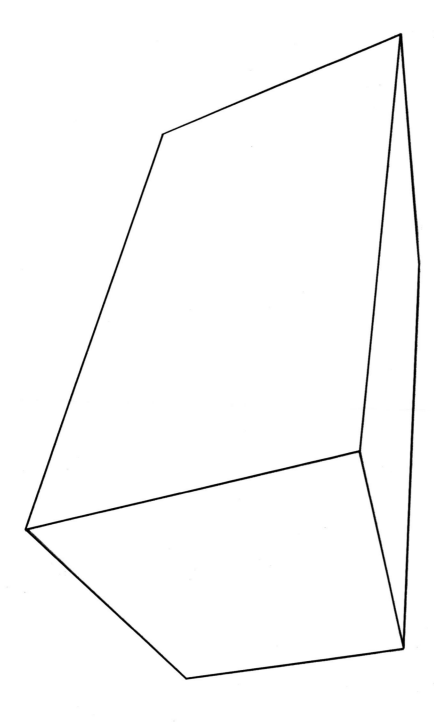

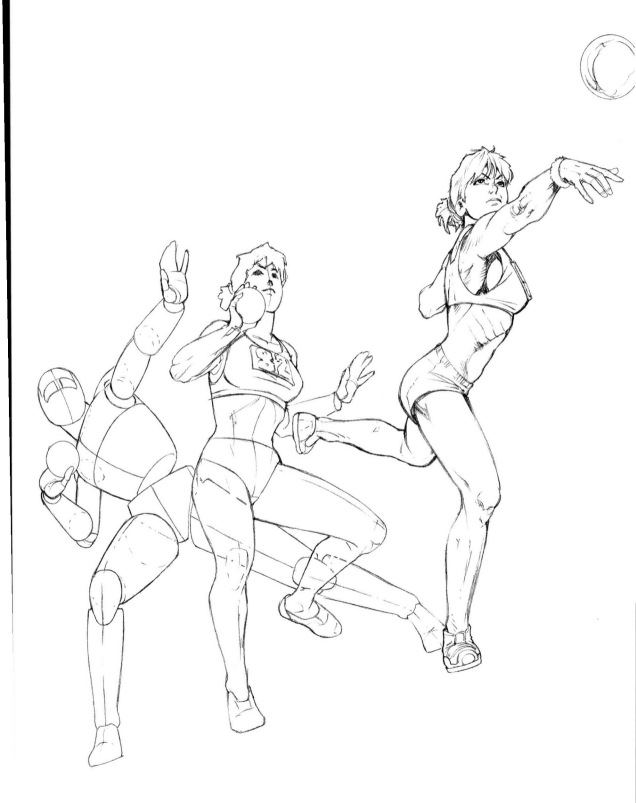

# INTRODUCING THE GLASS MANNEQUIN

In this chapter I will introduce you to a simplified model of the human figure. This *mannequin* figure will help you with all types of poses, from low-key to high-action ones. It works by removing details so that you can focus on placing the figures in perspective and on working out their posing. Using this method, you will learn to break down a figure to its simplified component parts, then to rebuild it into whatever pose you wish. The aim is to give you the versatility to draw whatever you imagine and to do it *off the top of your head*.

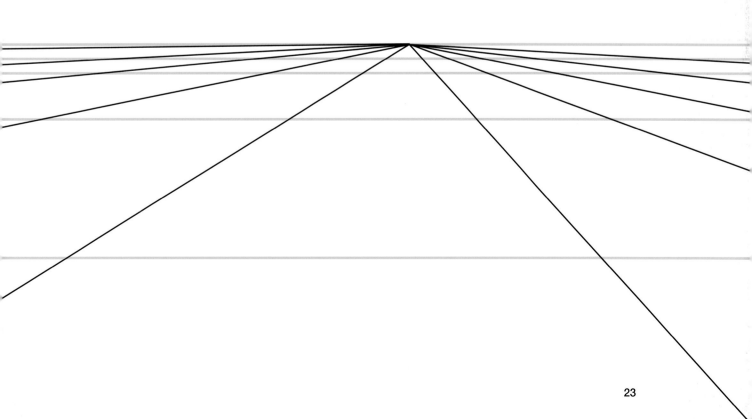

# Outlining the Freehand Process

Typically an illustrator begins with a *gestural line*—a loose unstructured line used to capture the essence of the intended pose. She then builds a mannequin framework based on the gestural line, blocking in the basic structure of the body in a simplified form. The next step is to "feature up" the figure, by adding the detailing of costume and anatomy. The finishing stage requires a darker, more controlled line and some general shading.

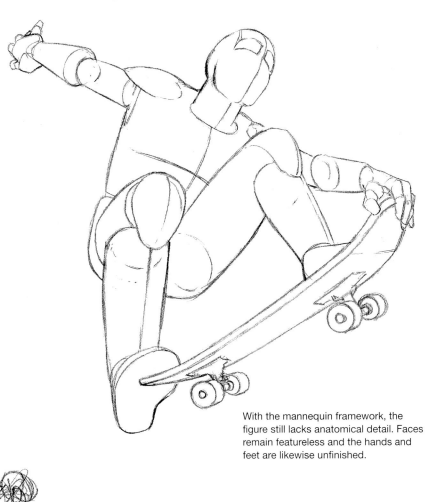

Look at this example of gestural lines. Considerations of anatomy or proportions are not particularly important at this stage.

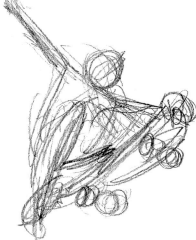

With the mannequin framework, the figure still lacks anatomical detail. Faces remain featureless and the hands and feet are likewise unfinished.

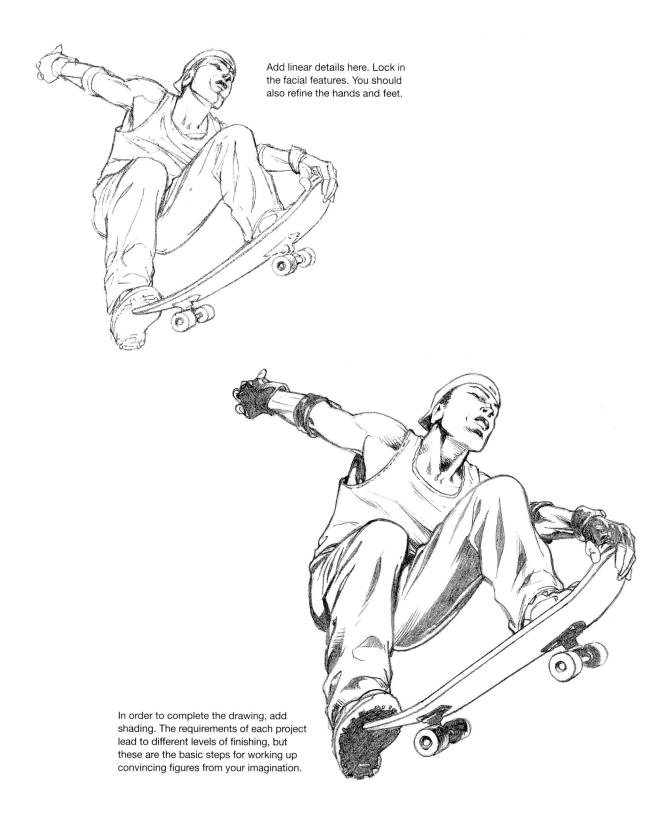

Add linear details here. Lock in the facial features. You should also refine the hands and feet.

In order to complete the drawing, add shading. The requirements of each project lead to different levels of finishing, but these are the basic steps for working up convincing figures from your imagination.

## Meet the Glass Mannequin

The construction of a basic mannequin figure is at the center of the freehand process. I call this figure the *glass mannequin*. It's a simplified model of the human body that allows you to visualize a wide range of complex actions from varied angles. It maintains the body's mass, overall shape, and three-dimensional volume, but lacks anatomical detail.

### WHY A GLASS MANNEQUIN?

Typically the mannequin is drawn as either transparent or semitransparent. This method makes it easier for you to draw an arm or leg that projects out from behind another part of the body. Being able to see that arm or leg, which may otherwise be hidden, will help you to position and scale that limb correctly.

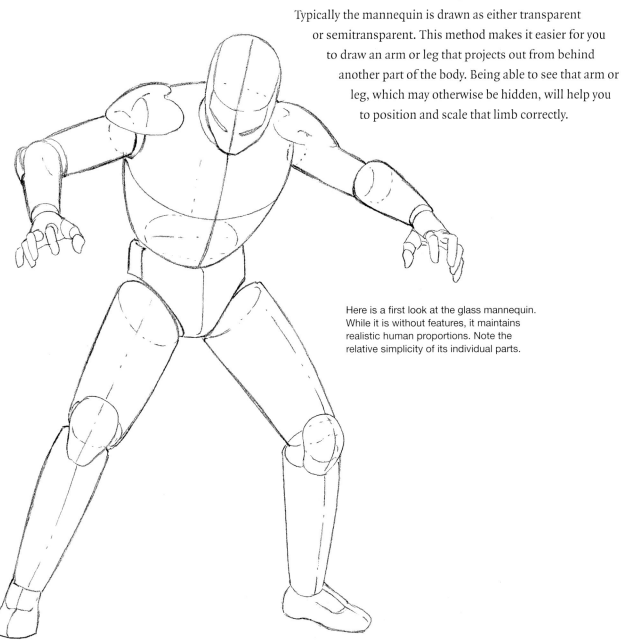

Here is a first look at the glass mannequin. While it is without features, it maintains realistic human proportions. Note the relative simplicity of its individual parts.

## EXPLODED VIEW

Mastering the drawing of individual parts in perspective from every conceivable angle is less daunting than trying to tackle the whole figure at once. Here is a look at the component parts of the mannequin figure: practice the individual parts until you feel ready to move on to the next step.

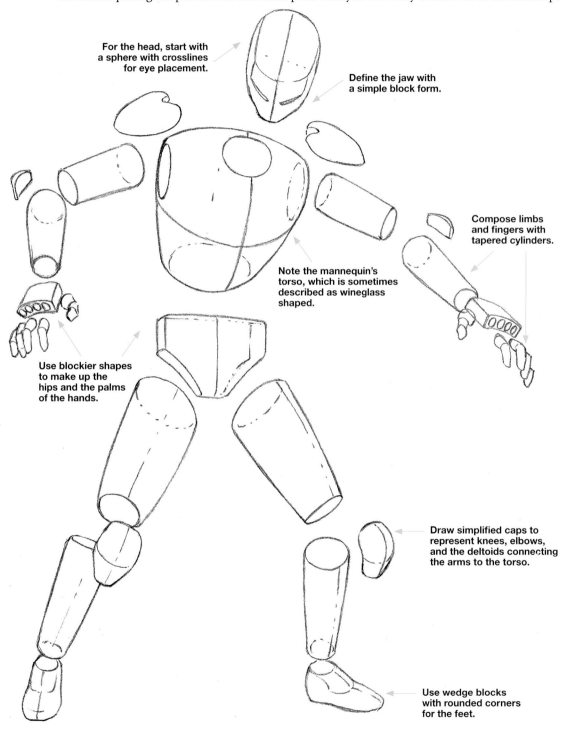

For the head, start with a sphere with crosslines for eye placement.

Define the jaw with a simple block form.

Compose limbs and fingers with tapered cylinders.

Note the mannequin's torso, which is sometimes described as wineglass shaped.

Use blockier shapes to make up the hips and the palms of the hands.

Draw simplified caps to represent knees, elbows, and the deltoids connecting the arms to the torso.

Use wedge blocks with rounded corners for the feet.

## Basic Principles of Foreshortening

You need to be able to move (that is, rotate) your glass mannequin's component parts. Doing that requires a fundamental understanding of foreshortening. Let's use the simple cylinder to demonstrate the key principles at work.

Note the degree to which the cylinder's actual length appears to shorten as it rotates top-first toward the viewer. This is the most obvious effect of foreshortening. But note as well the change in the ellipses representing the tops and bottoms of the cylinder.

As you view the ellipses closer to eye level, they narrow to the point of becoming thin slits. But that's not all. By isolating and examining a segment of one of the contour lines during the transition, you can see that they also flatten and lose their curvature. Whatever the shape of a given object as defined by its cross-sectional contours, it is at its most extreme when viewed from high or low angles.

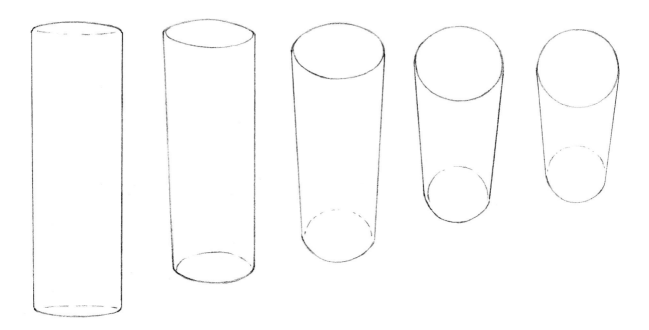

You can trace the construction of every one of these cylinders back to a horizon line and vanishing point(s). Three-dimensional thinking, as outlined in chapter 1, is essential for creating the illusion of depth in forms that rotate in space. Thinking this way will guide you in making the correct proportional adjustments for any given object as it moves relative to the viewer's eye.

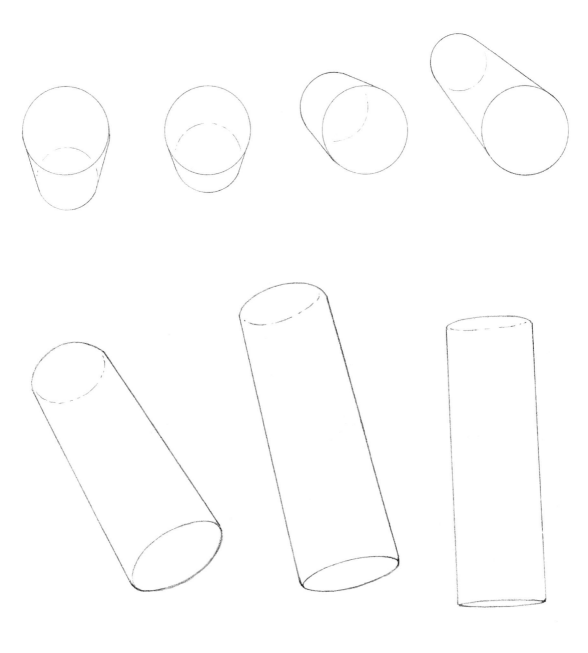

# The Mannequin Torso

The most complex component of the glass mannequin is the *torso*, which requires you to become adept at plotting and drawing smooth, curving surfaces. You must also learn to judge the angle of the opening on the constructed torso where the head and neck connect. I'll refer simply to that opening as the *neck hole*, which sits at a specific angle as seen below. The challenge is in maintaining that angle as the perspective shifts.

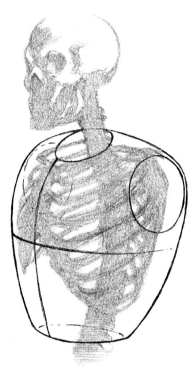

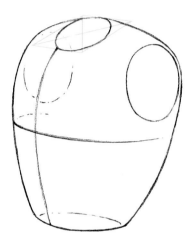

Note the angle of the neck hole on the mannequin torso. This is where the wineglass allusion breaks down, since unlike the wineglass, the top of the mannequin torso is anything but flat.

Here is the mannequin torso with a skeleton underlay. One look at a human skeleton should show you where that distinctive angle across the top of the mannequin torso comes from.

## MANNEQUIN TORSO IN SEQUENTIAL ROTATION

Let's look at some images of a mannequin torso in full rotation. These demonstrate the effect of foreshortening—sometimes gentle, sometimes extreme—on proportions of the object being rotated. They also underscore the importance of maintaining transparency in these torsos to assist in the positioning of a far arm or head that is partially obscured by the body itself.

Copy the torsos below and practice drawing more of your own!

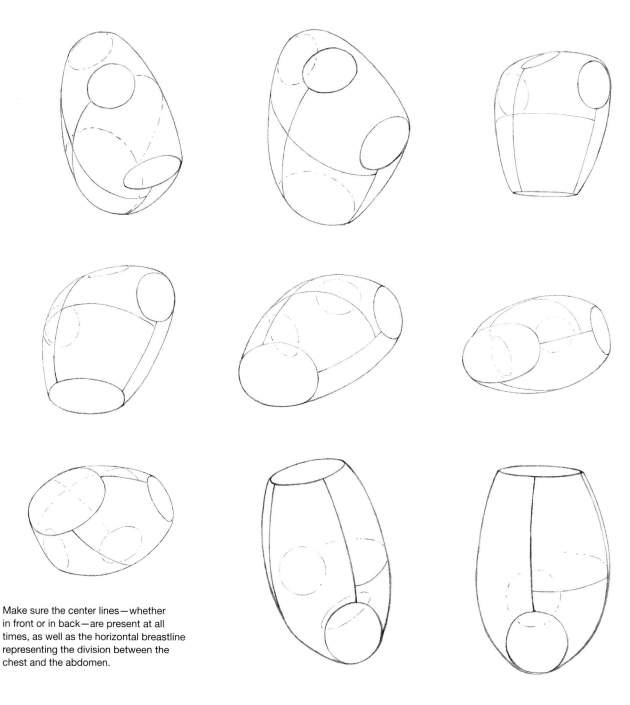

Make sure the center lines—whether in front or in back—are present at all times, as well as the horizontal breastline representing the division between the chest and the abdomen.

## The Mannequin Hips

Along with the torso, mannequin hips are the most challenging component when it comes to rendering the human figure from all angles.

When viewed from the back you can draw mannequin hips as a simple rectangular box form; however, from any angle revealing the figure from the front, you should draw the hips as shown below. Draw lots of these hips for practice!

Note: The angled surfaces allow for a more natural connection of the mannequin legs to the hips. They also reflect the appearance of the real figure. The squared-off shape of the mannequin hips contrasts with the soft curves of the mannequin torso. This can help you distinguish one from the other when they overlap.

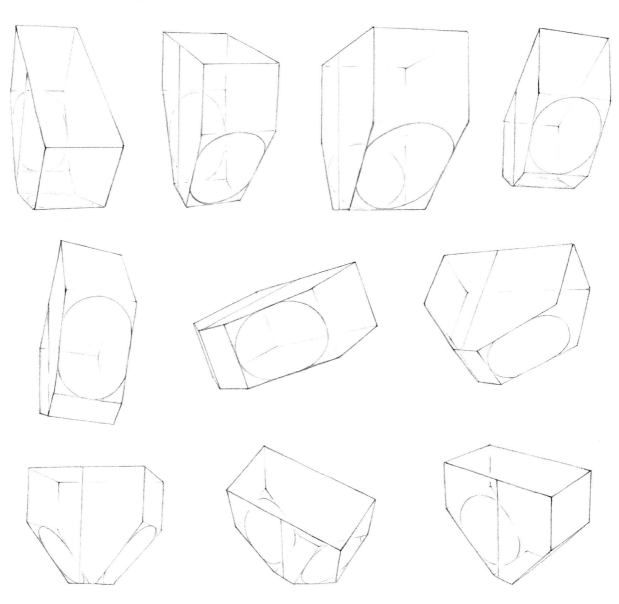

# The Core in Motion

The torso and hips together comprise the trunk, or *core*, of the body. There is a natural tendency to start a figure drawing with the head since it is such an obvious focal point. Problems typically crop up when you try to connect the core of the body to the head afterward. Beginners find themselves redrawing and/or repositioning the head until it finally fits the body they have drawn. This occurs because the relationship between the torso and hips that forms the essential gesture behind most poses has not been established yet. Look at some examples of mannequin torsos and hips in rotation from various viewpoints. The arms, legs, and even the neck and head, will flow naturally out of this core "positioning."

Practice drawing many of these core constructs. Try all possible bends, twists, and curves through the figure. Draw them from every conceivable angle.

Here's an eye-level side view of the mannequin torso and hips drawn in semitransparent fashion. This model is essentially "static" aside from a gentle curvature to its back.

This high-angle view shows a figure that both tilts forward and bends at the waist. Notice the moderate foreshortening throughout the form.

Here's a back view with strong curvature. Foreshorten both the torso and hips, but in opposing directions.

Here's a side view with a twist: Note that a lateral line runs lengthwise across the side of the form, augmenting the usual center lines. This additional line helps the artist gauge the degree of bending, twisting, or curving.

The net result of a twisting or bending action is that the individual parts may have their own alignments. Here the torso is strongly foreshortened toward the viewer, while the hips are foreshortened to a lesser degree.

This mannequin core tilts back, with almost equal foreshortening applied to both torso and hips.

## Mannequin Head Construction

In order to explore a full range of poses, you need to be able to draw the head from all angles. I will discuss the head in greater detail in chapter 6. However, mastering the simplified mannequin head is an important first step.

Here is a seven-step procedure for blocking in the head from any point of view.

Start by drawing a circle/sphere. (Go for "sphere." The sooner you think in 3-D the better!)

Drop in a vertical center line. This line helps you determine the angle from which the head will be viewed.

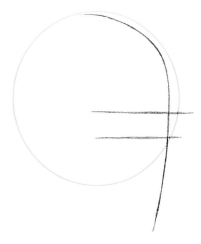

Add two horizontal crosslines representing the tops and bottoms of the eye sockets. Use these lines to establish the viewer's point of view as either high, low, or eye level.

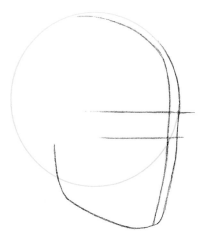

Extend a basic block-form jaw. Note that the curvature of the jawline changes dramatically depending on the viewer's eye level.

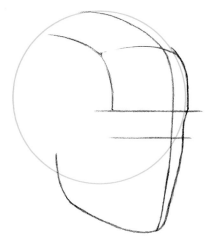

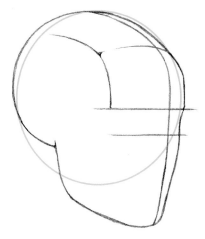

"Square up" the forehead. By transforming the soft curves of the forehead into more angular forms, the mannequin head more closely reflects the shape of a real skull.

Form the sphere into a skull. This step has two stages:

**Stage 1:** Extend the curvature of the back of the head beyond the edges of the sphere.

**Stage 2:** Cut a sharper angle from the back and top of the head down to the forehead.

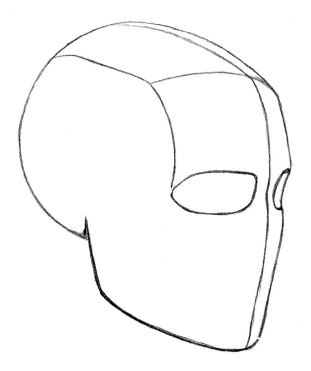

Finally, drop in the eye sockets using the two sets of crosslines as a guide. You will add facial features later, but need to define the eye sockets now. They represent an area bounded by the forehead above, the cheekbones below, the temples to the outsides, and the bridge of the nose on the inside.

## CONSTRUCTING THE MANNEQUIN HEAD FROM A HIGH ANGLE

Although the mannequin head is essentially featureless (without eyes, ears, nose, or mouth), it provides important landmark elements that allow you to set up a full range of viewing angles. Let's start with a high angle, or bird's-eye view.

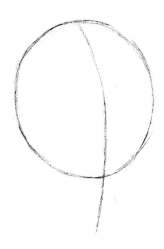

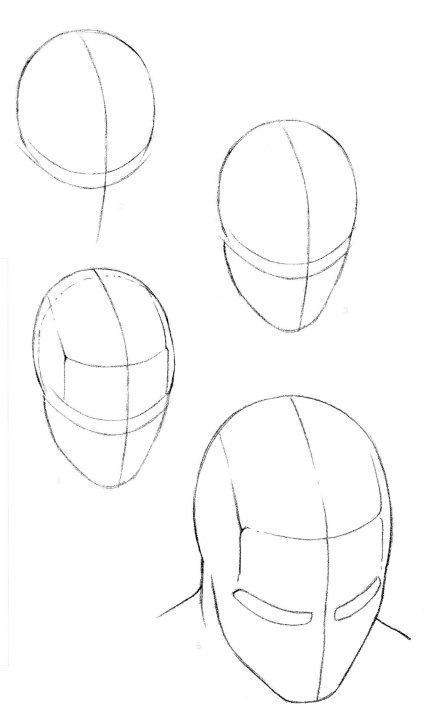

1  As with the example on page 34, first draw a basic sphere. Then establish a center line that follows the curve of the sphere.

2  Draw in a double line, again following the curve of the sphere. Since this is a high-angle POV, place these lines below the midpoint of the sphere. These lines define the upper and lower boundaries of the eye sockets.

3  "Rough in" the jaw. From this angle, the jaw has a strong concave curvature, but is also more tapered (that is, delicate in appearance), due to the effect of perspective.

4  Refine the shape of the sphere by squaring up the forehead. It is worth noting that from this angle even the top of the forehead is defined by a concave curve. Such is the nature of a strong high-angle POV.

5  Leave a space for the bridge of the nose, then finish up the sockets. Note the degree of curvature and the fact that both upper and lower borders of the sockets are concave in shape.

## CONSTRUCTING THE MANNEQUIN HEAD FROM A LOW ANGLE

The challenge in a low-angle or worm's-eye view is adjusting the curvature of the crosslines and—ultimately—the completed eye sockets, as they angle away from the viewer. There is a degree of visual compression to be considered here as well.

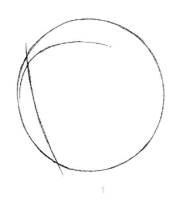

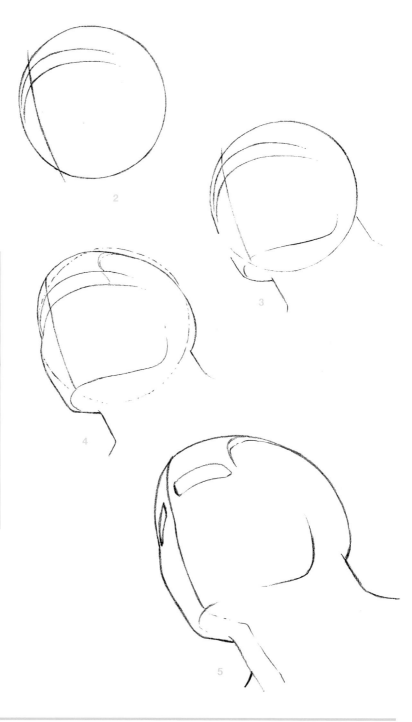

1   Place crosslines on a sphere to help establish the angle of the head.

2   Use double lines, following the curvature of the sphere, to form the boundaries of the eye sockets.

3   Block in the jaw.

4   Modify or "re-shape" the sphere so that it becomes more skull-like around the forehead.

5   The correct placement of the eye sockets on the head is crucial for the creation of a convincing high- or low-angle view. Note how high up the eye sockets are on the form in the high-angle view, as opposed to their positioning in the low-angle view.

CONSTRUCTING MANNEQUIN HEADS FROM VARYING ANGLES

In a transition from an eye-level to a low-angle view, the curve of the jaw first flattens and then inverts, becoming A-shaped. The eye sockets' curvature also becomes more extreme as the head rotates into higher and lower angles. Notice how compressed the eye sockets become at the more extreme angles, and how their outlines, from top to bottom, follow the frame curvature.

While the grouping in this section is not comprehensive, it does represent a reasonable number of high and low angles, with three-quarter, front, side, and back views.

Try drawing some of your own mannequin heads! I suggest drawing some from the angles "in between" the ones featured here.

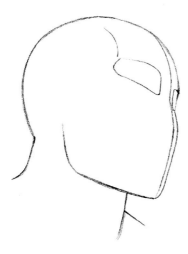

Here is a side view of a mannequin head from a very slight low angle POV.

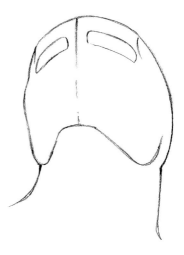

This is a very slightly-turned front view mannequin head from a low angle POV in which the eye sockets are seen closer to the top.

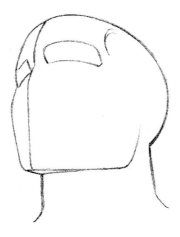

This is a three-quarter very slightly low angle view of the mannequin head from the front. Remember to draw in the center line which helps you place the eye sockets now located closer to the upper portion of the head, with only a tiny portion of chin showing here.

Here is a three-quarter high angle view of the mannequin head from the side. Note a hairline is needed as well as the center line which helps to differentiate the top of the head and face. Locate the brow line in order to place the eye sockets.

This very high angle, fron view shows the top of the mannequin head with the hairline close to the front leaving only a small portion of the face visible and slits for the eyes.

Here is a three-quarter side and back view of the mannequin head from a high angle. The facial features are not visible.

Finally, here is the high angle, back view of the mannequin head. Its hairline shows that the head is slightly tilted upwards. Very little of the face is shown.

# Joining the Mannequin Head to the Torso and Hips

Connecting the mannequin head to the torso and hips is the next step in building whole figures. The addition of the head reinforces the gestural flow established throughout the torso and hips. Draw your own variations of these figures from every angle you can imagine!

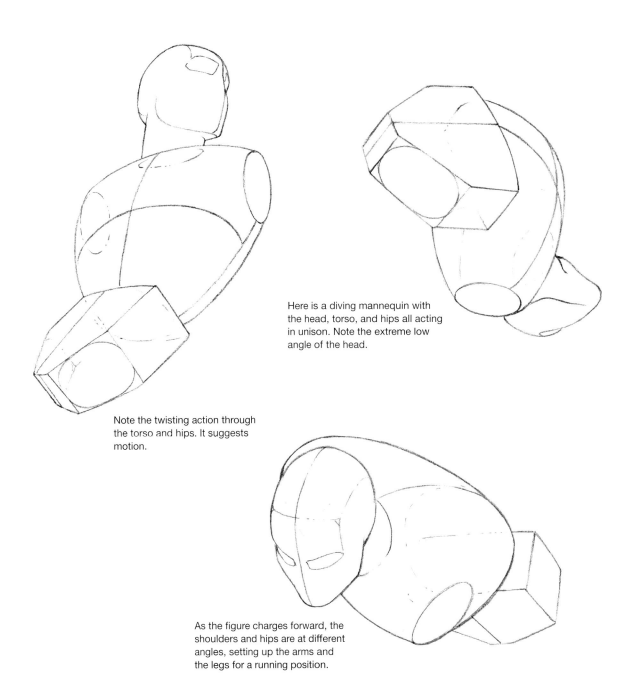

Here is a diving mannequin with the head, torso, and hips all acting in unison. Note the extreme low angle of the head.

Note the twisting action through the torso and hips. It suggests motion.

As the figure charges forward, the shoulders and hips are at different angles, setting up the arms and the legs for a running position.

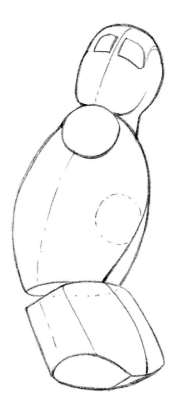

This mannequin appears to be in mid-turn. A dominant lateral line will help you assess the degree of twisting in a figure.

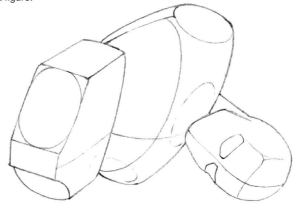

In this pose the head, torso, and hips are in perfect alignment with one another on a flowing curve.

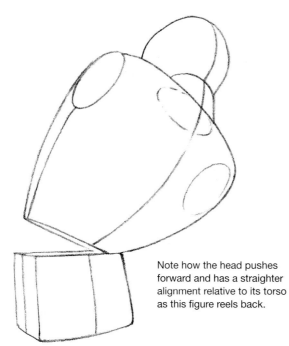

Note how the head pushes forward and has a straighter alignment relative to its torso as this figure reels back.

Here is a tumbling figure with a strong curvature throughout its body. Note the extreme foreshortening in both the head and torso.

## Mannequin Deltoids

The mannequin deltoids straddle the top and sides of the mannequin torso. They connect the arms to the torso and are a vital addition to the mannequin model. Without the deltoids, the figure's arms would appear to be free-floating.

The indentations that give deltoids their heart-shaped appearance are also important landmarks. They represent a point of connection between the collarbones in the front and the shoulder blades (scapula) in the back.

Like the other components of the mannequin, these deltoids are simplified versions of the real things. They retain the same mass, overall shape, and placement as their real-life counterparts.

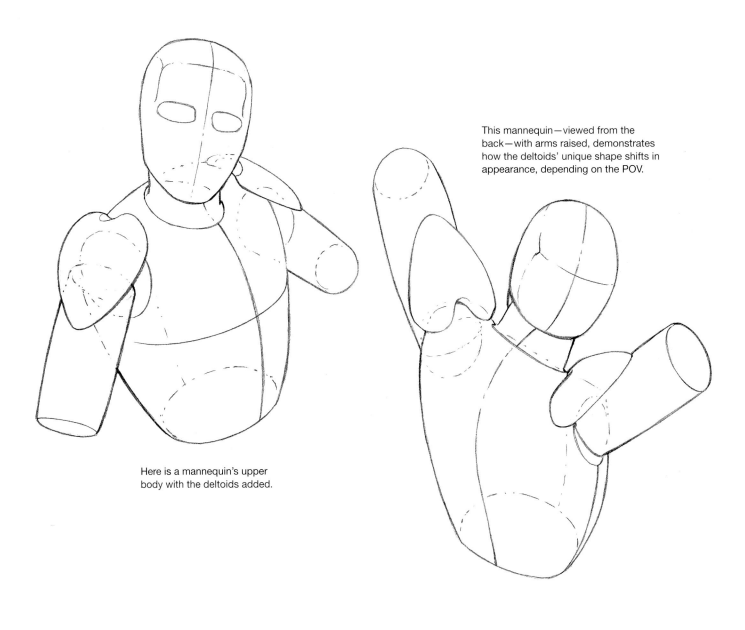

This mannequin—viewed from the back—with arms raised, demonstrates how the deltoids' unique shape shifts in appearance, depending on the POV.

Here is a mannequin's upper body with the deltoids added.

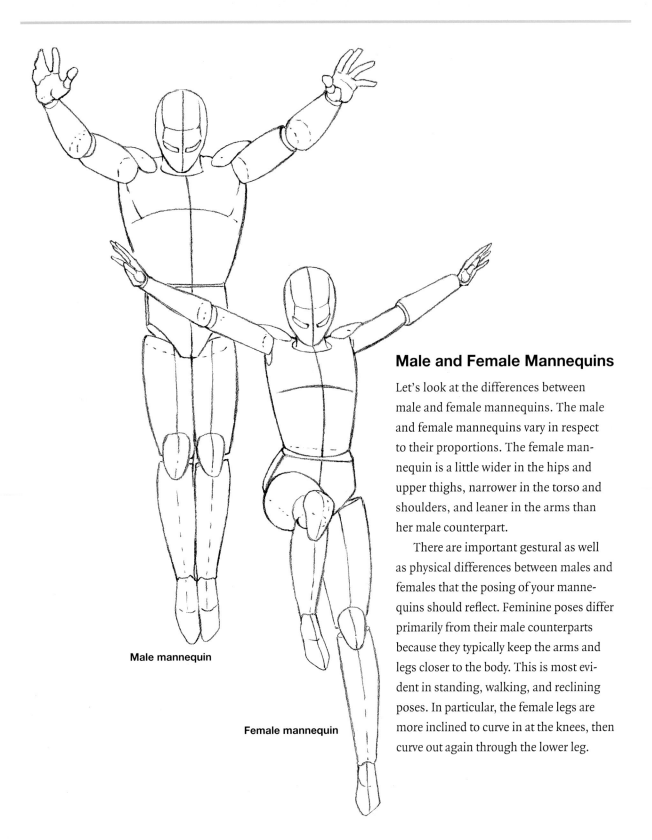

Male mannequin

Female mannequin

## Male and Female Mannequins

Let's look at the differences between male and female mannequins. The male and female mannequins vary in respect to their proportions. The female mannequin is a little wider in the hips and upper thighs, narrower in the torso and shoulders, and leaner in the arms than her male counterpart.

There are important gestural as well as physical differences between males and females that the posing of your mannequins should reflect. Feminine poses differ primarily from their male counterparts because they typically keep the arms and legs closer to the body. This is most evident in standing, walking, and reclining poses. In particular, the female legs are more inclined to curve in at the knees, then curve out again through the lower leg.

# Completed Mannequins in Motion

Below, I have completed a number of the earlier core drawings, giving them arms and legs. The choices I made were designed to work with the established gestural flow running through the poses, but were not the only possible ones.

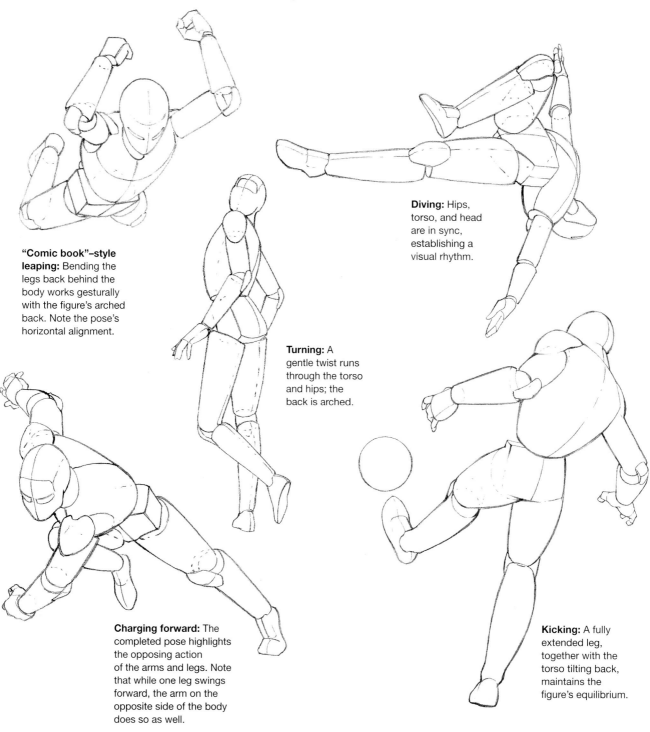

"Comic book"–style leaping: Bending the legs back behind the body works gesturally with the figure's arched back. Note the pose's horizontal alignment.

Diving: Hips, torso, and head are in sync, establishing a visual rhythm.

Turning: A gentle twist runs through the torso and hips; the back is arched.

Charging forward: The completed pose highlights the opposing action of the arms and legs. Note that while one leg swings forward, the arm on the opposite side of the body does so as well.

Kicking: A fully extended leg, together with the torso tilting back, maintains the figure's equilibrium.

## EXERCISE: Drawing Mannequin Parts

Practice drawing the following using the high- and low-angle POVs:

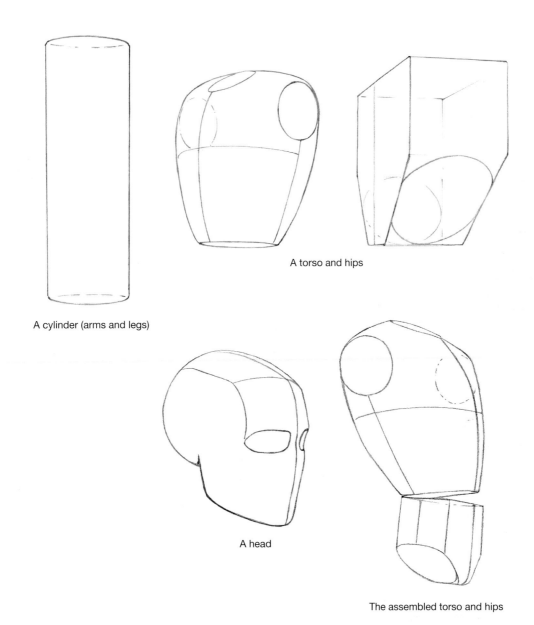

A cylinder (arms and legs)

A torso and hips

A head

The assembled torso and hips

# 3

# THE STANDING FIGURE

In this chapter you will study the standing figure with a focus on the mannequin. I will show you how weight is distributed and supported by the body, and the resultant natural lines of rhythm that shape every pose. Those forces can give life to your freehand figure drawing. I'll also cover applying perspective to your standing figures at both high and low angles, and offer up an alternative approach to building the figure in a box.

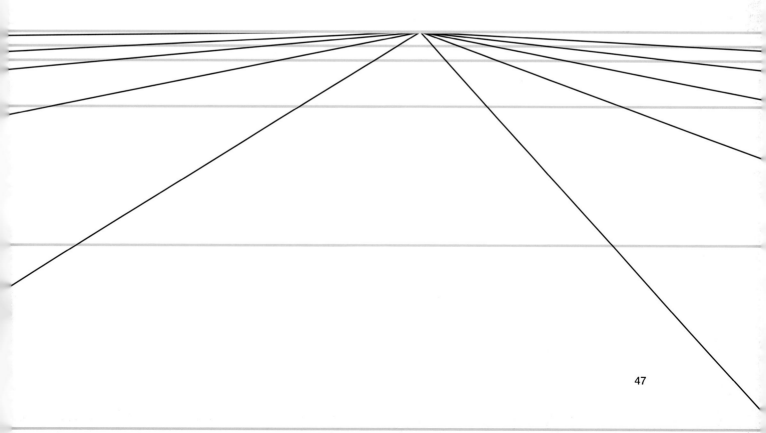

## The Natural Lines of Rhythm

There are many visualization tools you can use when freehand drawing. Two of the most basic and useful ones are the S-*curve* and the C-*curve*, collectively known as the *natural lines of rhythm*. These lines are usually subtle in form, but they are powerful tools for breathing gestural, fluid life into your freehand figures, helping you to avoid stiffness. While the S- and C-curves typically run from "head to toe" through the figure, you can also find them in individual limbs—as in arms and legs—imparting a natural visual flow.

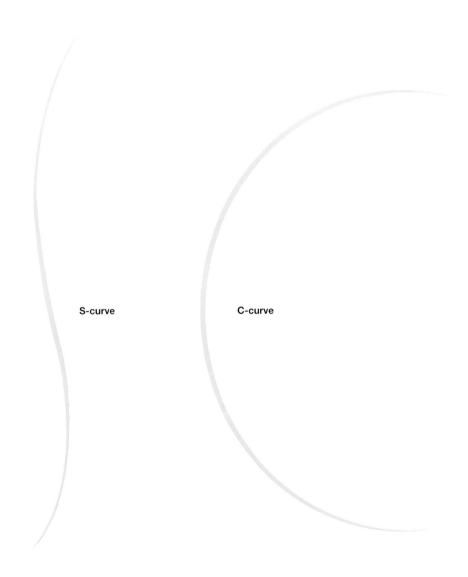

S-curve          C-curve

# The Standing Figure—Arms at Rest

One of the greatest challenges you will face in drawing the human figure is found in the battle against stiffness. Nowhere is that struggle more keenly felt than in posing standing figures.

Of all the possible standing poses, the most difficult ones to breathe visual life into are those in which the figures stand at rest, with their arms at their sides. So let's start there.

Observe anyone standing in one place for a period of time and you will notice that the person constantly shifts his or her weight from one leg to the other. Bodies must deal with the constant tug of gravity. To avoid fatigue, we regularly redistribute our weight. You can see the effect this has on the body in the comparative study of two figures below.

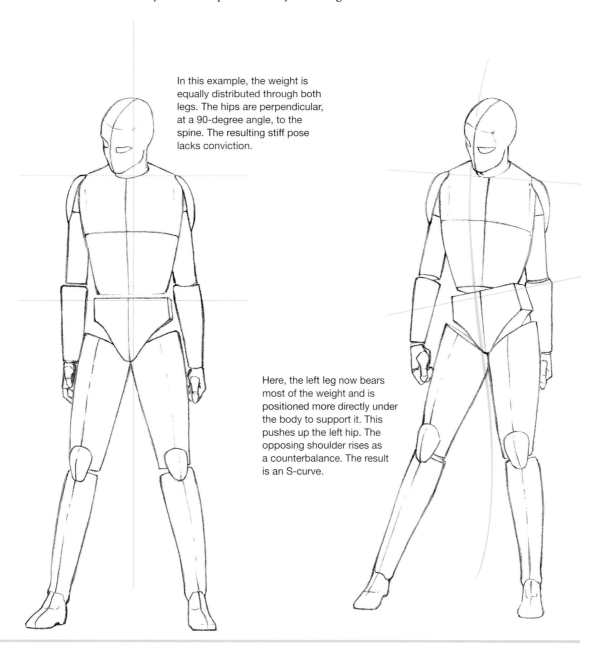

In this example, the weight is equally distributed through both legs. The hips are perpendicular, at a 90-degree angle, to the spine. The resulting stiff pose lacks conviction.

Here, the left leg now bears most of the weight and is positioned more directly under the body to support it. This pushes up the left hip. The opposing shoulder rises as a counterbalance. The result is an S-curve.

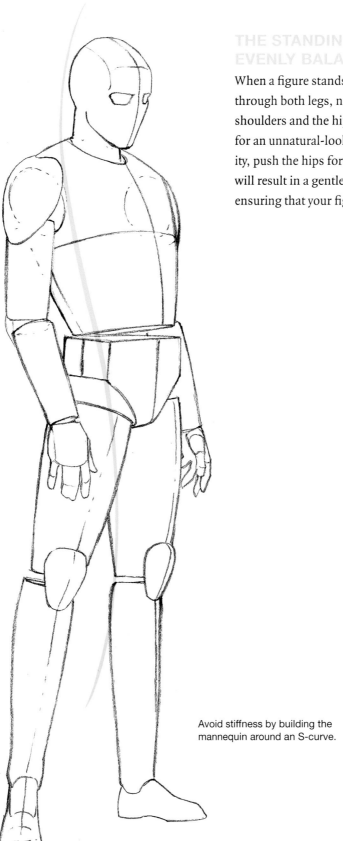

## THE STANDING FIGURE—WEIGHT EVENLY BALANCED

When a figure stands with weight evenly distributed through both legs, no opposing angles run through the shoulders and the hips, and so there is a certain potential for an unnatural-looking stiffness. To add some fluidity, push the hips forward relative to the shoulders. This will result in a gentle S-curve running through the spine, ensuring that your figure takes on a relaxed appearance.

Avoid stiffness by building the mannequin around an S-curve.

## THE ARM AT REST

You can apply the natural lines of rhythm to individual limbs as shown in the example of a relaxed, or "at rest," arm. A relaxed arm, hanging loosely at the side of the body, does not extend straight down. From the shoulder to the elbow, it angles back a little. From the elbow down to the wrist, it changes direction, angling forward. Once it reaches the wrist, it changes direction again, with the palm angling almost straight down. The fingers then curl gently inward. Together these changes in direction result in a gestural S-curve running through the arm.

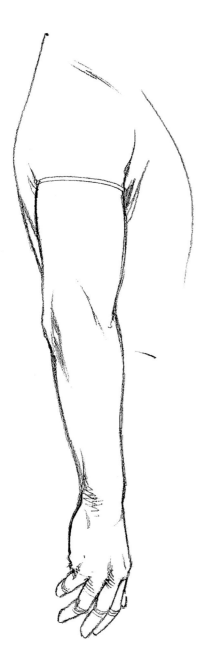

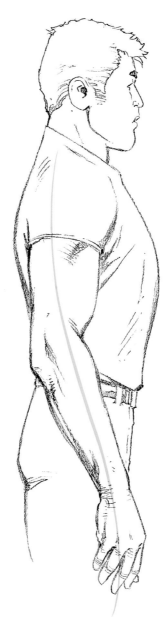

This figure demonstrates a more natural positioning for the arm, generating another S-curve.

Drawing the arm at rest as running straight down the side of the body is a common mistake. Just try it: holding your own arm perfectly straight takes work!

## THE FULLY EXTENDED LEG

A gestural S-curve originates in the bones, but it is also clearly visible in the fully-formed leg, especially an extended one. Another way in which the curve shows itself is in how the leg sets back at the knee joint, as illustrated in the three mannequin leg studies below.

Learning to incorporate the S-curve into your own mannequin constructions will help you to avoid stiffness in your poses, and lend solidity to the structure of your drawn legs.

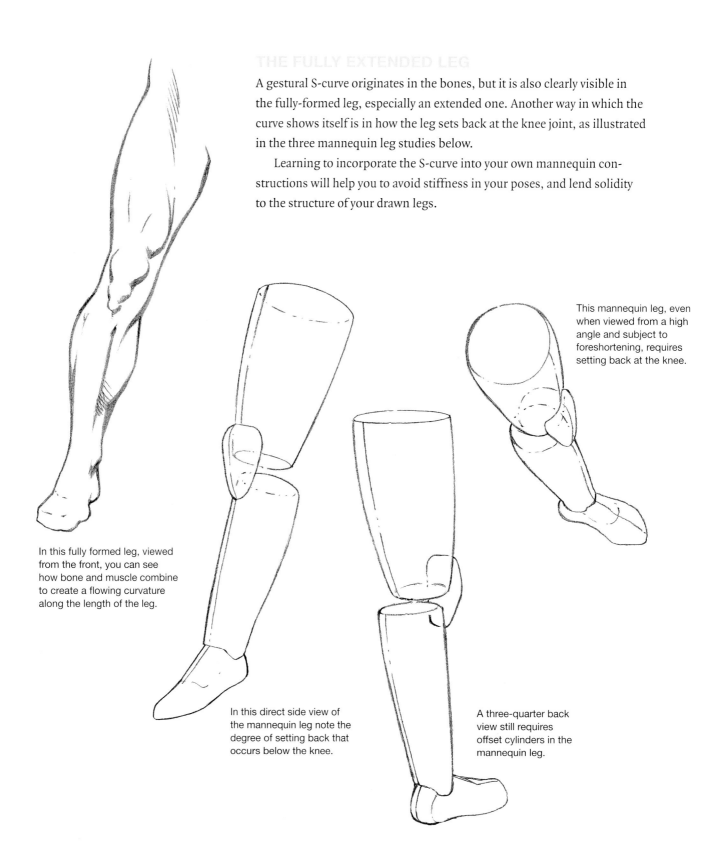

This mannequin leg, even when viewed from a high angle and subject to foreshortening, requires setting back at the knee.

In this fully formed leg, viewed from the front, you can see how bone and muscle combine to create a flowing curvature along the length of the leg.

In this direct side view of the mannequin leg note the degree of setting back that occurs below the knee.

A three-quarter back view still requires offset cylinders in the mannequin leg.

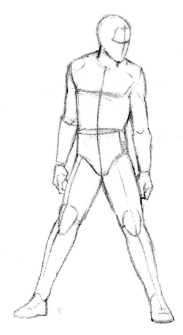

# Drawing the Standing Figure from a High Angle

The following is a demonstration of how to construct standing figures at a high angle. Pay special attention to fitting the figure into the environment so that he or she will not appear to tip over to one side. This task is made easier if you lay down a grid *before* drawing your mannequin in perspective.

When it comes time to draw the figure, ask the following questions:

- What is the angle of the shoulders relative to the hips?
- How is the figure's weight distributed?
- Are the hips positioned directly under the shoulders?
- Are the hips moving forward? Are they moving back?
- Is there an obvious S-curve or C-curve at work?

1 First, plan out your desired pose in a small "thumbnail" sketch, drawn from the simplest but clearest point of view. For this example, I used a frontal view at eye level.

2 Lay down a perspective grid to represent the ground plane. This grid will help you visualize the exact angle of the surface. It is invaluable for placing your standing figure's feet properly.

3  It's time to draw. Start with the figure's core, referring to your thumbnail sketch for guidance.

4  Add the head. It will complete the gestural flow through the figure's core. At this angle, the head overlaps the torso, and in doing so, reinforces the POV.

5 Draw the legs. Consider the angle from which each leg is viewed before drawing it in. Note the different degrees of foreshortening at work in this example. Here, and with the arms in the next step, the transparency of the mannequin proves helpful for plotting the placement of legs that can't be fully seen.

6 Complete the figures by drawing in their arms. Remember the gestural S-curve that runs through a relaxed arm.

# Drawing the Standing Figure from a Low Angle

As outlined in chapter 1, using the box method for drawing standing figures is one effective way to deal with applying strong perspective. However, let me now introduce you to another approach that doesn't require the box. This method works particularly well when the subject is viewed from a three-quarter side angle.

First, establish a low horizon line and vanishing points at left and right. This establishes your mannequin in perspective. However, there is one important factor to note: drawing the shoulders and hips in perfect alignment may risk the resultant figure looking stiff.

By alternating the angles running through both the shoulders and the hips as shown in the second version, and adjusting the legs by positioning the one on the side with the raised hip more directly under the body, while angling the other leg out, you establish a gestural S-curve throughout the figure, therefore avoiding stiffness.

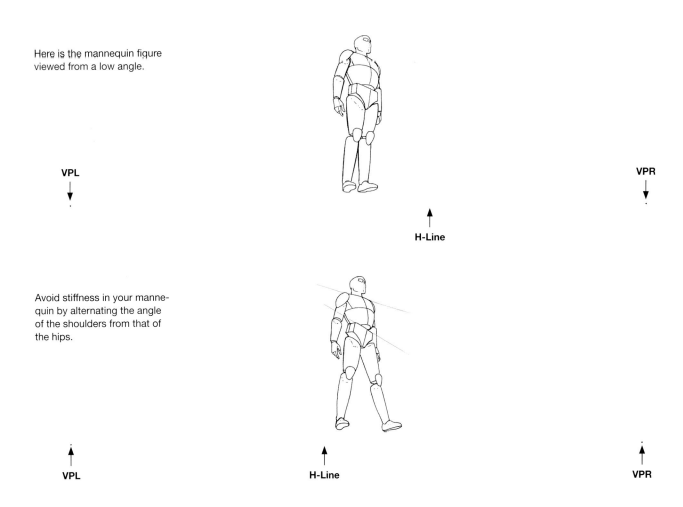

Here is the mannequin figure viewed from a low angle.

VPL

VPR

H-Line

Avoid stiffness in your mannequin by alternating the angle of the shoulders from that of the hips.

VPL

H-Line

VPR

## How the Viewer's Proximity Affects the Image

As the examples below illustrate, it is not only a matter of high angle versus low angle versus eye level. How close you place the viewer to the object you're drawing is also important. So be aware that the effect on proportions due to changes in the viewer's proximity to the subject is as important as the degree of high or low angle applied to it.

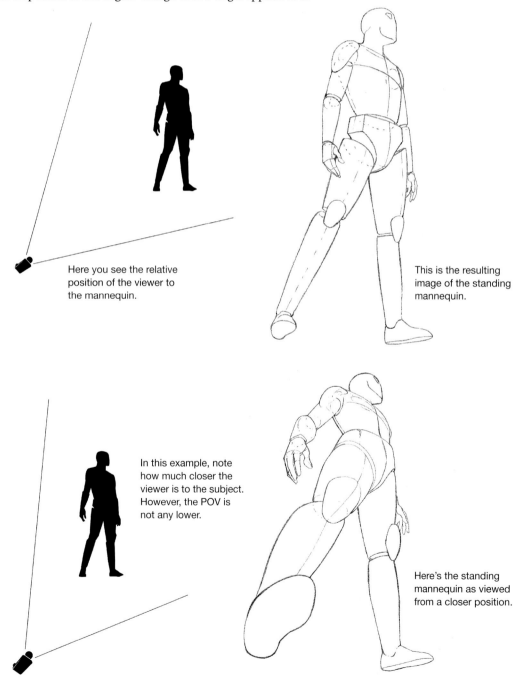

Here you see the relative position of the viewer to the mannequin.

This is the resulting image of the standing mannequin.

In this example, note how much closer the viewer is to the subject. However, the POV is not any lower.

Here's the standing mannequin as viewed from a closer position.

## "Classic" Standing Poses

Up to this point, I've focused on the most basic standing poses—those with both arms at rest at the mannequin's sides. However, there are many more possibilities to explore.

How we hold our arms is a key component in our overall body language. The poses covered in this section all involve *changed-up* arm positions, designed to suggest states of mind such as confidence, nervousness, contemplation, impatience, and more.

Every pose that you draw should evoke an attitude. Be sure to observe and incorporate body language into all of your figure work.

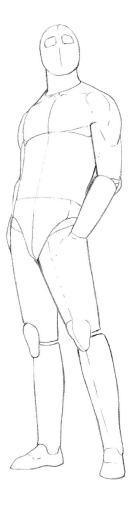

**Mannequin with hands in pockets:** The weight is distributed equally through both legs. With the hips shifted forward relative to the shoulders, the pose has an S-curve running through it.

**Finished figure:** The looseness of the pants legs requires that you drop the fabric almost straight down to the feet. There is, however, still some hint of the setting back at the knee.

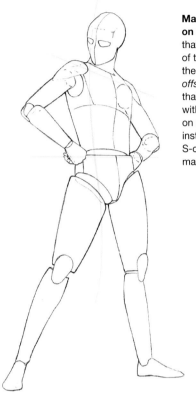

**Mannequin with hands on hips, front view:** Notice that while the positioning of the arms is symmetrical, the shoulders and hips are *offset*, by which I mean that they are not aligned with each other, taking on alternating angles instead. A strong gestural S-curve runs through the mannequin's core.

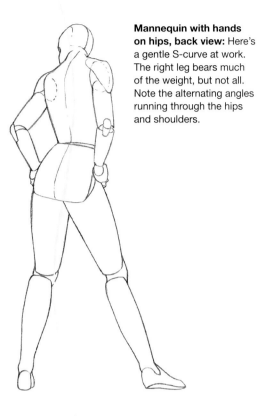

**Mannequin with hands on hips, back view:** Here's a gentle S-curve at work. The right leg bears much of the weight, but not all. Note the alternating angles running through the hips and shoulders.

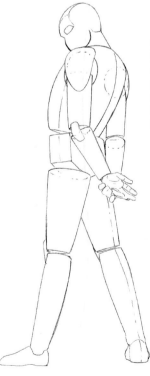

**Mannequin with arms behind back from a side view:** This view clearly shows that it is the arching of the back and the tilting forward of the head that gives this pose its S-curve.

**Mannequin with arms behind back from a high angle:** In the example above I have gridded the floor underneath the figure in order to establish the perspective and plant the feet accurately. Note the visible S-curve.

## Arms Folded: An Issue of Clarity

Let's make a comparative study of two figures with their arms folded across their chests. In the pose at left the figure seems either insecure or too cold. Look at the visual cues that would give the viewer this impression. The first figure's shoulders are raised, giving him the appearance of being tight and tense. The head hangs low and is at an angle that suggests he is avoiding eye contact. His footing seems just a little unsure with most of his weight resting on the left leg.

By comparison the figure on the right seems relaxed and confident. The curvature of the back and the solid stance of the legs both act to reinforce this impression. Also the arms are folded a little lower across the chest.

Together these figures serve as a strong object lesson for the importance of clarity in posing. Overall these are very similar poses, yet it is the subtler details that make all the difference between them. By making use of subtleties such as the positioning of the limbs, the angling of the head, even how the mannequin's weight is distributed, you can give the viewer specific insights into a figure's attitude or mental state.

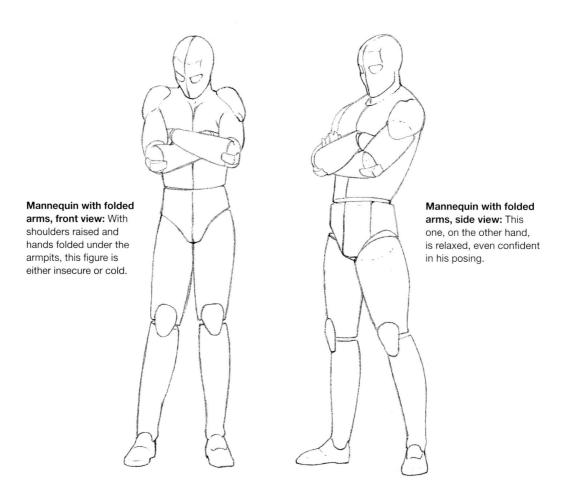

**Mannequin with folded arms, front view:** With shoulders raised and hands folded under the armpits, this figure is either insecure or cold.

**Mannequin with folded arms, side view:** This one, on the other hand, is relaxed, even confident in his posing.

# Using Props in Posing the Figure

Beyond mastering the various arm positions catalogued in the previous pages, you can draw standing figures holding and/or using a wide range of props, for example, a briefcase or a handbag. At times, this will mean adjusting the distribution of weight through the figure to accommodate the prop. A prop can also give a specific context to a pose, working with the figure's body language.

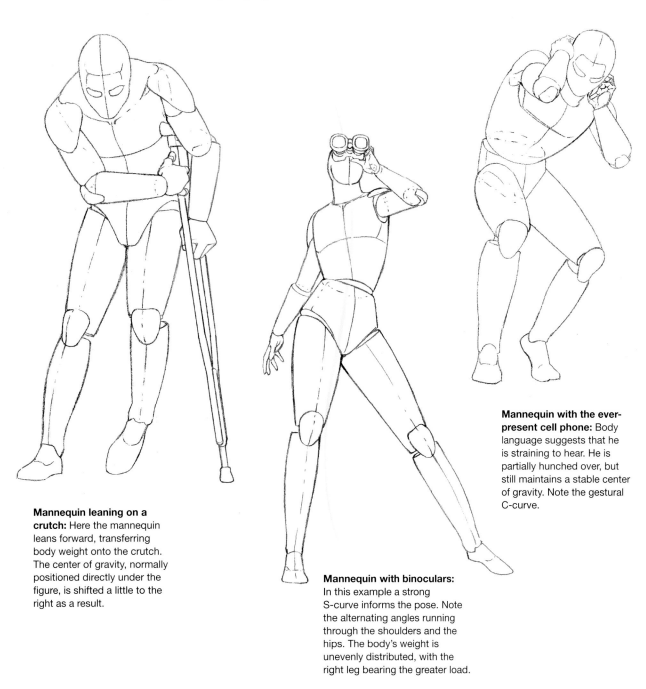

**Mannequin leaning on a crutch:** Here the mannequin leans forward, transferring body weight onto the crutch. The center of gravity, normally positioned directly under the figure, is shifted a little to the right as a result.

**Mannequin with binoculars:** In this example a strong S-curve informs the pose. Note the alternating angles running through the shoulders and the hips. The body's weight is unevenly distributed, with the right leg bearing the greater load.

**Mannequin with the ever-present cell phone:** Body language suggests that he is straining to hear. He is partially hunched over, but still maintains a stable center of gravity. Note the gestural C-curve.

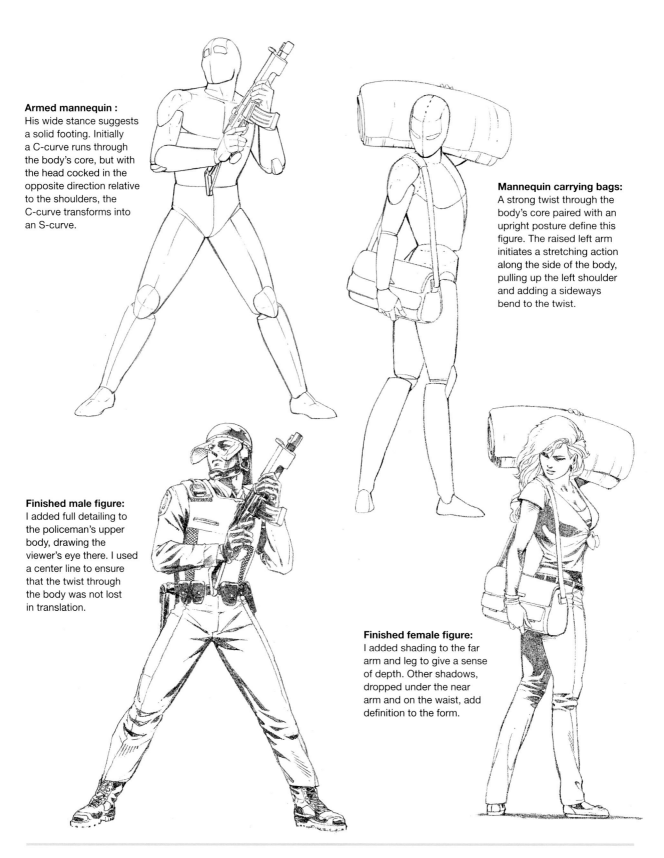

**Armed mannequin :**
His wide stance suggests a solid footing. Initially a C-curve runs through the body's core, but with the head cocked in the opposite direction relative to the shoulders, the C-curve transforms into an S-curve.

**Mannequin carrying bags:**
A strong twist through the body's core paired with an upright posture define this figure. The raised left arm initiates a stretching action along the side of the body, pulling up the left shoulder and adding a sideways bend to the twist.

**Finished male figure:**
I added full detailing to the policeman's upper body, drawing the viewer's eye there. I used a center line to ensure that the twist through the body was not lost in translation.

**Finished female figure:**
I added shading to the far arm and leg to give a sense of depth. Other shadows, dropped under the near arm and on the waist, add definition to the form.

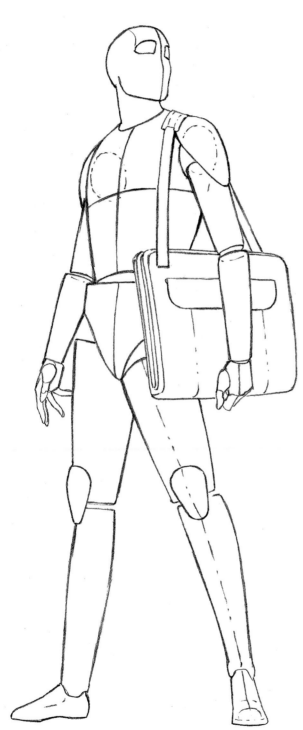

## EXERCISE: Standing Mannequin with Prop from Various Angles

Practice drawing eight views of the figure on the left, employing high and low angles, as well as back, side, and front views.

Before you start to draw, make a study of the figure. You need to answer some key questions:

- How is the body's weight distributed?
- To what degree is the figure affected by the weight of the portfolio?
- What is the angle of the shoulders relative to the hips?
- Is there a noticeable S-curve or C-curve running through the figure?
- Do the hips line up directly below the torso or are they slightly ahead of or behind the torso?
- How is the head oriented relative to the body?

Answer these questions first, then start drawing.

# THE WALKING AND RUNNING FIGURE

In this chapter, you will examine the figure in both walking and running poses. Both share many of the same attributes, but each also has its own distinctive features. One key feature of both is the opposing action of the arms and legs.

One opposing action occurs when one leg swings forward and the opposite arm comes forward at the same time. When one leg pushes back, it is the opposite arm that swings back with it. Inevitably this leads to a twisting action running through the torso and hips—subtle in a walking figure but more obvious in a runner.

Before you embark on a serious study of walking and running figures, you must understand another primary concept behind freehand figure drawing, one that is very pertinent to this chapter—*the tipped line of balance.*

# The Tipped Line of Balance

Like the S-curve and C-curve, the *tipped line of balance* is a fundamental tool for giving life and energy to drawn figures.

Draw a line through the center of a body's trunk. You can tip this line forward, backward, or to the side, depending on the pose. You can use it to gauge the gestural dynamics of the pose. Or you can lay it down first as a foundation for your drawing.

While a walking figure will often benefit from a line that gently tips forward, a running figure almost always requires a stronger one. In general, you should apply a tipped line of balance to any figure "in motion": the greater the degree of tip, the more dynamic the resulting pose.

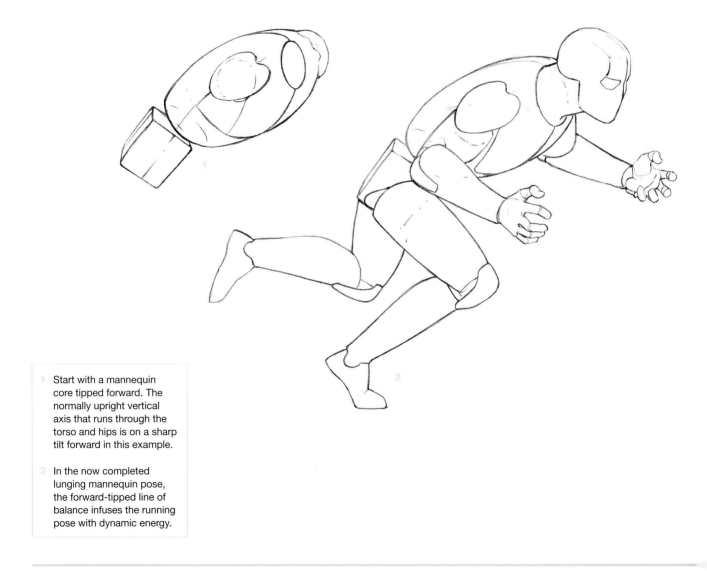

1   Start with a mannequin core tipped forward. The normally upright vertical axis that runs through the torso and hips is on a sharp tilt forward in this example.

2   In the now completed lunging mannequin pose, the forward-tipped line of balance infuses the running pose with dynamic energy.

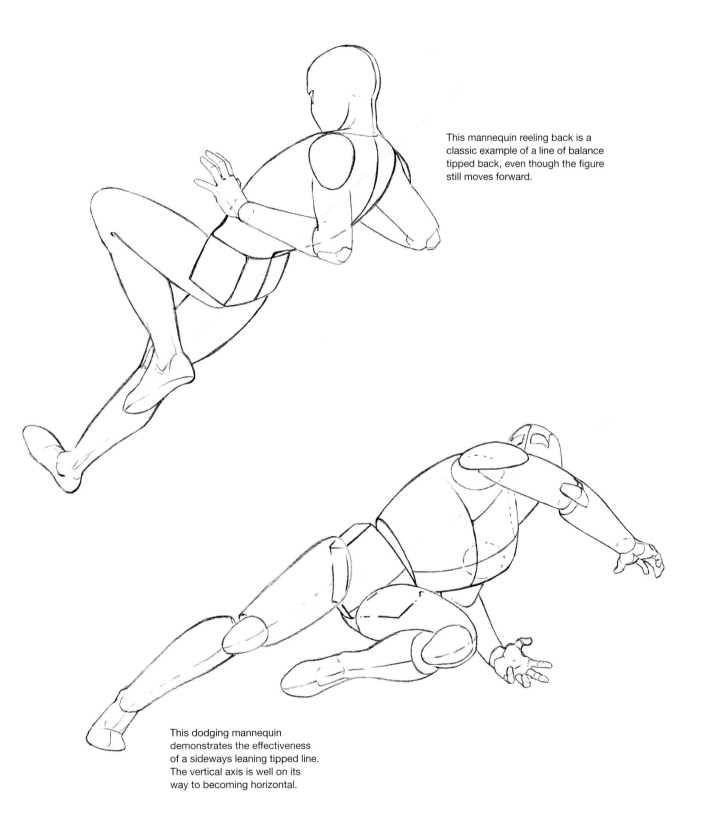

This mannequin reeling back is a
classic example of a line of balance
tipped back, even though the figure
still moves forward.

This dodging mannequin
demonstrates the effectiveness
of a sideways leaning tipped line.
The vertical axis is well on its
way to becoming horizontal.

# The Walking Figure

*Standard walking* and *running cycles* are useful tools for understanding the mechanics of forward motion. You can break them down into a greater number of steps than are shown below and on pages 76–77. For these examples I have chosen to use eight-step cycles.

### EIGHT-STEP WALK CYCLE

Key points to note are the opposing actions of the arms and legs and how the body rises up in mid-cycle. Not all stages of the walk cycle read well as individual poses. For example, step seven looks particularly awkward with the arms and legs at the midpoint of crossing each other. The full stride as illustrated in steps four and eight serve as stronger foundations for the walking figure.

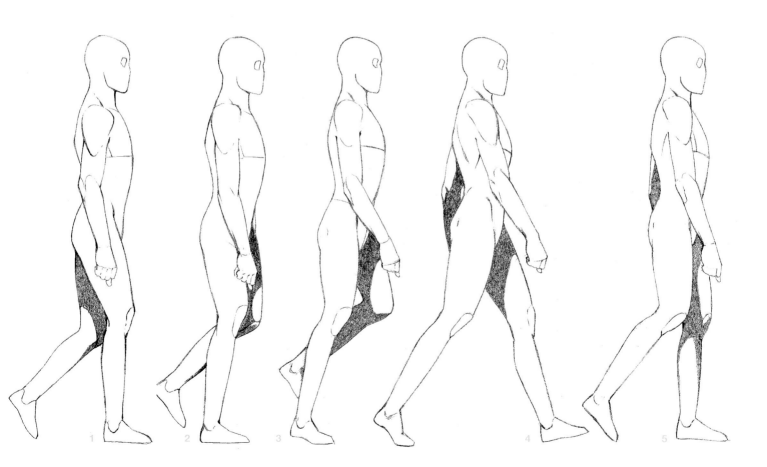

## Adding Features and Clothing

When completing a figure by drawing over a mannequin, be careful not to reduce or remove fundamental gestural cues such as the line of rhythm. The costuming that you add needs to work with the underlying gesture, not against it.

One way to facilitate this is to ensure that your rendering of the costume is built around the mannequin's vertical center line. By keeping track of it, you will maintain not only the gesture, but also the original perspective of the mannequin.

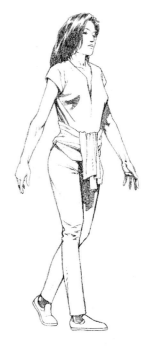

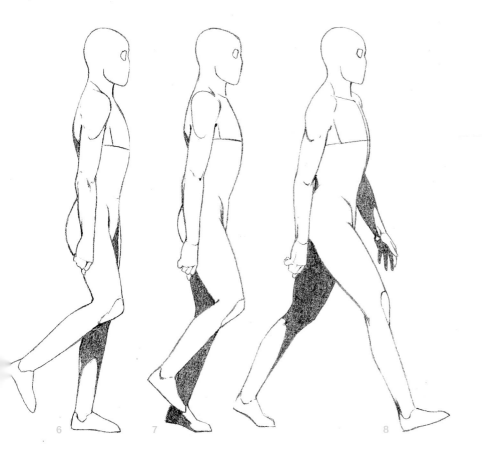

6        7                                    8

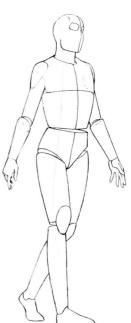

These illustrations of a woman and her mannequin counterpart show the subtler mechanics of the walking figure. The leg bearing the body's weight (the right leg) pushes the hip up on that same side. The shoulder on the opposite side rises to act as a counterbalance.

## THE WALKING MANNEQUIN, FRONT VIEW

In a walking mannequin viewed from the front, the opposite movement of the arms and legs is the dominant feature. The alternating rise and fall of the shoulders and hips is also evident, but note that the head does not match the angle of the shoulders. It is straight, or "squared-up." This is common in many active poses and reflects an instinct to keep the head as level as possible for the sake of balance. These traits are shared with the running figure, but in a more exaggerated form. What is unique to the walking figure is the inclination of the legs to angle gently under the body in order to maintain balance.

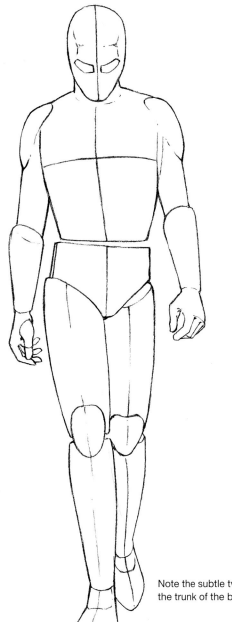

Note the subtle twist through the trunk of the body.

There is a tendency in most walkers to angle their feet slightly outward for added stability.

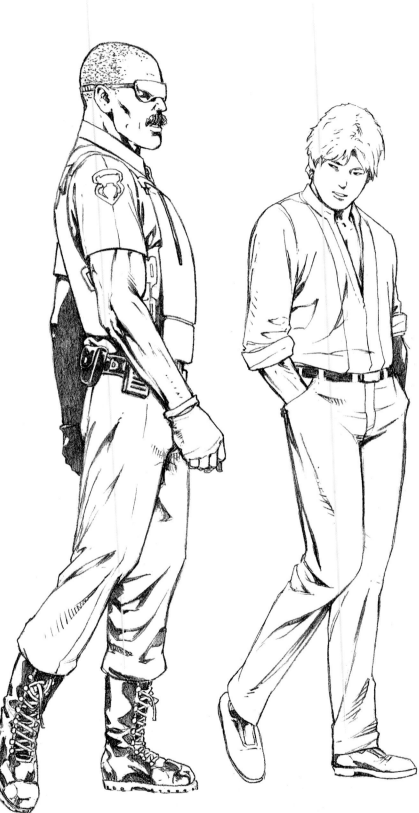

## WALKING FIGURE MOVING FORWARD, TIPPING BACK

There is a special consideration regarding the tipped line of balance as it applies to the walking figure. While you may apply a tipped line of balance forward to a walking figure, it is not always necessary. As the examples to the left demonstrate, there are walking poses that actually work best when constructed around a tipped line of balance backward.

With these two figures, the tipped line of balance backward—although slight— adds to their body language.

## WALKING FIGURES WITH ACTIVE OR OCCUPIED HANDS

In all of the previous examples, the walking figures have had free-floating arms. Of course, the real world is full of people walking to and fro with either one or both arms holding or carrying something or occupied in gesturing during conversations. I've included some examples of those figures in this section.

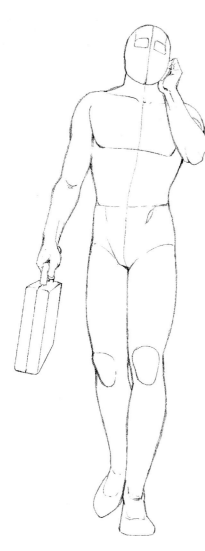

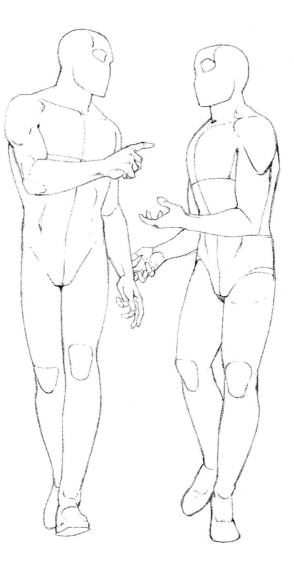

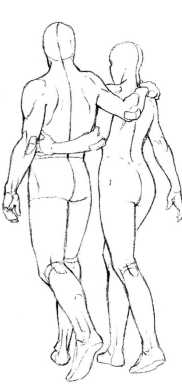

**Walking mannequin with briefcase on cell phone:** Note the gentle twist through the torso and hips, and the way he subtly cocks his head toward his phone.

**Two walking mannequins in conversation:** While the opposing actions of the arms and legs are not in effect because they are using their arms to gesture, these characters still have gentle twists running through their bodies.

**Mannequin couple walking:** Here is a back view of a couple—with his arm around her shoulder and her arm around his waist. The usual opposing action of the arms and legs cannot come into play. Note the line of balance running through each figure and the angles of their feet. (Their stages of the walk cycle are only slightly out of sync.)

## WALKING FIGURES CARRYING WEIGHT: A QUESTION OF BALANCE

Here are a few varied examples of figures carrying weight. Watch for the adjustments in posing required in each instance in order for the figures to maintain their balance.

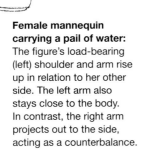

**Male mannequin lugging a sack:** The weight of the sack changes the dynamics of the pose. Note the shifting of the shoulders and hips, as well as the tipping forward of the torso to counter the weight of the load.

**Female mannequin carrying a pail of water:** The figure's load-bearing (left) shoulder and arm rise up in relation to her other side. The left arm also stays close to the body. In contrast, the right arm projects out to the side, acting as a counterbalance.

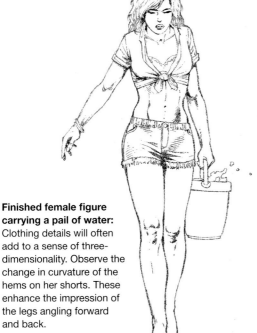

**Finished female figure carrying a pail of water:** Clothing details will often add to a sense of three-dimensionality. Observe the change in curvature of the hems on her shorts. These enhance the impression of the legs angling forward and back.

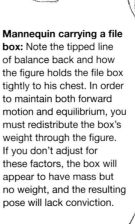

**Mannequin carrying a file box:** Note the tipped line of balance back and how the figure holds the file box tightly to his chest. In order to maintain both forward motion and equilibrium, you must redistribute the box's weight through the figure. If you don't adjust for these factors, the box will appear to have mass but no weight, and the resulting pose will lack conviction.

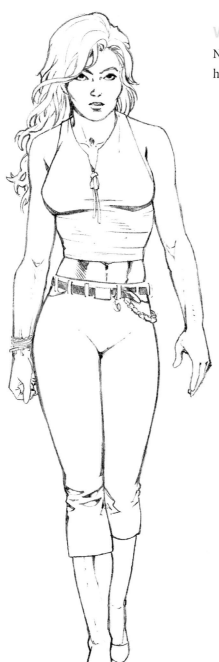

## WALKING FIGURES VERSUS RUNNING FIGURES

Now let's take a comparative look at walking and running figures, highlighting the similarities and differences between them.

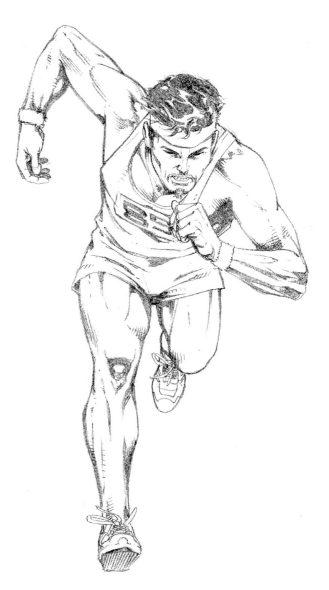

**Walking figure** (Please note):

- alternating rise and fall of shoulders and hips
- opposing arm and leg motion
- a *subtle* tipped line of balance, or none at all
- legs angling inward under the body
- feet angling slightly outward

**Running figure** (Please note):

- alternating rise and fall of shoulders and hips
- opposing arm and leg motion
- a *strong* tipped line of balance forward
- legs dropping straight downward under the body
- foot on trailing leg curving slightly inward

## Comparing Two Runners

The images below depict mannequins at the same phase of the run cycle—demonstrating the differences between a "moderate" and a "full-out" run.

The key elements of a classical running pose are present in both images—but are exaggerated in the one at top. There is a more pronounced tipped line forward and a stronger twist through the torso and hips. The left arm in this image is also noticeably higher. The left knee rises up as well—bringing it tighter to the torso—as the full body leans forward.

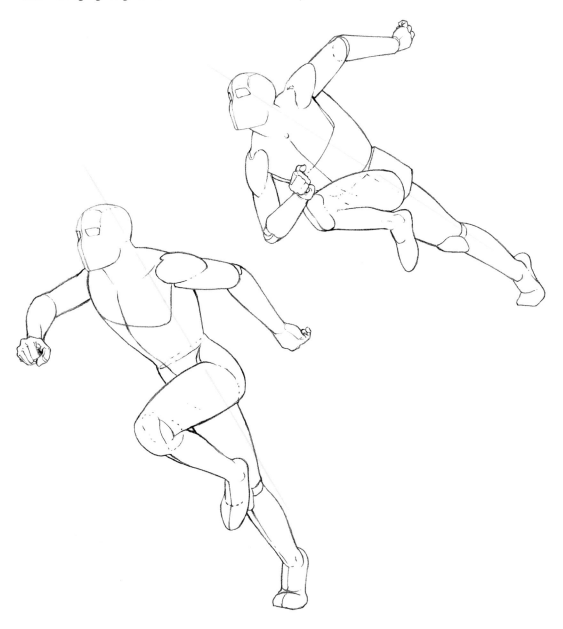

## The Running Figure

It is now time to focus on the running figure. Let's look at a run cycle—a study of the mechanics of forward motion—and some variant styles of running poses.

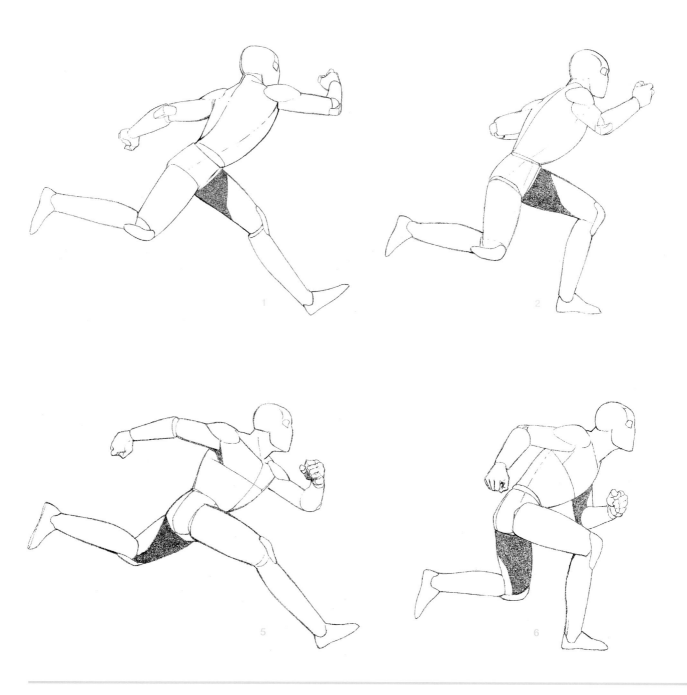

## AN EIGHT-STEP RUN CYCLE

Across these two pages is a run cycle in eight steps. Note how the figure gains height in mid-stride, just as in the walk cycle. Observe as well, the angle of the feet in each step of the cycle. At full stride, the forward leg's heel strikes the ground with the foot angling up. Getting this type of detailing correct will help you to add a gestural *snap*—enhancing your running poses.

Within this run cycle of figures, there are key positions (see positions one and four), that you can base strong running poses around.

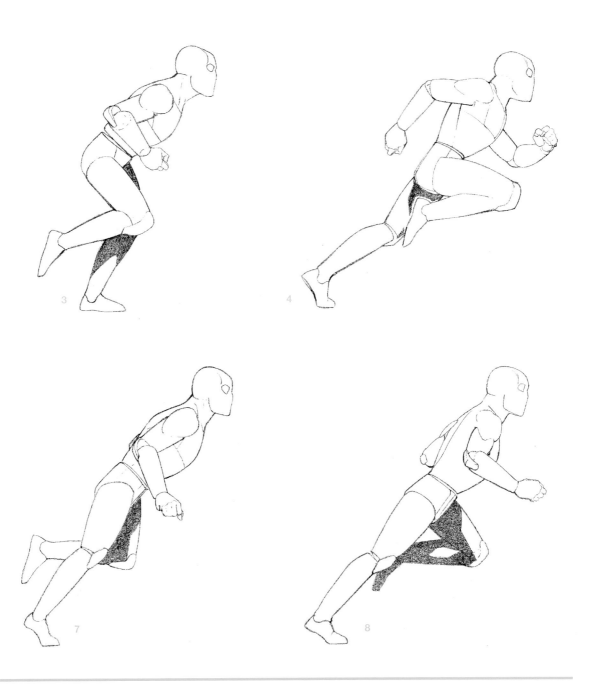

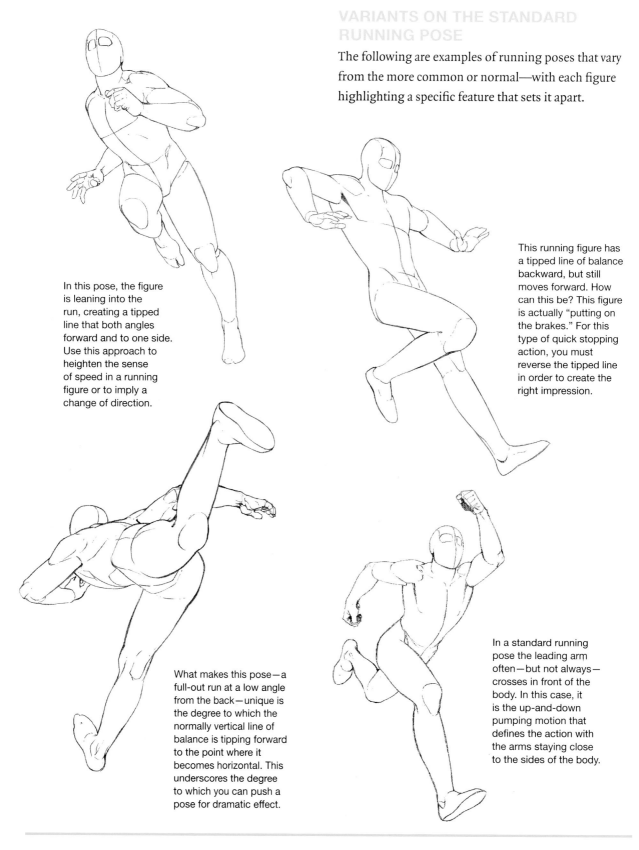

The following are examples of running poses that vary from the more common or normal—with each figure highlighting a specific feature that sets it apart.

This running figure has a tipped line of balance backward, but still moves forward. How can this be? This figure is actually "putting on the brakes." For this type of quick stopping action, you must reverse the tipped line in order to create the right impression.

In this pose, the figure is leaning into the run, creating a tipped line that both angles forward and to one side. Use this approach to heighten the sense of speed in a running figure or to imply a change of direction.

What makes this pose—a full-out run at a low angle from the back—unique is the degree to which the normally vertical line of balance is tipping forward to the point where it becomes horizontal. This underscores the degree to which you can push a pose for dramatic effect.

In a standard running pose the leading arm often—but not always— crosses in front of the body. In this case, it is the up-and-down pumping motion that defines the action with the arms staying close to the sides of the body.

## EXERCISE: Posing and Staging Runners at the Finish Line

Now it's your turn to draw mannequin runners.

- Draw a running mannequin coming down the track in various phases of the run cycle, with a "winner" crossing the finishing line. Try adding a sense of exhaustion to the winner's body language as well.

- Draw a mannequin running, but show him or her "putting on the brakes" with a tipped line backward.

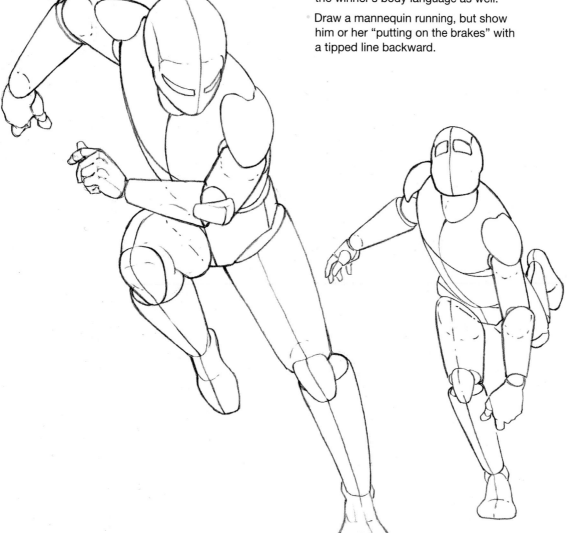

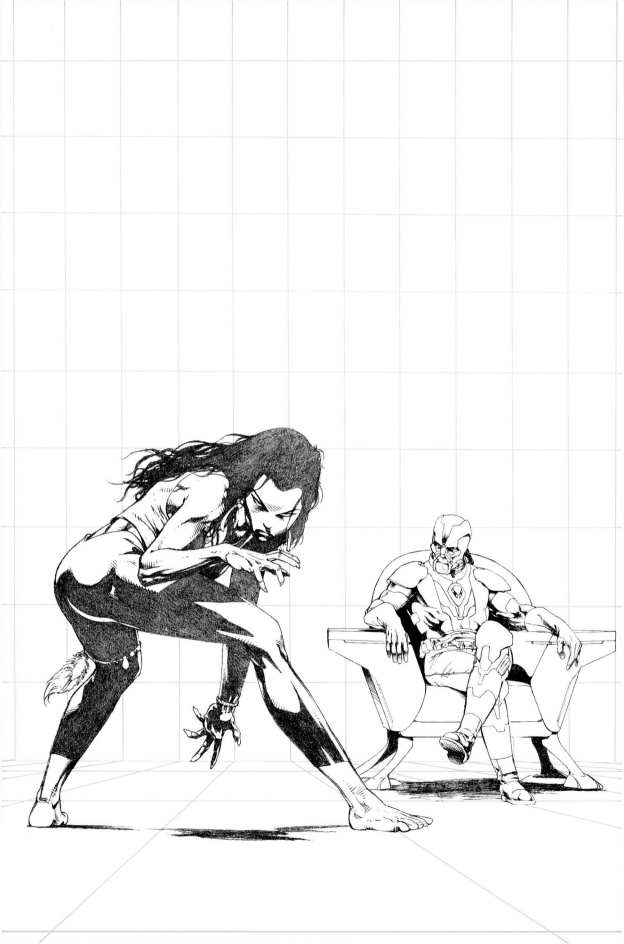

# THE CROUCHING, SITTING, AND RECLINING FIGURE

The type of poses covered in this chapter are once again of the natural variety, and so should be very familiar to you. Many of these poses are by definition static, chronicling the figure in a state of repose. They generally fall into one of the three categories named in the chapter title.

It is challenging to make general statements about the diverse range of poses covered in this chapter. If there's a common theme, it's the importance of tracking how a body's weight is distributed, and how it is supported in each situation.

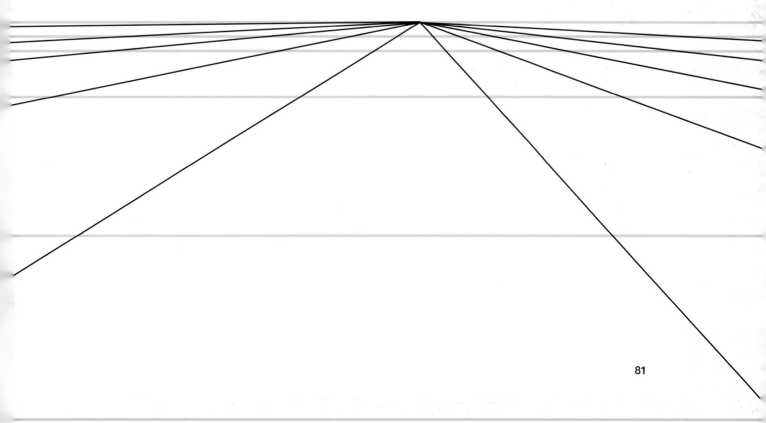

# The Crouching Figure

Let's look at the first type: the standing figure in a crouched position. Doing so will help you better understand principles such as balance, the center of gravity, and the distribution of weight.

The crouching pose comes with a strong tipped line of balance that can easily lead to the character pitching forward head-first. The legs keep that from happening. They swing forward under the body, acting as a counterbalance. Equilibrium is achieved, with further stability provided by the spread-apart feet. To make the pose feasible, the weight of the upper body is supported by the arms and the legs.

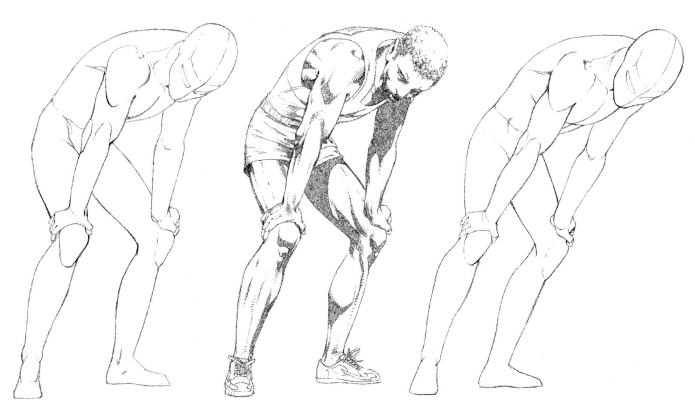

**Crouching mannequin:**
This mannequin's pose is built around a gestural C-curve (which is also the prevalent line of rhythm among seated and reclining poses).

**Finished figure:** Note how the detailing reinforces the angles established in the mannequin underdrawing, especially through the torso and hips.

**Mannequin leaning forward:**
With this type of pose, it is easy to become distracted by the dominant aspects of the upper body's tipped line forward. If the legs are not positioned properly under the torso, then the figure will appear off-balance, as shown here.

## CONSTRUCTING THE CROUCHING MANNEQUIN FROM AN ALTERNATE ANGLE

The crouching pose offers up another good opportunity to demonstrate the step-by-step process. In this demonstration, I have changed the sequence of steps for constructing the figure—giving the hips, legs, and feet priority. Placing the feet accurately on the ground is important and ensures that the legs are in correct perspective.

By using this method, you can develop the ability to break down any given pose. Analyzing the pose's key features combined with the ability to move the mannequin's component parts around in perspective will ultimately give you the versatility to re-create your characters from any POV.

1 Start with a floor grid. The floor grid helps translate proper perspective within a two-dimensional plane. Block in the legs, and place the feet squarely on the grid to give the pose a sound foundation.

2 Next, add the torso, using a gestural C-curve as your guide. The curvature in this example suggests that you should view the figure from the back, with a good amount of foreshortening.

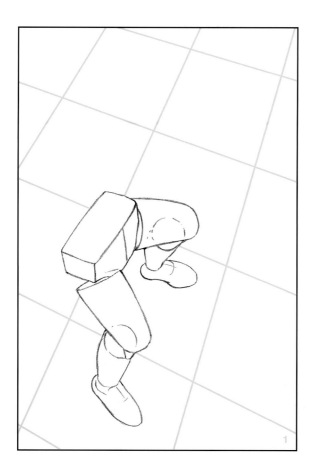

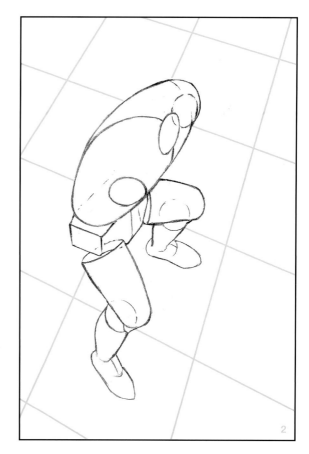

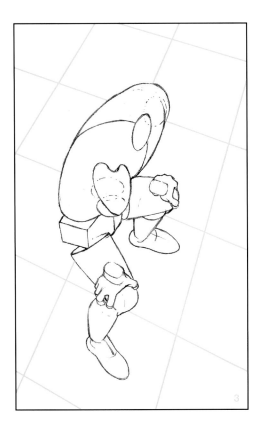

3   Draw in the mannequin deltoids. Place the hands and wrists. By locating these crucial landmark elements, you make the task of blocking in the foreshortened arms straightforward.

4   Draw in the mannequin arms with strong fore-shortening. Block in the visible elbow, ensuring that your construction lines maintain the curvature of the larger forms of the arms. Even small elements such as these benefit from following the curvature of the larger forms.

5   Add the head to complete the pose. Here, the head is viewed from an extreme high angle with the initial crosshairs establishing a tilt that follows the flow of the C-curve.

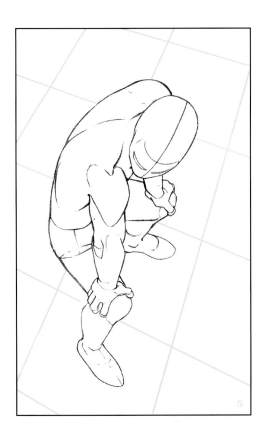

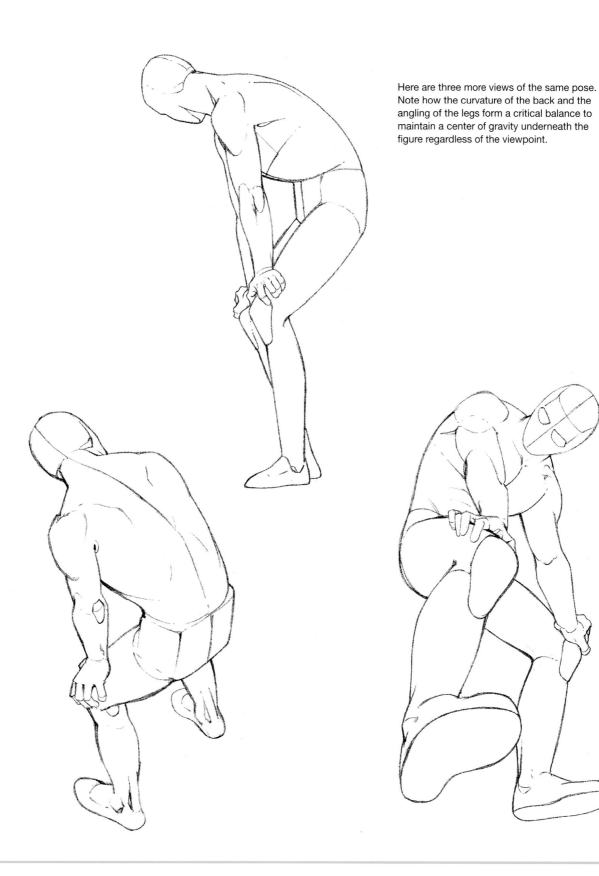

Here are three more views of the same pose. Note how the curvature of the back and the angling of the legs form a critical balance to maintain a center of gravity underneath the figure regardless of the viewpoint.

## The Squatting Figure

Below are three examples of squatting mannequins. In the squatting pose—a variation of the crouch—the figure is positioned low to the ground. In this respect, the poses are similar. Where they differ is in how each figure's weight is distributed.

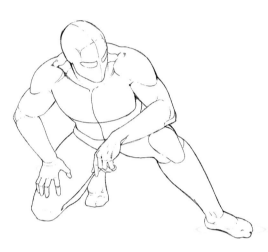

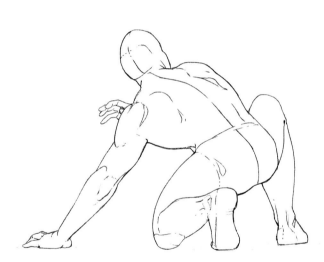

**Semi-kneeling squat, front view:** Evenly distribute the body's weight between both legs, with the upper body's weight resting on the thighs, as shown. In this example, I've circled pressure points where the weight is supported. Once again the center of gravity is directly under the body.

**Semi-kneeling squat from the back:** In this pose the center of gravity shifts a little to the left, because the figure leans in that direction and supports himself on his left arm. Form this pose around a reverse S-curve and place the pressure points at the right foot, the left knee, and left hand.

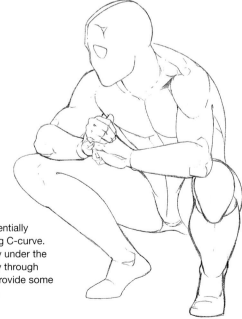

**Squatting mannequin:** This is an essentially symmetrical pose built around a strong C-curve. The figure's center of gravity is directly under the body. The weight is distributed equally through both legs. The elbows and forearms provide some additional support for the upper body.

## RELATED POSES

While they do not strictly fall into the category of "crouching," below are two variations worth noting.

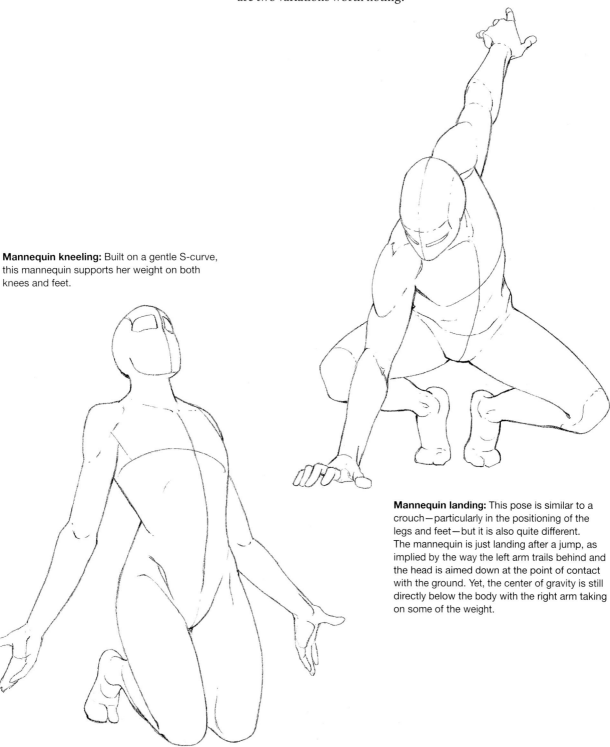

**Mannequin kneeling:** Built on a gentle S-curve, this mannequin supports her weight on both knees and feet.

**Mannequin landing:** This pose is similar to a crouch—particularly in the positioning of the legs and feet—but it is also quite different. The mannequin is just landing after a jump, as implied by the way the left arm trails behind and the head is aimed down at the point of contact with the ground. Yet, the center of gravity is still directly below the body with the right arm taking on some of the weight.

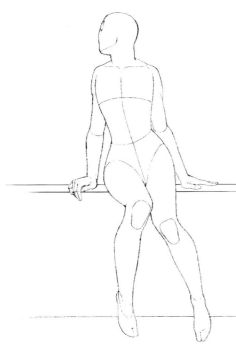

# The Sitting Figure

Let's now look at a range of sitting figures, starting with those in elevated positions like those sitting on benches and chairs, and then moving to examples sitting on the ground. In seated poses, much of the body's weight is supported by the tailbone. Gesturally, these poses are almost always based on the C-curve.

**Mannequin sitting on bench:** There is no back support, so the figure leans forward with elbows and forearms pressing into his thighs to support his upper body. Whatever weight is not supported runs down through the lower legs to the feet. The net result is a figure with a pronounced C-curve.

**Mannequin perching on tabletop:** The mannequin leans slightly to the right. Her right arm supports some of the body's weight, with the major support coming from the tailbone. A C-curve further defines the pose.

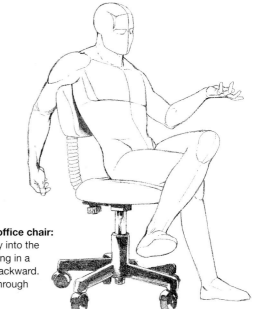

**Mannequin sitting on easy chair:** The figure leans back, taking full advantage of the chair's back support. As a result, a gentle tipped line backward defines the pose. The crossing of the left leg over the right breaks the monotony of an otherwise symmetrical pose.

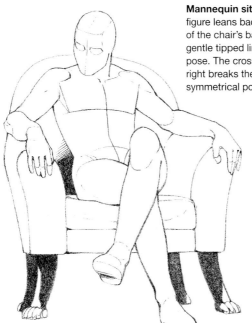

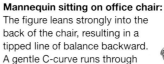

**Mannequin sitting on office chair:** The figure leans strongly into the back of the chair, resulting in a tipped line of balance backward. A gentle C-curve runs through the pose.

1 Mannequin sitting with one leg tucked in and one stretched out: This is a very stable pose with the gestural differences between the legs adding visual interest. The torso leans gently forward and to one side, while the arms support the weight of the upper body.

2 Finished figure: Note that some additional anatomy has been applied to both arms and legs. The folds in clothing act as cross-contour lines helping to define the mannequin's form reinforcing the specific angles of the limbs and torso.

## THE FIGURE SITTING ON THE GROUND

The act of sitting on a flat surface results in an inordinate amount of pressure being exerted on the tailbone. The constant tug of gravity puts pressure on whichever specific region of the spine is used to support a given pose. In response, we tend to shift position constantly when sitting.

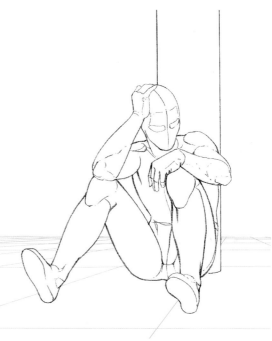

**Mannequin sitting with knees up and legs apart:** In this position you put pressure on the hips to angle back. To maintain balance, the figure leans forward, completing a C-curve. Note that the feet angle upward. I have added a pillar behind the figure to give it back support—without which the pose would be unsustainable.

1. Mannequin laying on the ground: In this example, the mannequin lies on her side, her back arched, and her upper body supported by her forearms. The resultant pose has a gestural C-curve. The head is raised about as much as possible given her prone position. In posing your figure, you must always consider the possible range of movement. Pushing a head and neck—or a limb—beyond what's possible will give your pose an unnatural appearance.

2. Finished figure: In this finished version, the stretching and twisting through the torso and hips are accentuated by the detailing, both in anatomy and clothing.

# Reclining Figure

When drawing figures in reclining poses, don't be concerned with issues of maintaining balance or locating centers of gravity. What distinguishes the reclining pose from all others in this chapter is that support for the body's weight is spread across much—if not all—of the figure. Still, the tug of gravity plays a vital role in shaping these poses.

Strong stretching actions, the arching of the back, and a gentle inward curling of the feet, are all distinguishing features, whether the figure is lying on its belly, its back, or on one side. Comfort is the goal, and a sense of relaxation should permeate these poses.

It is also important to note that the figures in this category are built around a horizontal axis. This means you will have to deal with a high degree of foreshortening. Using a mannequin under drawing is even more crucial for these poses.

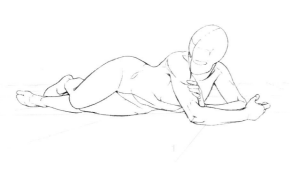

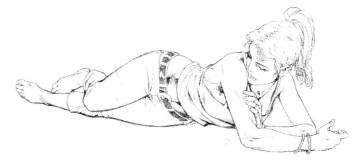

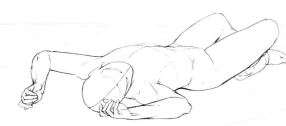

**Mannequin laying on her back:** In this instance, the weight is distributed evenly through the body's core. Note how the arm positions flow naturally out of the stretching action.

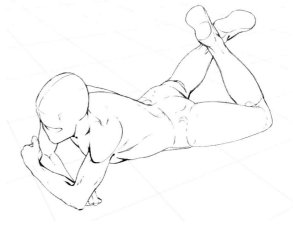

**Mannequin laying on his stomach:** This pose is virtually symmetrical, with the centers of support at the belly, thighs, and forearms. With the upper body propped up by the arms, there is a strong C-curve running through the torso and hips.

## EXERCISE: Crouching Sprinter Mannequin in "Rotation"

Here are two views of a crouching sprinter's mannequin. Use them as a guide to re-create the mannequin from a variety of alternative angles. Keep track of the basics—the natural line of rhythm and tipped line of balance—which will help you define the pose.

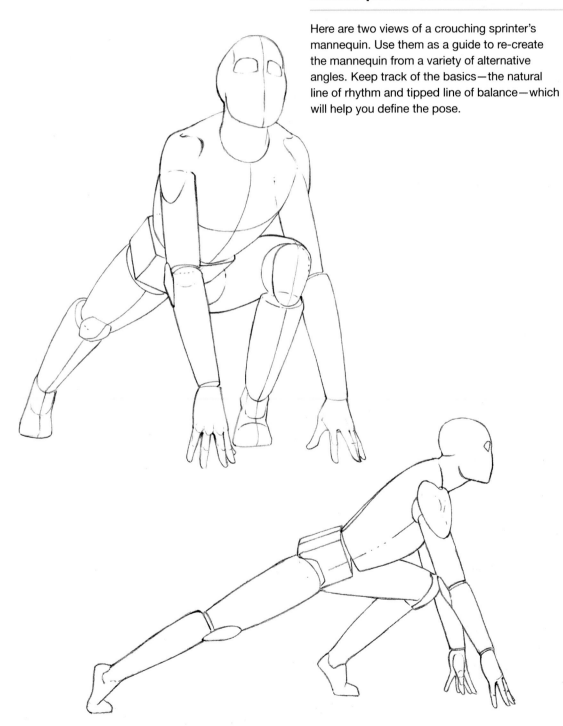

# 6

# DRAWING
# THE HEAD

At this stage you should begin refining the form of your basic mannequin. This is a process that will ultimately include adding surface anatomy to the body and adding details to the mannequin's hands and feet.

Let's start this process with a study of the mannequin's head. You will need to both shape and position the facial features on the head in the widest possible range of camera angles in order to be truly versatile in your freehand figure drawing.

First, I will show you the ideal proportions of the human head, focusing on the sizing and placement of facial features. Before proceeding, however, here is a caveat for you to consider: These proportions serve as a standard—a kind of template—against which you can measure all manner of variations. This standard exists not only on paper, but in our collective consciousness. For example, if you perceive that someone has narrow-set eyes, there must be an implicit average or "normal" spacing between the eyes that serves as your basis for comparison.

Variations from the "norm" give distinctive traits to the characters you design. So while these proportional guides are useful tools, they should only act as a starting point for the design and rendering process.

# Proportional Guide to the Human Head

Some notable relationships to look for in heads:

- The tops of the ears line up with the brow, while the bottoms line up with the base of the nose. From a side view, it is useful to note that the ears start two thirds of the distance from the front to the back of the head (discounting the nose).

- A horizontal line marking the midway point between the top and bottom of the head bisects the eyes.

- The space between the eyes is equal to the width of one eye from edge to edge.

- The width of the average mouth is about one third of the total width of the head, and the top of the upper lip sits one quarter of the distance from the bottom to the top of the head.

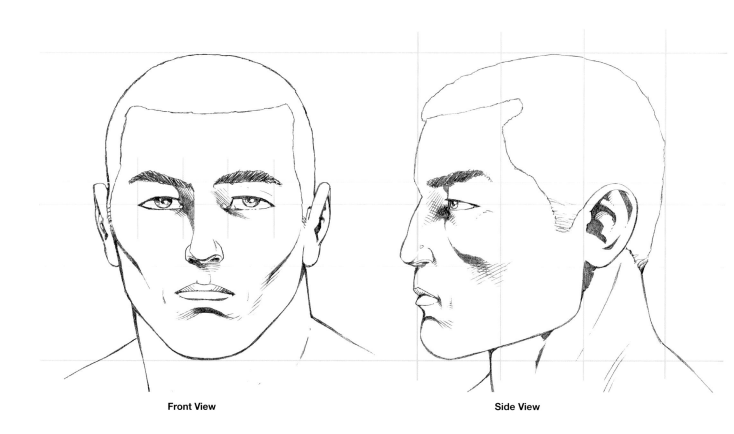

**Front View**                     **Side View**

# Construction of the Head

Constructing the human head complete with facial features and the ability to do so from every conceivable angle are skills vital for the development of your artistic ability.

Begin this process by gradually building up the basic mannequin head introduced in chapter 2.

Here is a basic three-quarter view of the head at eye level. The three-quarter view is particularly effective at bringing out the three-dimensional form in this subject.

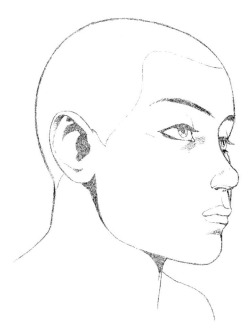

Refine the basic mannequin head by blocking in the nose, cheekbones, the gently bowl-shaped dental arch, the chin, and the ears.

In this next stage, position key landmarks in relation to one another. Detail the facial features: the eyes, nostrils, lips, and ears. At this point, you also need to establish the hairline. In general, it is best to work from large to small when adding or refining details.

The structure of an eye is essentially that of a ball within a socket. Skin flaps (eyelids) stretched across the top and bottom of the ball give the visible portion of the eye a more elliptical appearance. Graphically, both the eyes and the sockets that they fit into are composed of *concave* and *convex curves*. Simply put, a *concave curve* assumes the shape of a bowl while a *convex curve* is its opposite, a dome shape.

As the two lids come together at the outer edge of the eye, the upper lid overlaps the lower. The *pupil*—the black, highly reflective center—is surrounded by the *iris*, the colored part of the eye. This three-quarter view illustrates how the pupil appears imbedded in the iris.

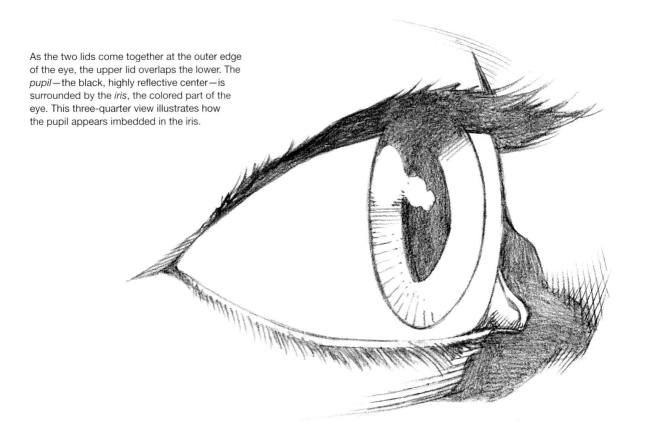

## Detailing the Eyes

Let's look at one approach to rendering detail around the eyes. To add the shadow cast by the upper eyelids, darken the irises and the whites of the eyes but also add highlights to give the eye a reflective quality. In the inner corner of the near eye, draw in the tear duct—a detail that adds naturalism to your overall image.

Here, I chose a three-quarter view to illustrate a point regarding the effect of perspective on circular forms, such as eyes. In this example, the far eye appears a little narrower than the near one and the iris appears smaller. This approach helps create the impression of a surface curving gently away in perspective. The far eye becomes more elliptical and less circular in shape.

Multiple light sources are suggested by placing dual highlights into the irises and pupils. This will add a reflective quality to your drawn eyes.

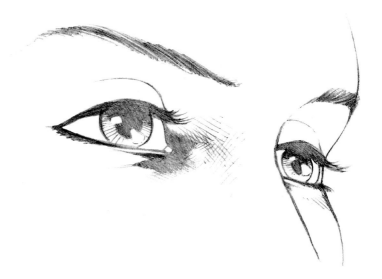

## Placing the Eye Within the Socket

The socket is a hollow form bordered by the brow above, the bridge of the nose on the inside, the upper edge of the cheekbone below, and the temple along the outer edge. Within this socket, the bowl-shaped form of the eye is centrally positioned as illustrated below.

This eye-level POV clearly demonstrates that the eye is centrally located within its socket.

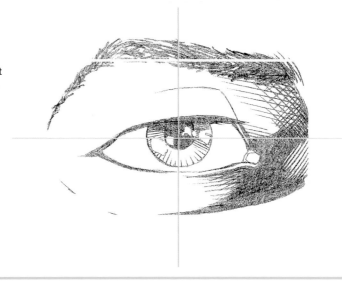

## A CLOSER LOOK AT THE EAR

Of all the features of the head, none are as changeable in appearance when viewed or drawn from different POVs as the ears. Accordingly, the ears warrant a closer study.

First, I'll show you the major anatomical landmarks of the ear.

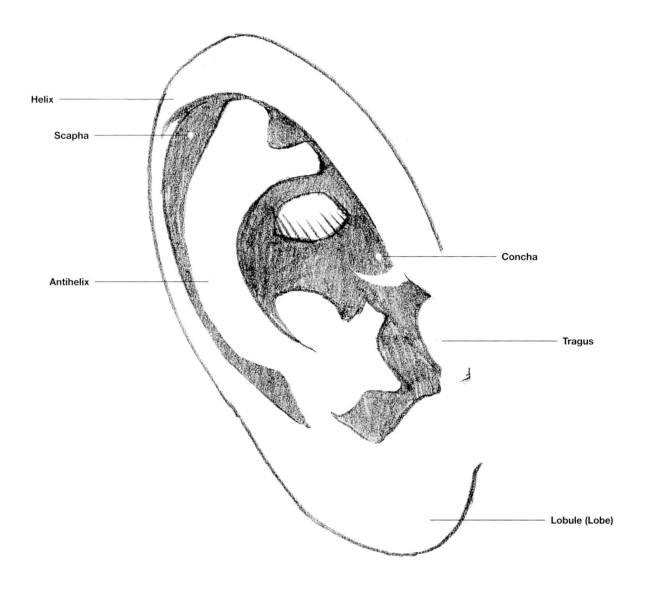

Helix

Scapha

Antihelix

Concha

Tragus

Lobule (Lobe)

**Ear from the side, extreme high angle:** The helix is dominant with the tragus sitting low in the image. The lobe is diminished severely.

**Ear from the side, high angle:** The helix appears thicker and overlaps the antihelix noticeably as it curves around the top of the ear. The lobe appears shallower and diminished overall.

**Ear from the side, extreme low angle:** The lobe dominates the image with the helix reduced to a thin edge.

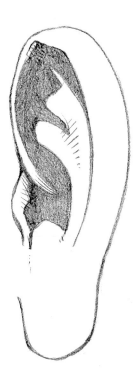

**Ear from a three-quarter view, eye level:** The helix (as seen from the back) is at its thickest. It overlaps the antihelix as it curves into the lobe. The concha is most visible from this angle.

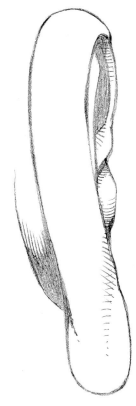

**Ear from the back, eye level:** Here you see three different surfaces: the helix running into the lobe, a glimpse of the tragus and antihelix, and the underside of the ear as it connects to the head.

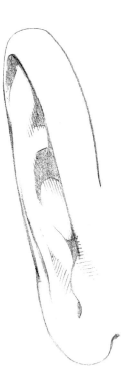

**Ear from the front, eye level:** The inside features of the ear are visibly compressed here. The emphasis is on the leading edge of the helix, the tragus, and the lobe.

## Cross-Contouring the Head

A technique referred to as *cross-contouring* will aid in drawing the head, helping you accurately visualize shapes in perspective. Refining the shape of a form begins by following its overall curvature. Since the head is spherical in nature, cross-contouring becomes particularly useful at high and low angles for shaping facial features.

When viewed from extreme high and extreme low angles, the features, especially the eyes, the line of the brow, and the mouth appear to sync up with the cross-contour curves. These cross-contour curves will also help you to accurately place the facial features on the head at extreme POVs.

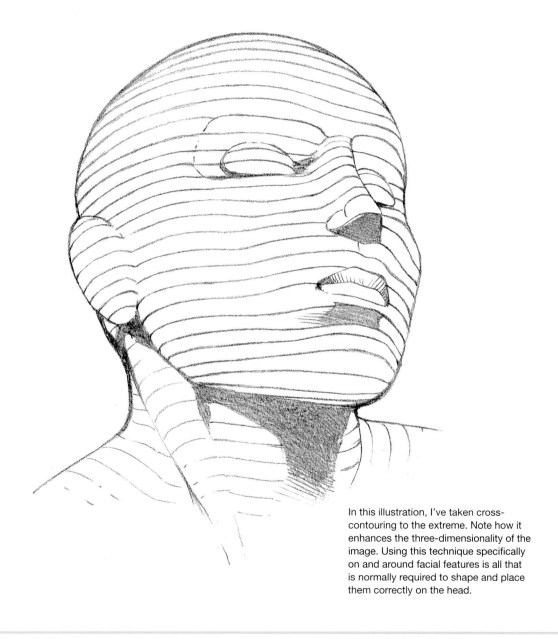

In this illustration, I've taken cross-contouring to the extreme. Note how it enhances the three-dimensionality of the image. Using this technique specifically on and around facial features is all that is normally required to shape and place them correctly on the head.

## HEAD CONSTRUCTION FROM VARIED ANGLES

Here is a series of head constructions covering a wide range of angles. In each case, the construction begins with the refined mannequin head, establishing the eye sockets, a simplified form of the nose, the muzzle of the mouth, cheekbones, chin, and a basic shape of the ear. At this stage, you should be concerned with placing these features accurately on the head in accordance with perspective.

The placement and shaping of the eye in its socket is demonstrated in two steps. This is such a delicate and crucial phase that I have given it special attention.

Each example concludes with a finished head—complete with all facial features and a hairline. For clarity, I have kept the drawings as *clean line art*, without halftones or excessive rendering details. Each head construction comes with its own challenges, but the procedure by which these are addressed never varies.

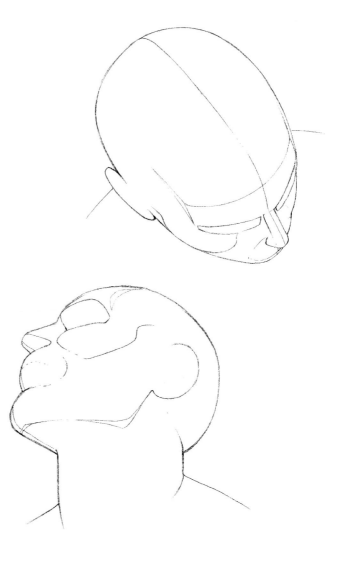

1 Structural underdrawing: Note the changes in positioning of the facial features due to the high camera angle.

2 Finished head: The nostrils are still slightly visible because they angle gently up at the sides.

## Head Construction from A Three-Quarter View, High Angle

The emphasis is on the top of the head and the brow. Note how the shape of the brow line and the forehead follow the curvature of the spherical base form in cross-contour. You can see the same in the sockets and in the bowl-shaped dental arch. All facial features are a little compressed by perspective here, but those that angle away from the viewer (such as the upper lip and the underside of the nose) do so to a greater degree.

From this high angle, the eye is no longer centered in the socket. It appears to rise up, pushing against the brow, leaving extra space between it and the lower edge of the socket.

**Finished eye:** Note how both the upper and lower lids follow the concave curvature dictated by the high-angle point of view (POV).

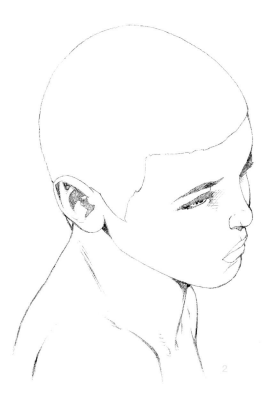

1 Structural underdrawing: The top of the head seems to be greatly exaggerated, due to the stronger foreshortening at this POV.

2 Finished head: In this completed image it's clear how much the features have shifted. At this angle, the cheeks appear to sit higher relative to the eye sockets, and the ears are positioned well behind and above the other facial features.

## Head Construction from the Front, Extreme High Angle

In this example the concave curvature is related to cross-contouring (see page 100). The top of the head and the forehead dominate the image even more than in the previous example. Note that most of the facial features are relegated to the lower quarter of the head. The ears are the exception, as they are mounted on the sides of the head. They appear to be positioned higher on the head, relative to the other features, when viewed from this angle. There is the general compression of the facial features, including the narrowing of the distance between brow and hairline, due to foreshortening. The nose overlaps the lips, while the upper lip—because it faces away from the viewer—is reduced to a thin strip. Even the lower lip is diminished proportionally a little. The chin is barely visible.

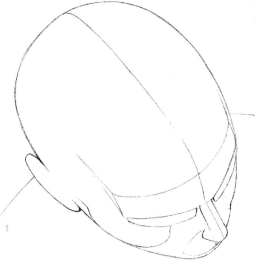

From this extreme angle the whole socket narrows, and both the upper and lower boundary lines become concave. The eyes appear to sit high in the socket, which is actually overlapped by the brow line.

**Finished eye:** reflects the concave curvature of the overall form and is compressed (that is, narrowed) by the strong perspective. The eyes themselves are barely visible under the upper eyelashes.

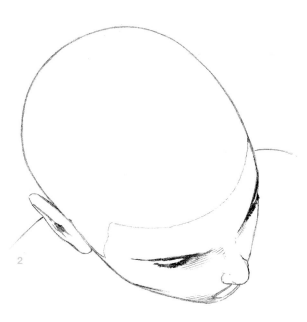

1  Structural underdrawing: Facial features line up with the convex curvature of the cross-contour lines and are a little more compressed overall.

2  Finished head: The top of the head recedes as evidenced by the repositioned hairline.

## Head Construction from a Three-Quarter View, Low Angle

When looking up at the mannequin head from a low angle, you should see some changes in the relative positioning and sizing of the features. The jaw and chin are more prominent, while the forehead is diminished. There is some compression here, most noticeable in spots that curve away from the viewer, such as the space between the nose and the lips, the lower lip, the top of the chin, and the upper edge of the cheekbones.

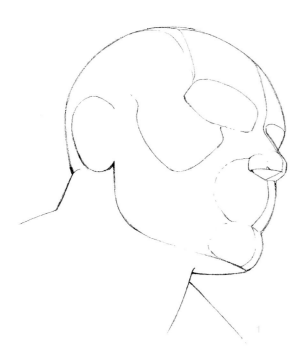

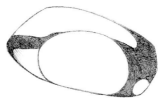

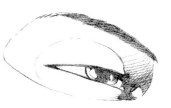

Upper and lower borders are still convex and concave in curvature respectively. The compression of the eye socket is minimal, but the eye is no longer centered in the socket. Instead, it touches the socket's lower border.

**Finished eye:** Narrow the eye's shape a little—reflecting the degree of change in the socket—and flatten the lower lid's concave curvature out to some degree without having it disappear completely.

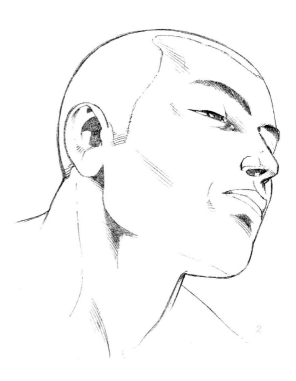

1 Structural underdrawing: At this more extreme angle, the forehead recedes from our POV and is barely visible.

2 Finished head: The ears have altered in shape and are now very low in the image. Note that the back of the head is actually visible.

# Head Construction from the Front, Extreme Low Angle

At an extreme low angle, the facial features compress, rising to the top of the head. The curving forms of the cheekbones drop lower in relation to those features, as do the ears. The underside of the jaw, the chin, and the base of the nose face the viewer and are therefore predominant. The degree of narrowing depends on the angle of each individual surface. The upper lip, the base of the nose, the eye socket between the eye and the brow—none are compressed, since they face the viewer. But the lower lip, the space between the lips and the nose, and the forehead are narrowed to the point of near nonexistence.

Strong convex curves define the forms of both the socket and the eye at this angle. The eye itself sits low in the socket.

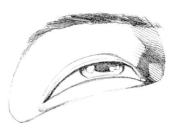

**Finished eye:** The eye appears narrowed by the strong angle with the curvature of the eyelids at their most extreme. It also rests against the upper edge of the cheekbone with all visible space separating it and the brow.

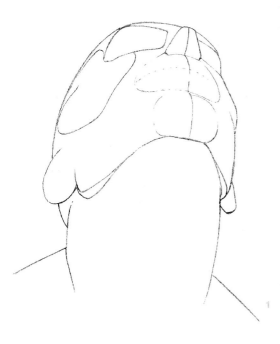

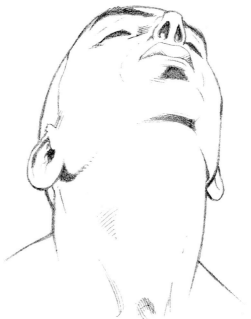

## Head Construction with Mouth Open

There is a special consideration that I must stress for drawing a figure with an open mouth. Be prepared to swing the character's jaw down and back. This is needed because the jaw pivots on a hinge located just ahead of the earlobe. The wider the mouth is open, the more it angles back. A jaw dropped straight down results in a wooden expression.

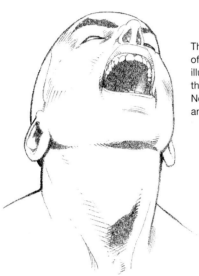

This is a version of the low-angle illustration with the mouth open. Note how the jaw angles back.

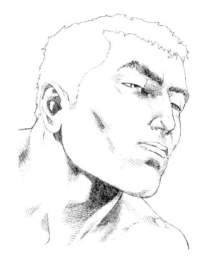

Let's look at the same pose again from a different angle. This image and the two below illustrate a key point concerning the opening of the mouth.

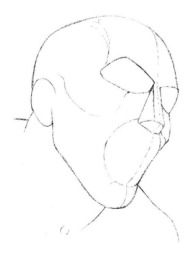

In the mannequin head, the jaw pivots on a hinge located slightly ahead of the ear lobe.

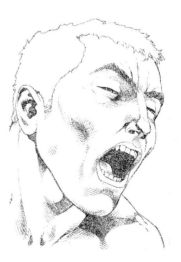

Here you can see the full effect of the hinging action as the mouth opens wide.

1 Structural underdrawing: The actual facial features are compressed almost out of existence in this mannequin head.

2 Finished head: Once again the ears have dropped lower in the image relative to all the other features.

## Head Construction from a Three-Quarter View, Extreme Low Angle

Let's take the extreme low angle to the limit. The features are severely compressed and, in fact, overlap one another. The neck, underside of the jaw, and the base of the nose predominate. Note the low positioning of the ears relative to all the other features. Don't hesitate to use this type of overlapping in your own drawing. Layering elements one on top of the other is a basic way of creating depth.

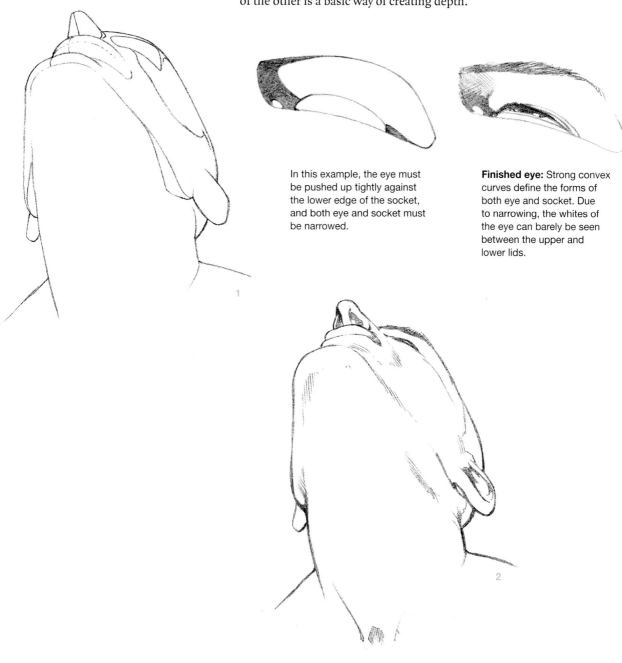

In this example, the eye must be pushed up tightly against the lower edge of the socket, and both eye and socket must be narrowed.

**Finished eye:** Strong convex curves define the forms of both eye and socket. Due to narrowing, the whites of the eye can barely be seen between the upper and lower lids.

1  Structural underdrawing: Note
   the gentle shifting of features
   here, with the eye socket rising up
   a little higher relative to the ear.

2  Finished head: Note how the
   facial features conform to the
   strong cross-contour curvature
   in this instance.

## Head Construction from the Side, Low Angle

Stepping back from the extremes of the previous example, let's look at the head from a gentle low-angle side view. Cross-contouring helps to determine the shape of the facial features and their placement on the head. There is a gentle compressing of the features, most notably in the eyes and the lips due to the low-angle POV.

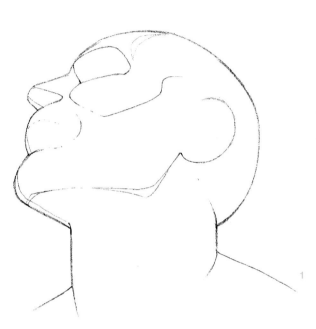

The eye sits low in the socket resting against its lower edge. There is more space between the eye and the brow.

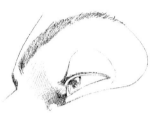

**Finished eye:** The upper and lower lids conform to the overall curvature of the cross-contouring, but the lower lid does so to a lesser degree.

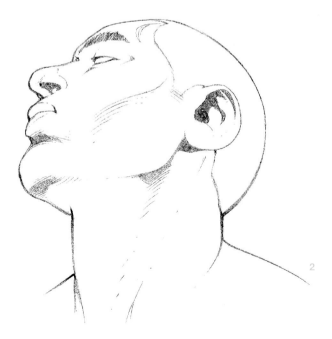

1   Structural underdrawing: Note the continued presence of the center line wrapping around the head. It acts as a guide reinforcing the orientation of the form you are drawing.

2   Finished head: The ear is viewed from behind, but is positioned at the dead center of the head, thanks to the three-quarter view.

## Head Construction from a Three-Quarter View, Low Angle

At this angle, both vertical and horizontal compression are at work. In addition to the compression that occurs from the low-angle POV, the facial features compress vertically, meaning they appear to narrow, as they curve away from the viewer. Whether the head is at a high angle, low angle, or at eye level, it is important to compress the facial features to the correct degree when drawing three-quarter views from the back. Problems may arise when you attempt to draw in too much of the mouth, or render the eye, as if seen from a direct side view.

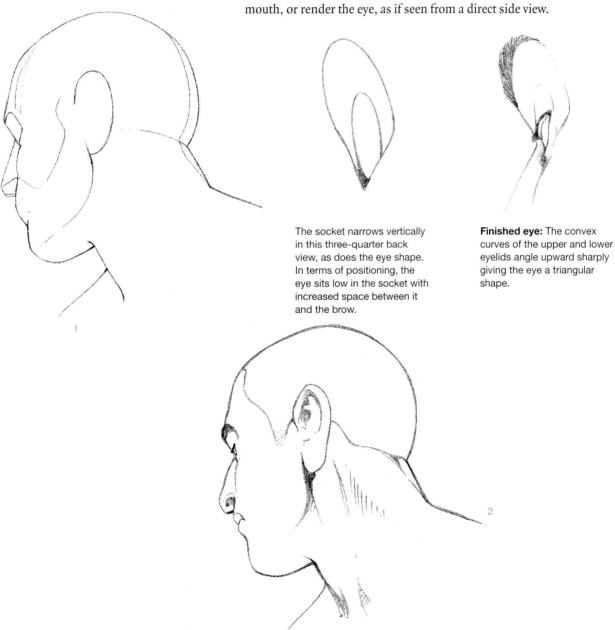

The socket narrows vertically in this three-quarter back view, as does the eye shape. In terms of positioning, the eye sits low in the socket with increased space between it and the brow.

**Finished eye:** The convex curves of the upper and lower eyelids angle upward sharply giving the eye a triangular shape.

1 Structural underdrawing: There is a notable change in the look of the ear from this angle, even though it has moved only a little from the central position in the previous example. The back of the lobe angles almost directly at the viewer.

2 Finished head: Due to the low angle, the hairline is positioned high on the head, but the space between it and the ear is at its most pronounced.

## Head Construction from a Three-Quarter View, Extreme Low Angle

In this example, the POV is from a lower angle and the head is turned even farther from the viewer than in the previous construction. The back and bottom of the skull, the underside of the jaw, and the ear, seen from an oblique angle, dominate the image, while the other facial features curve away, almost out of view.

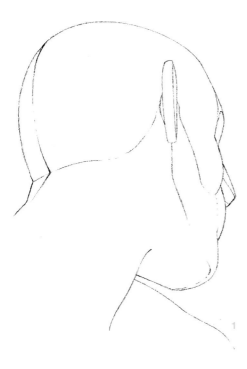

The eye socket and cheekbone appear to flow into each other, with both extremely narrowed at this angle. The same can be said for the eye, just barely visible and set low against the bottom edge of the socket.

**Finished eye:** Just the eyelids and lashes are visible. From this extreme POV, both are noticeably compressed.

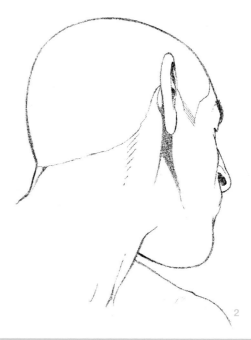

1. Structural underdrawing: At this angle the visible features of the face all line up along a strong concave curve. Note the continued presence of the center line wrapping around the skull.

2. Finished head: From this angle the features become minimized. Note the configuration of the hairline and the positioning of the ear low on the head.

## Head Construction from a Three-Quarter View, High Angle

Concave curves define the shape of the head from this angle, as well as the facial features. Compression—both horizontal and vertical—influences the facial features' appearance. The visual emphasis is on the top and back of the head, the cheekbones, and the forehead. The facial features are virtually out of sight. Besides the ear, the upper eyelid and the nose are all that remain in view.

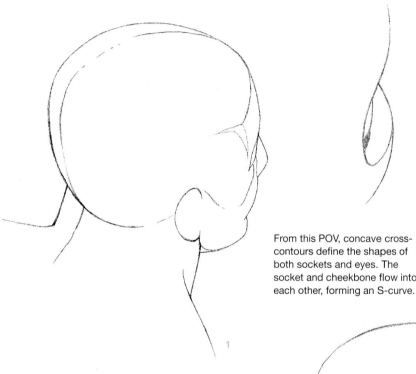

From this POV, concave cross-contours define the shapes of both sockets and eyes. The socket and cheekbone flow into each other, forming an S-curve.

**Finished eye:** Note the positioning of the nose relative to the eye socket and cheekbone. Then compare that to their counterparts from the previous examples. At low angles, the bridge of the nose sits high, joining the eye socket almost at its top edge.

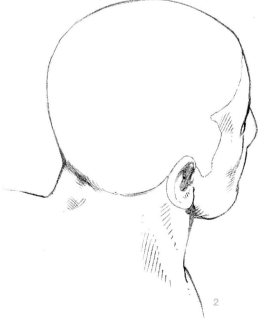

## Comparing Male and Female Hairlines

Below is a comparative look at a male and a female head, illustrated from the same POV. Let's focus on the differences between the hairlines. The contour of the woman's hairline is both simpler and smoother. The man's is more angular.

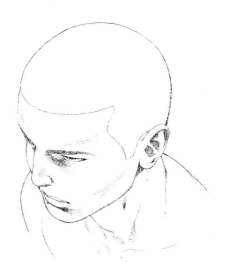
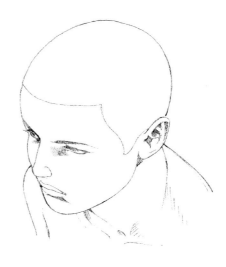

## Head from a Back View

Look at the connection of the neck to the base of the skull, and notice the positioning and appearance of the ears. Again, I stress how important it is to maintain center lines in your head constructions. This is doubly true for back views where there are no facial features to help reinforce the head's orientation.

With no facial features present, the completed head form is defined by maintaining a sense of volume and three-dimensional quality.

## EXERCISE: Drawing the Planar Head

*Planar studies* involve breaking down normally rounded surfaces and details of an object into more angular, but also more simplified planes. By simplifying and squaring-up the surfaces of a given subject, the resultant planar study helps you determine the lighting aspects for basic light, halftones, and shading areas. Beyond these considerations, planar studies are another aid for training the mind and eye to visualize the forms you illustrate as having real three-dimensional depth. The practice is particularly useful in the preliminary stages of applying values or color to a subject.

Using the planar studies as templates, draw your own versions of the head from a variety of angles. In particular, include the more extreme high and low angles.

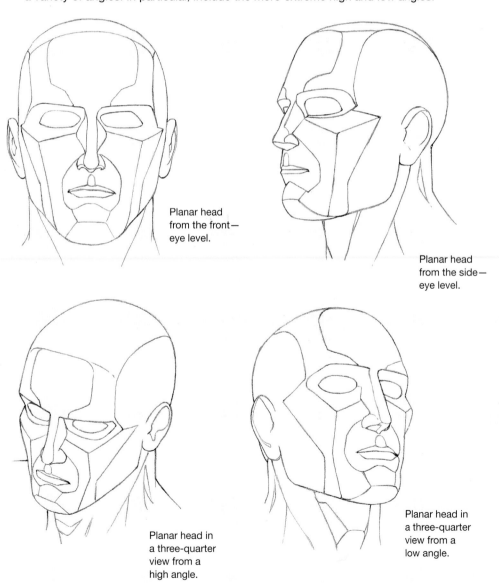

Planar head from the front—eye level.

Planar head from the side—eye level.

Planar head in a three-quarter view from a high angle.

Planar head in a three-quarter view from a low angle.

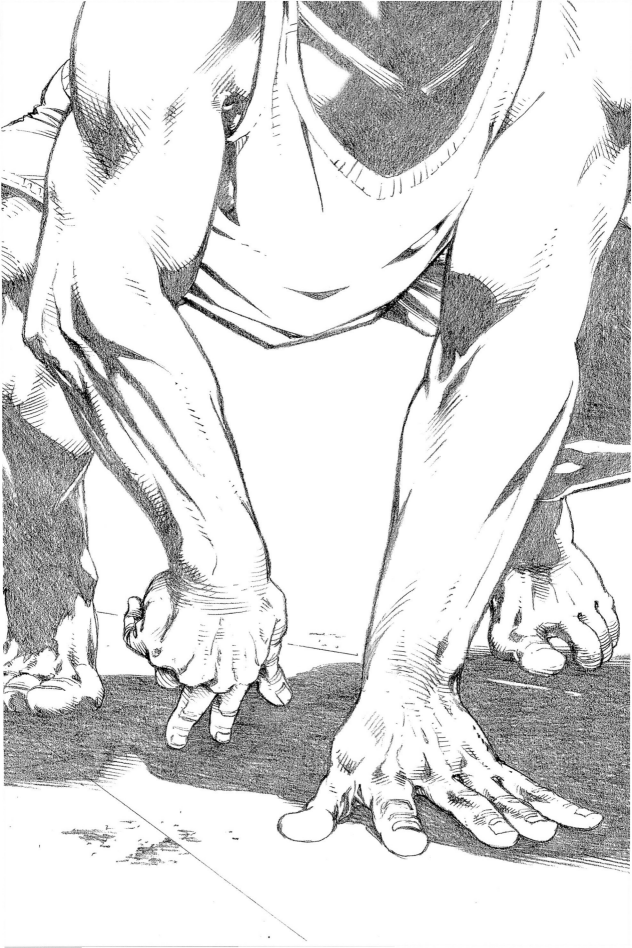

# DRAWING HANDS AND FEET

As the next step in the process of refining the mannequin, this chapter takes a closer look at drawing the hands and feet. Subtleties in their outward appearance and in their underlying structure make them challenging subjects, but the mastery of both hands and feet is essential for developing your ability to produce convincing freehand figure drawings. The methodology outlined here will help you to achieve this goal.

I'll begin with a study of the human hand, highlighting anatomical detail and a number of notable gestural traits. The hand is the most complex and generally varied component of the human form. The general methodology behind drawing hands is the same as outlined in previous chapters on drawing whole figures: you must create a simplified model—first blocking in the basic shapes. Treat the fingers and thumb as separate elements that you add to the block form of the palm. However, it's best to make a gestural line drawing of the complete hand first to capture the essence of a pose. Once the gesture has been established, then break down and reconstruct the hand, giving it solidity in your final rendering.

Following a look at hands, I'll move to the feet. Once again I've included a look at the anatomical landmarks that give the foot its distinctive shape. I'll introduce you to a simplified model, useful for blocking in the foot from any angle in the early stages of drawing.

# The Anatomy of the Hand

Before beginning a study of the hand, let's establish some standard terminology.

- *Palm*: the central mass of the hand
- *Palmar view*: the underside of the palm
- *Dorsal view*: the top or back of the hand
- *Inner view*: the side of the hand with the thumb
- *Outer view*: the side of the hand with the little finger

The following series of illustrations highlights the anatomy of the hand, with emphasis on those features that shape the hand's visual topography. These are the landmarks that you need to study in order to add definition to the mannequin hand. In the last of these illustrations I have also included the bones of the fingers to help guide you in the placement of the knuckles.

Metacarpophalangeal pads

Abductor transversus pollicis

Abductor pollicis

Abductor minimi digiti

Here is an inner palmar view of the surface anatomy of the hand.

Here is an outer palmar view of the surface anatomy. The anatomical features included here and in the previous image represent the visible topography of the hand in a palmar view.

Abductor pollicis

Abductor transversus pollicis

Scaphoid

Metacarpophalangeal pads

Abductor minimi digiti

Annular ligament

Tendons of the extensor digitorum communis

Extensor minimi digiti

Dorsal interosseous

Extensor pollicis

Here is the inner dorsal view of the surface anatomy. The most visible features are a series of extensors angling from the wrist to each knuckle, and the muscles flanking the extensors of the palm.

## The Arc Through the Fingers

Here is an important feature of the hand. And while this feature is not anatomical, it needs to be recognized and factored into your drawings of hands. It is a curving arc that runs through the knuckles, with the knuckle of the second finger at its peak. This arc repeats itself in a more exaggerated way through each successive joint, and lastly across the fingertips. You will note that no matter what position your hand takes—with fingers spread or curled inward—the arc is still visible.

The knuckles, joints of the fingers, and the fingertips line up in turn along gently curving arcs whether the fingers are spread—as in this example—or are held together or curled inward.

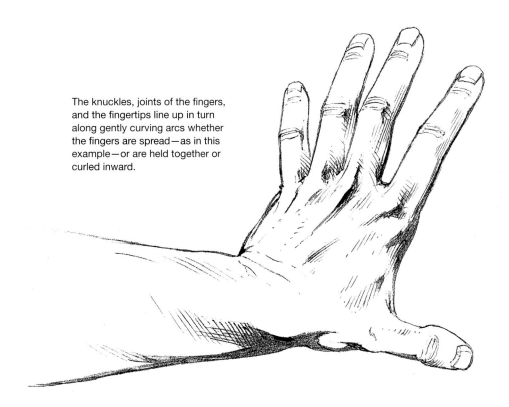

## Constructing the Hand

Let's look at the component parts of the mannequin hand. At its center is a block form. It tapers in two directions, becoming both wider and deeper as it angles away from the fingers and toward the wrist, and taking on a wedge shape. Applying a gentle curvature to the surface where the fingers connect will help you with their placement.

A truncated cone represents the first joint of the thumb. It is connected on the inner side of the block of the palm in such a way that about one half of the cone drops below the block's base. At this stage, the fingers are constructed of simple cylinders in three tiers. Another basic cylinder represents the middle tier of the thumb, but its tip should be drawn with a taper.

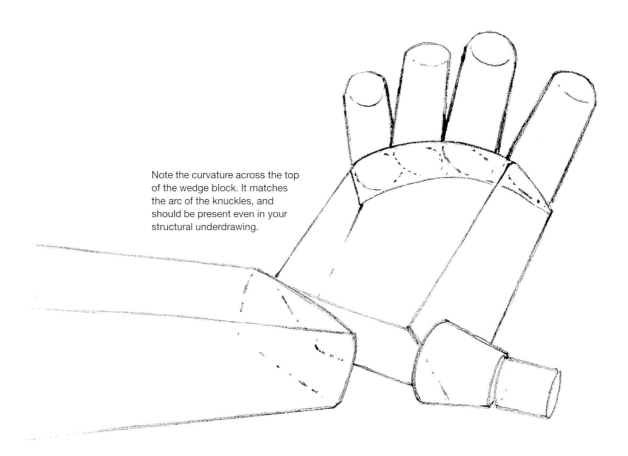

Note the curvature across the top of the wedge block. It matches the arc of the knuckles, and should be present even in your structural underdrawing.

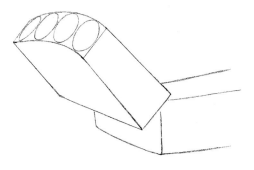

For this example I modified the wedged block by bowing the shape of its face. This is a crucial adjustment for drawing fingers that are curled inward.

## A SECONDARY ARC

There is another arc that runs through the block of the palm that impacts the gesture of the hand. However, it is not always present—like when the hand is flattened against a surface or when the fingers are extended straight out or bent back.

This secondary arc appears when the fingers curl inward, impacting the spacing of the fingers. This is especially true when the hand is viewed from any three-quarter POV.

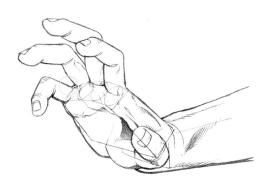

Using the previous wedged block, I formed a hand with fingers now curling inward. Note the spacing between the fingers: there is overlapping between the first and second fingers, but an actual gap appears between the third and fourth fingers.

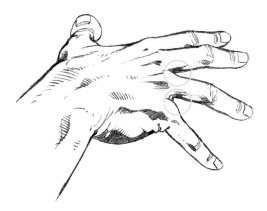

Here, I have drawn a hand from a different angle, but using the same varied spacing of the fingers. Close observation of such details will lead to more natural drawings.

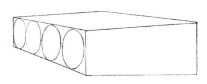

The wedged block of the palm is at its simplest when the hand is flattened. In terms of the secondary arc, this is the "exception to the rule."

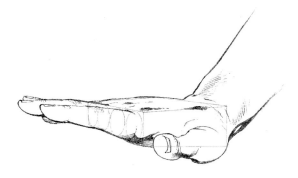

Here is a fully formed hand with fingers extended straight out. This drawing was made using the previous wedged block underdrawing as a starting point.

This is a palmar view of a relaxed hand with the fingers curling inward. Note that the little finger leads the way, angling most sharply toward the bottom and center of the palm. Each finger follows in succession.

## ANGLING THE FINGERS

One gestural quirk of the hand is a tendency for the fingers to angle inward when bending. But note that they do not do this uniformly; the fourth finger tends to angle in more sharply than the rest.

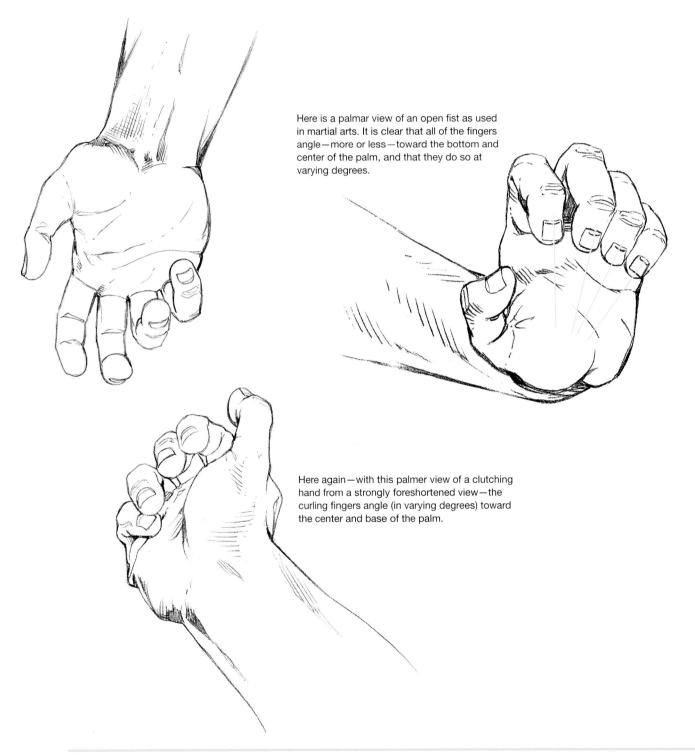

Here is a palmar view of an open fist as used in martial arts. It is clear that all of the fingers angle—more or less—toward the bottom and center of the palm, and that they do so at varying degrees.

Here again—with this palmer view of a clutching hand from a strongly foreshortened view—the curling fingers angle (in varying degrees) toward the center and base of the palm.

1 Here is a structural model of the hand as a closed fist. It is marked by strong changes in direction: first across the back of the hand from the wrist to the knuckles, then from the knuckles down to the first joint of the fingers.

2 This illustration of the completed fist shows the degree of taper that exists between the knuckles and the first joint of the fingers (highlighted here by a superimposed outline).

## FORMING A FIST

With its fingers folded in, the closed fist would seem to be one of the simpler hand positions to draw. However, it's actually very easy to get wrong. The fingers are pressed tightly against one another creating the appearance of uniformity. But, if you take that too far, your drawings of the closed fist will look rigid and lifeless. Instead, focus on the differences between the fingers. Their lengths are different, leading to a tapering down from the first finger to the little finger. The angling inward—especially of the little finger—also applies here. And while the fingers tend to line up with one another when in a clenched position, the one exception is found in the first finger. It typically rises a little higher relative to the others. In this instance, getting the details right does make all the difference.

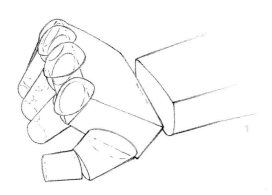

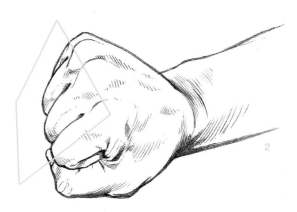

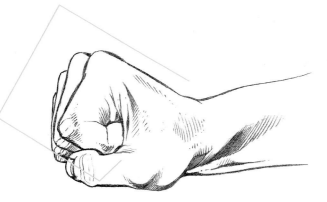

For this side view of a closed fist, note the sharp change in direction through the joints of the fingers and again into the palm. It illustrates the tendency of the first finger to angle a little higher than the others.

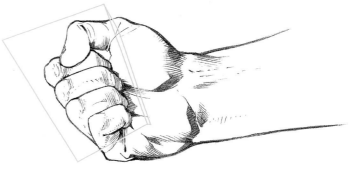

From this angle, the tapering of the fingers—from the first to the fourth—is once again a defining feature of the closed fist (palmar view). The fingers angle gently inward with the little finger doing that the most. The tip of the thumb lines up with the division between the second and third fingers.

## A Comparison of Male and Female Hands

The female hand differs from its male counterpart. It is generally slimmer in proportion and smoother in muscle tone.

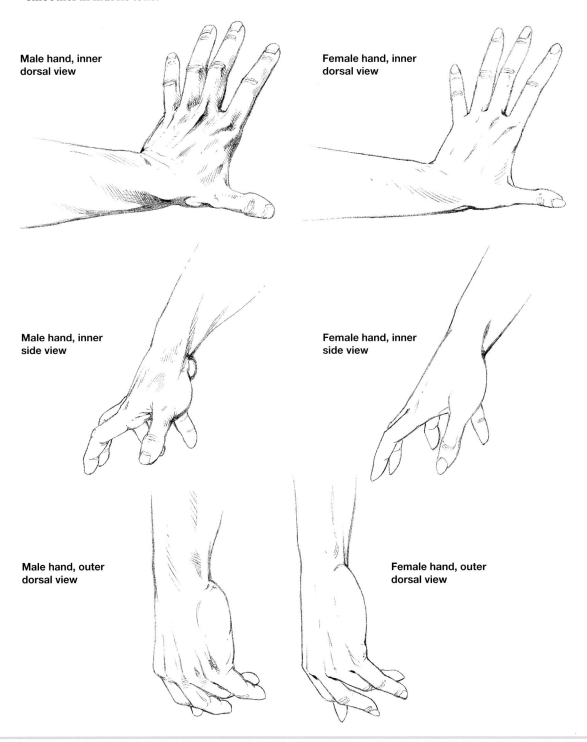

**Male hand, inner dorsal view**

**Female hand, inner dorsal view**

**Male hand, inner side view**

**Female hand, inner side view**

**Male hand, outer dorsal view**

**Female hand, outer dorsal view**

## HAND CONSTRUCTIONS FROM VARIED VIEWS

Drawing a hand begins with a structural underdrawing. The block of the palm is its foundation. From it, you extend the fingers and thumb, joint by joint. In the constructions ahead, I have extended the fingers to the first joint only in the second step. This is done for clarity's sake, but also to invite you to complete them yourself.

### The Reaching Hand, Palmar View

The dominant landmarks of the palmar view are the three metacarpophalangeal pads located directly under the fingers, the thumb pad (thenar), and the pad running up the little finger side of the palm (hypothenar). Together their raised surfaces create a hollow in the center of the palm.

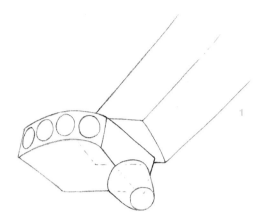

1

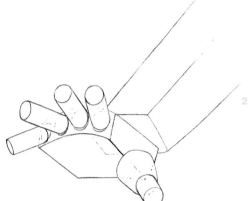

2

1 Structural underdrawing: Build a gentle curvature into the top of the wedged block; it will aid in the positioning of the fingers.

2 Extend the fingers and thumb. As you build out the fingers and thumb from the block of the palm, lay down arcing construction lines to act as a further guide to each finger's placement and relative size.

3 Finished hand: The remaining joints of the fingers line up along the arcs, including the fingertips. Note that the arcs are not parallel to each other.

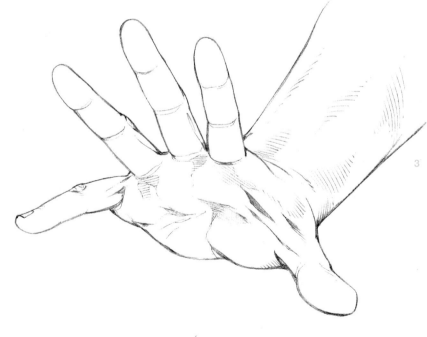

3

## Gestural Hand, Palmar View from Behind

In this example, the fingers are held straight. Consequently, the curvature across the top of the palm is absent.

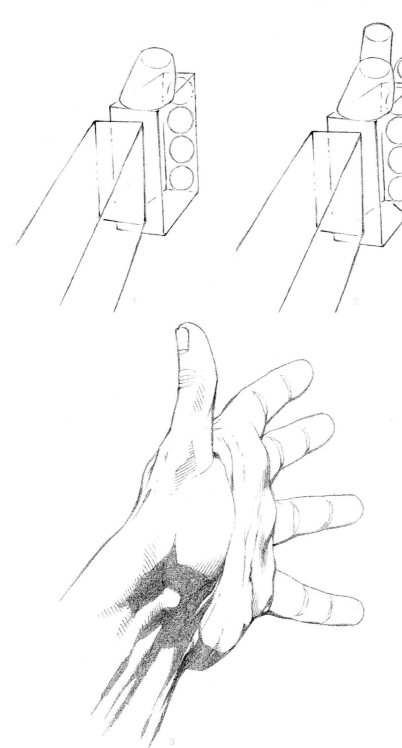

1  Structural underdrawing: Foreshorten the wedged block of the palm and overlap it with the wrist. The origin points of the fingers are technically out of sight, but draw them in, as if your model were made of glass. That surface from which the fingers emerge is not curved in this case, due to the fingers being outstretched as opposed to curling inward.

2  Extend the fingers and thumb. At this angle, transparency in the model is essential for locating the points of origin of each finger. Use arcing construction lines to once again help you line the fingers up.

3  Finished hand: From this angle, the thumb and its thenar pad dominate the image, but the three pads just below the fingers are also very visible and distinct. There is a progressive foreshortening across the fingers, with the little finger appearing longest, and the first finger shortest.

## Reaching Hand, Outer Palmar View

Here is a reaching hand viewed from below and behind. The fingers are bent. Combined with the angle, this feature results in a hand with fingers overlapping one another to successively greater degrees.

1 Structural underdrawing: The mannequin hand, viewed slightly from behind, must be transparent in order for you to locate the origin points of the fingers. Include a slight twist at the wrist, which is indicated here by the jostling of the block forms of the palm and the wrist.

2 Extend the fingers and thumb. As you extend the fingers out to the first joint, it should be apparent that they are foreshortened progressively as they move away from the viewer. The little finger is seen from a side view with no foreshortening. Some foreshortening is evident in the third finger, more in the second, and strong foreshortening is clearly at work in the first joint of the first finger.

3 Finished hand: Foreshorten the thumb a little as it moves away from the viewer. Notice there is no foreshortening in effect in the fingers beyond the first joints. However, the impact of that progressive foreshortening is present in the spacing of the fingers: the little finger almost completely overlaps the third finger, the third somewhat overlaps the second, and there is a noticeable gap between the second and first fingers.

## Cupped Hand from Behind

This hand in the cupped position is marked by extreme foreshortening and an overlapping of forms. More than ever, transparency is key to sorting out the positioning of each finger and that of the thumb.

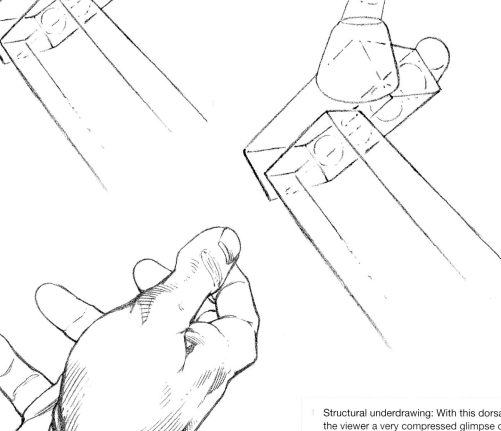

1 Structural underdrawing: With this dorsal view, you give the viewer a very compressed glimpse of the back of the hand from behind the wrist. Use extreme foreshortening for the wedged block of the hand, which is overlapped by the truncated cone of the thumb. Once again, transparency is key to locating the fingers.

2 Extend the fingers and thumb. The challenge is to keep track of the finger positions. As many as two joints of some fingers are hidden behind either the palm or the thumb. The little finger's first joint virtually disappears due to extreme foreshortening.

3 Finished hand: Position the extended fingers in a rough semicircle and use arced construction lines to guide their placement. This will help you successfully complete this challenging pose. The thumb, along with its thenar pad and counterpart—the hypothenar pad on the outer side of the palm—are the predominant features here.

## Gestural Hand, Foreshortened Front View

For this gesturing pose, the palm is open, but the fingers are held tightly together. Take note of the sharp changes in direction at both the wrist and knuckles. They give this pose its distinct silhouette.

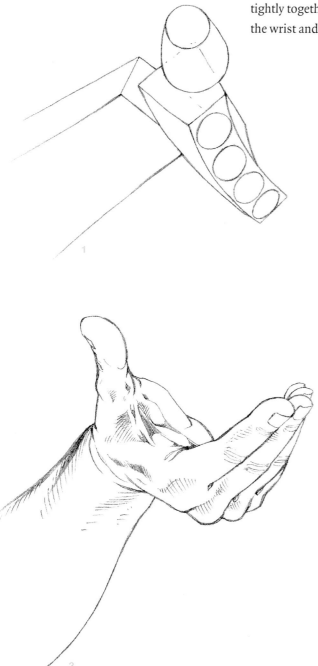

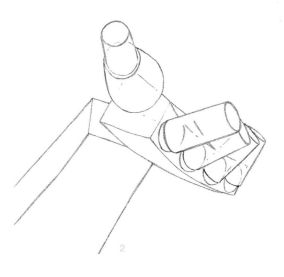

1 Structural underdrawing: Here the extreme foreshortening across the palm allows the viewer to glimpse both its dorsal and palmar surfaces simultaneously. The cone of the thumb is also foreshortened, but to a lesser degree. The top of the palm's wedged block has been gently curved to help with positioning the fingers.

2 Extend the fingers and thumb. In this example, the fingers are held tightly together. It is particularly helpful to employ arcing construction lines across the knuckles, joints, and fingertips.

3 Finished hand: One key feature of this hand position is the change in direction at the knuckles—the fingers bend inward as a unit. Foreshortening plays a major role in the drawing of the palm, but also more subtly in the thumb and fingers.

## Reaching Hand, Dorsal View from Behind

For this example, I have reversed the order, roughing in the first and fourth fingers first. Doing so establishes the outer parameters of the gesture, making it a useful alternative. The lesson here is *be flexible.* At times you will need to use common sense or your intuition to guide you.

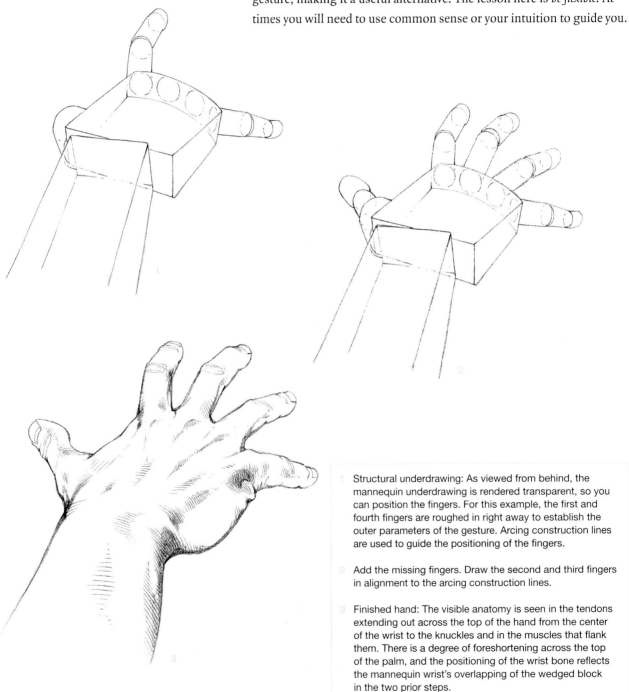

1.  Structural underdrawing: As viewed from behind, the mannequin underdrawing is rendered transparent, so you can position the fingers. For this example, the first and fourth fingers are roughed in right away to establish the outer parameters of the gesture. Arcing construction lines are used to guide the positioning of the fingers.

2.  Add the missing fingers. Draw the second and third fingers in alignment to the arcing construction lines.

3.  Finished hand: The visible anatomy is seen in the tendons extending out across the top of the hand from the center of the wrist to the knuckles and in the muscles that flank them. There is a degree of foreshortening across the top of the palm, and the positioning of the wrist bone reflects the mannequin wrist's overlapping of the wedged block in the two prior steps.

# Working Hands

Typically, working hands feature some type of holding or gripping action. They can show a more gentle handhold—as when the object held is delicate—or a stronger one when a firm grip is needed to support something heavy. In either case, you must identify the points of contact that act to support the object being held and the degree of pressure the hand, or hands, should appear to exert on that object. Otherwise, the action may not seem convincing.

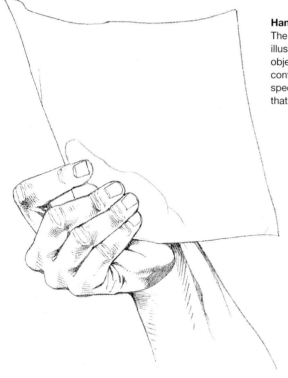

**Hand holding a sheet of paper:** The first consideration for illustrating any hand holding an object is to identify the points of contact with the object held. Give special attention to those points that secure the object in place.

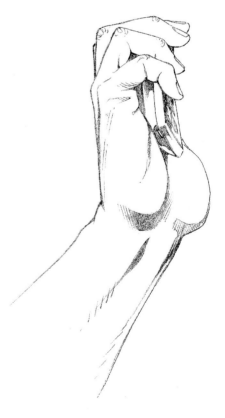

**Cupping hand:** Here is a classic cupped hand pose—in this case the hand is holding a cell phone. From this angle, the thumb is not visible, but it does support the phone from behind. The fingers curl around the phone, with each finger bent to a successively greater degree, from the first to the fourth. There is a strong change of direction at the wrist that is not absolutely essential, but that adds gestural flow to the pose.

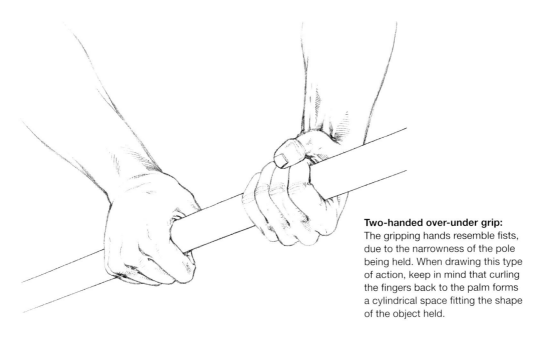

**Two-handed over-under grip:** The gripping hands resemble fists, due to the narrowness of the pole being held. When drawing this type of action, keep in mind that curling the fingers back to the palm forms a cylindrical space fitting the shape of the object held.

**Two-finger grip:** The first two fingers, curled through the handle, hold the cup in place. The third finger provides support by pressing up against the handle. Even from this angle—with so many finger joints out of sight—the inward angling of the fingers toward the center of the palm is evident.

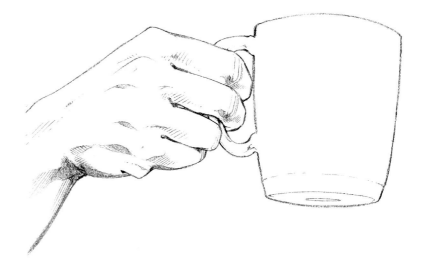

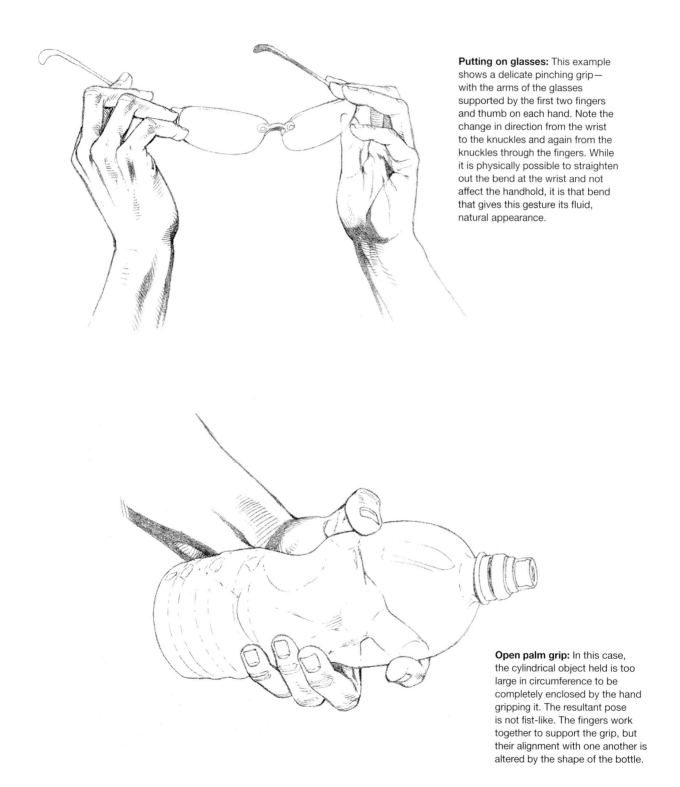

**Putting on glasses:** This example shows a delicate pinching grip— with the arms of the glasses supported by the first two fingers and thumb on each hand. Note the change in direction from the wrist to the knuckles and again from the knuckles through the fingers. While it is physically possible to straighten out the bend at the wrist and not affect the handhold, it is that bend that gives this gesture its fluid, natural appearance.

**Open palm grip:** In this case, the cylindrical object held is too large in circumference to be completely enclosed by the hand gripping it. The resultant pose is not fist-like. The fingers work together to support the grip, but their alignment with one another is altered by the shape of the bottle.

## Drawing the Foot

It is time to move from the hands to the feet. While very different in appearance and function, hands and feet do share many common characteristics.

Let's begin by focusing on the unique aspects of the feet. The series of arches that run through the foot is one of its most defining features. These arches provide stability and balance and put the spring in our steps. The most prominent of those arches is the *medial arch*, which runs laterally along the inner side of the foot. The *transverse arch* runs crosswise over the top of the foot. These arches provide the distinctive shaping of the foot and originate in the bones themselves.

The greater your understanding of the foot's internal structure, the more solid your freehand drawings of feet will become.

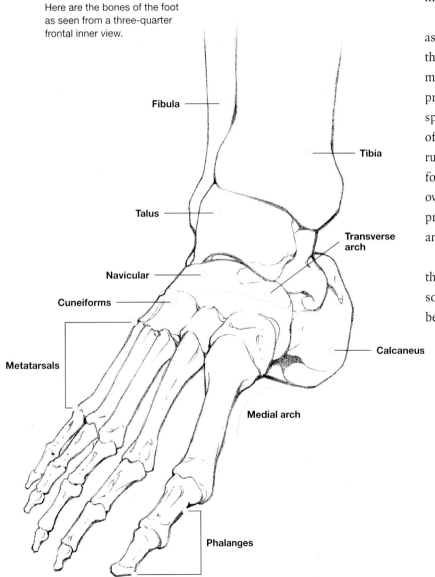

Here are the bones of the foot as seen from a three-quarter frontal inner view.

Fibula

Tibia

Talus

Transverse arch

Navicular

Cuneiforms

Calcaneus

Metatarsals

Medial arch

Phalanges

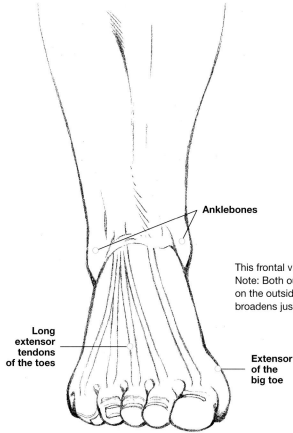

**Anklebones**

**Long extensor tendons of the toes**

**Extensor of the big toe**

## TENDONS OF THE FOOT

Moving from bones to surface features, to the left is a frontal view of the foot. Pay particular attention to the tendons that run from the toes up into the lower leg. These are the extensors that make movement in the toes possible. Note: The extensor tendon of the big toe and extensors of the other toes are only visible if tensed (that is, when bending or spreading).

Other key features, apparent at this angle, are the relative heights of the anklebones (the inside being the higher of the two) and the curling inward of the little toe.

This frontal view features the extensor tendons of the foot. Note: Both outer masses of the big toe pad and the sole pad on the outside of the foot are visible from this angle. The foot broadens just behind the toes, making this possible.

## SURFACE FEATURES OF THE FOOT FROM A LOW ANGLE

The predominant features of the foot from a low angle are the pads, which are labeled in the image below. The pads' positions on the sole of the foot are roughly the equivalent of that of the pads on the palms of the hand.

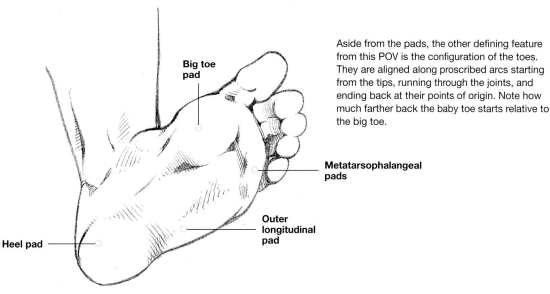

**Big toe pad**

**Metatarsophalangeal pads**

**Outer longitudinal pad**

**Heel pad**

Aside from the pads, the other defining feature from this POV is the configuration of the toes. They are aligned along proscribed arcs starting from the tips, running through the joints, and ending back at their points of origin. Note how much farther back the baby toe starts relative to the big toe.

Let's continue to look at the foot from different angles. Once again, I start with simplified models of the foot, then move to the finished drawing. These structural underdrawings break the foot down into its basic shapes. The lesser toes are blended into a single curved form, while the anklebones are constructed as diamond shapes with tapering cylinders extending upward. These cylindrical forms act as connectors to the legs. Center lines are included to help you keep track of any visual diminishing of the form due to perspective.

## Foot from the Side (Inside), Eye Level

The underdrawing of the foot from this angle shows the proportions and relative placement of the major features in an inner view. Note the positioning of the anklebone and the size of the big toe relative to its pad. Think of them as one unit—a larger and a smaller elliptical form aligned one behind the other, connected by a thick stem.

There is a strong curve running lengthwise across the sole of the foot at this angle. This medial arch is even evident in the foot pressed to the ground.

**Structural underdrawing:** Even in this structural underdrawing, the gesture of the arch is present.

**Finished foot:** Define the individual toes and refine the other shapes, including the curving out of the heel from the leg.

## Foot from the Side (Outside), Eye Level

Here is a comparative look at the foot from an outer view. In contrast to the medial arch, the arch on this side of the foot is not visible when the foot is pressed to the ground. What is evident is the outer longitudinal sole pad that bulges out a little when the foot is flattened.

Note the lower positioning of the anklebone here, which is relative to the inner view. From this angle, you can see the simple construction of the smaller toes in the underdrawing. They are drawn as a single form, on a gently curved strip. In refining the individual toes for the finished art, note the successive overlapping that's evident at this angle. And as with the fingers, the last baby toe curls inward.

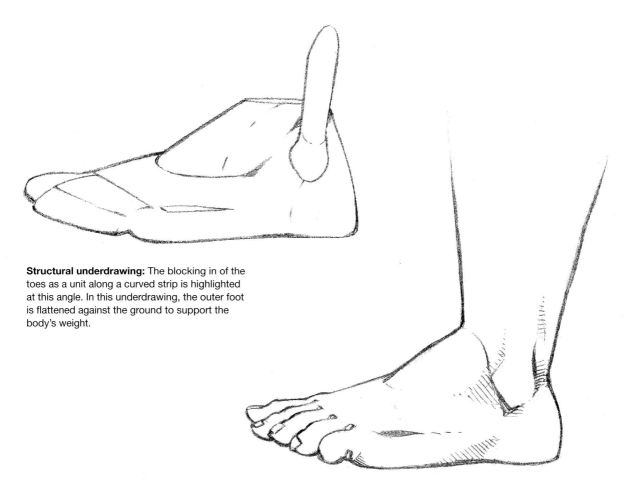

**Structural underdrawing:** The blocking in of the toes as a unit along a curved strip is highlighted at this angle. In this underdrawing, the outer foot is flattened against the ground to support the body's weight.

**Finished foot:** On the outer edge of the foot is the lateral longitudinal arch—the counterpart to the medial arch. When you flatten your foot against the ground, or any other surface, this arch is not evident. Only in an elevated foot does it manifest in a gentle curvature.

## Foot from the Side (Inside), Low Angle

This low angle highlights the construction of the big toe and the rounded forms of the sole pads. The medial arch is also a prominent feature in this inner view. Note the curvature running along the bottom of the foot at this angle.

**Structural underdrawing:** This foot from a low angle highlights the construction of the big toe and its adjoining pad. Be sure to draw in the gestural curves created by both the medial and lateral longitudinal arches.

**Finished foot:** The rounded forms on the sole pads are a dominant feature. Refine the shape of the big toe as illustrated and form up the smaller toes along the curve established in the underdrawing.

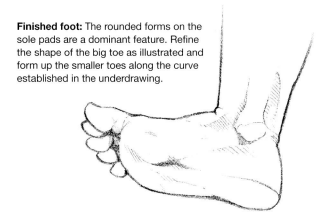

## Foot from the Side (Outside), Low Angle

The foot is foreshortened toward the viewer resulting in an overlapping of features. There is an accentuated curvature through the medial arch as the spacing between the pad of the big toe and the heel narrows. The anklebone appears to have shifted position back to the point of touching the outer edge of the heel. The rack of smaller toes is at such an angle that you can see a hint of their bottoms, in addition to the fronts and sides. In the completed foot, the refined toes line up along the curved arc lines set up in the underdrawing. They tend to curl down sharply to the first joint and then straighten out, from there to the tip.

**Structural underdrawing:** At this angle, you must factor in the effect of foreshortening on the foot's appearance. Shorten its overall length and shift its features as illustrated.

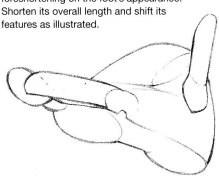

**Finished foot:** The focus is on refining the foreshortened toes and the shape of the heel.

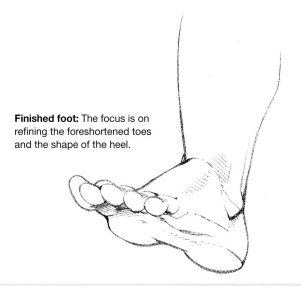

## Foot from a Three-Quarter View (Front), High Angle

This angle displays most of the features of the foot very clearly. Note the gently curving arcs along which the toes are aligned, the flaring out of the pad of the big toe and the curve of the medial arch on the inside foot. Along the outside foot, the curving created by the bulging of the longitudinal pad is also apparent. Placement of the anklebone appears to shift lower from this POV, and the flaring out of the heel, while still visible, is softened.

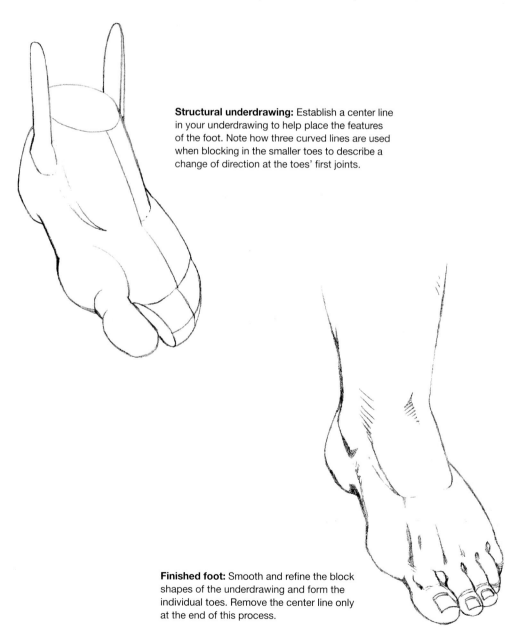

**Structural underdrawing:** Establish a center line in your underdrawing to help place the features of the foot. Note how three curved lines are used when blocking in the smaller toes to describe a change of direction at the toes' first joints.

**Finished foot:** Smooth and refine the block shapes of the underdrawing and form the individual toes. Remove the center line only at the end of this process.

**Structural underdrawing:** From this back view, note the visible offsetting of the two anklebones, with the inner, or medial, side placed higher.

### Foot from a Three-Quarter Back (Inside) View, Eye Level

The heel and the Achilles tendon are major features at this angle; but note, as well, the strong curve of the medial arch. Both anklebones are visible, with the inside one positioned higher than its outside counterpart. Foreshortening is in effect, compressing the proportions of the big toe and its pad.

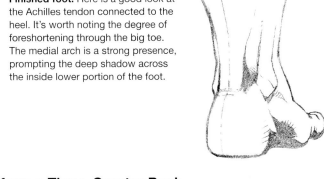

**Finished foot:** Here is a good look at the Achilles tendon connected to the heel. It's worth noting the degree of foreshortening through the big toe. The medial arch is a strong presence, prompting the deep shadow across the inside lower portion of the foot.

### Foot from a Three-Quarter Back (Inside) View, High Angle

Here is an alternate look at the foot from the back. This view has less foreshortening than the previous example due to the higher POV. The protruding anklebones and Achilles tendon have created a hollow area in between them. Note the shape and positioning of this area. Negative spaces such as these are as important to keep track of as any other landmarks of the body.

**Structural underdrawing:** Note how many surfaces or planes are visible from this angle. While it is essentially a back view, parts of the top of the foot and toes are still shown.

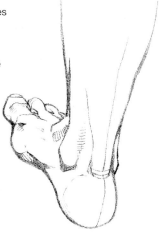

**Finished foot:** The medial arch defines the form of the inner foot from this angle. The center line running down through the heel will aid you in the positioning of the anklebones and the Achilles tendon. Remove it only after all details are drawn in.

## Foot from a Three-Quarter Back (Inside) View, Low Angle

The foot is elevated and not pressed against a surface. This is reflected by the visible curvature of the lateral arch running along the outside of the foot in both the underdrawing and in the finished foot.

There is a moderate degree of foreshortening through the foot from this angle, so adjust the proportions accordingly.

**Structural underdrawing:** The heel and big toe constructions dominate this angle, but note the shape of the curved framework used for positioning the smaller toes.

**Finished foot:** The medial arch is quite visible from this angle, highlighted by the shading just behind the pad of the big toe.

# The Foot in Motion

Feet are more compact in form than the hands. Toes do not have the same range of motion as fingers and thumbs, so the gestural options available for the feet are limited. Nonetheless, here are two examples of feet in alternate positions while in mid-motion.

This running foot is marked by strong changes in direction—first at the ankle, then at the toes. Due to the tension in the foot, muscles and tendons bulge more than normal, making them more visible.

This pose owes its distinctive gesture to the stretching action down the front of the leg. In fact, this pose is a classic example of *passive* and *active* sides at work, with all strong curves placed on one side of the foot exclusively.

# Cross-Contouring the Foot

As with the cross-contoured heads in chapter 6, these images show a series of contour lines running crosswise over the form. Cross-contouring highlights the topography of the foot, defining subtleties in the form that basic outlines can only hint at. This methodology is particularly useful when foreshortening is required. Cross-contours help you to visualize the object as a three-dimensional form.

Here is a cross-contoured foot from an outside view at a low angle. This view has three major plane changes, showing the bottom, the side, and top of the foot. The cross-contours reveal how the form of the foot transitions from one plane to the next.

This is a cross-contoured foot from an inside view at a high angle. Here, the cross-contours add a little extra dimension to the tendons running into the toes, and they add form to the medial arch.

Here's a cross-contoured foot from an outside view at eye level. Note the changing curvature of the cross-contours, particularly where they curl off the transverse arch to wrap around the foot's outside edge.

## EXERCISE : **Active Hands and Feet**

Below is a list of actions requiring specific hand positions. Find references for each one (for example, online or in magazines) before starting your drawings. And use your own hands—not only to see, but also to *feel* how the poses work.

- Hands clapping
- Pulling a wallet from a breast pocket
- Filing your nails
- Taking a photograph (with a camera)
- Gripping a railing (for dear life)
- Hands to head (suggesting fatigue)

Again, study the given examples, as well as check for reference material from sports magazines, or viewing your own feet with a mirror, practice drawing the following foot poses:

- Standing foot—flat on ground, outside view
- Walking foot—inside, side view
- Foot on tiptoe—side view; back view
- Foot from the back—showing heel

Draw two versions of each action, maintaining the pose, but changing the camera angle in your second version.

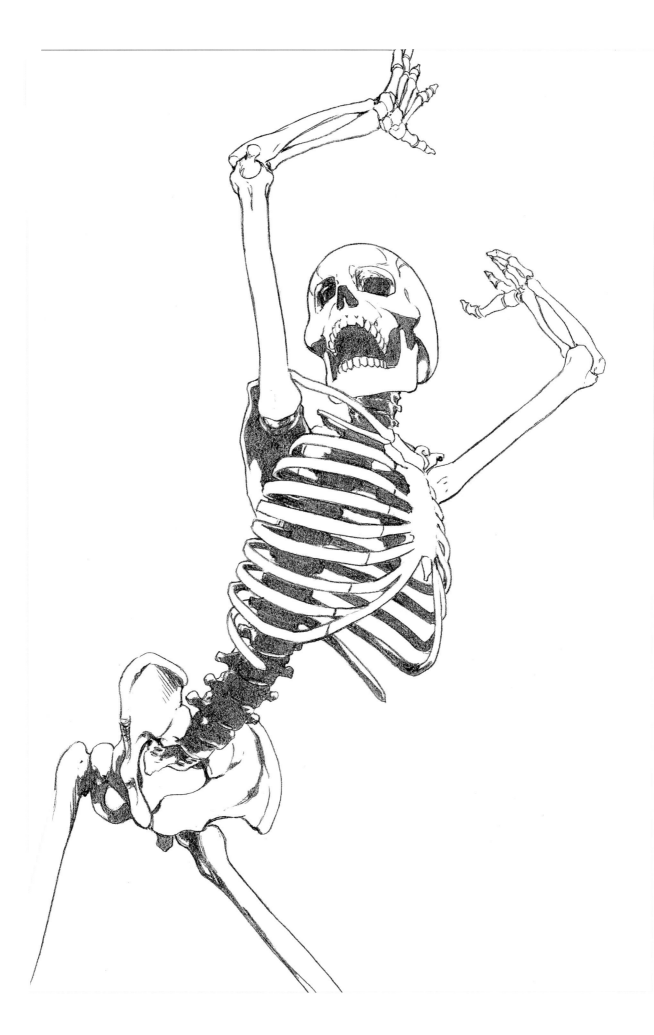

# THE SKELETON

For an artist concentrating on the human figure, an in-depth study of both skeletal and muscular anatomy is essential. Beyond the obvious surface features that you must take into consideration, there is also a great benefit in acquiring an overall understanding and appreciation of the body's mechanics. Even in terms of basic posing, a working knowledge of the range and the limitations of movement, as well as the ability of the body's various parts to bear stress, is vitally important.

This is the first of two chapters dedicated to human anatomy. I'll begin with the skeleton, the framework upon which the body is constructed, composed of bones that both shape and support it.

# Skeleton Overview

Let's start with the front and back views of the whole skeleton, identifying the component parts.

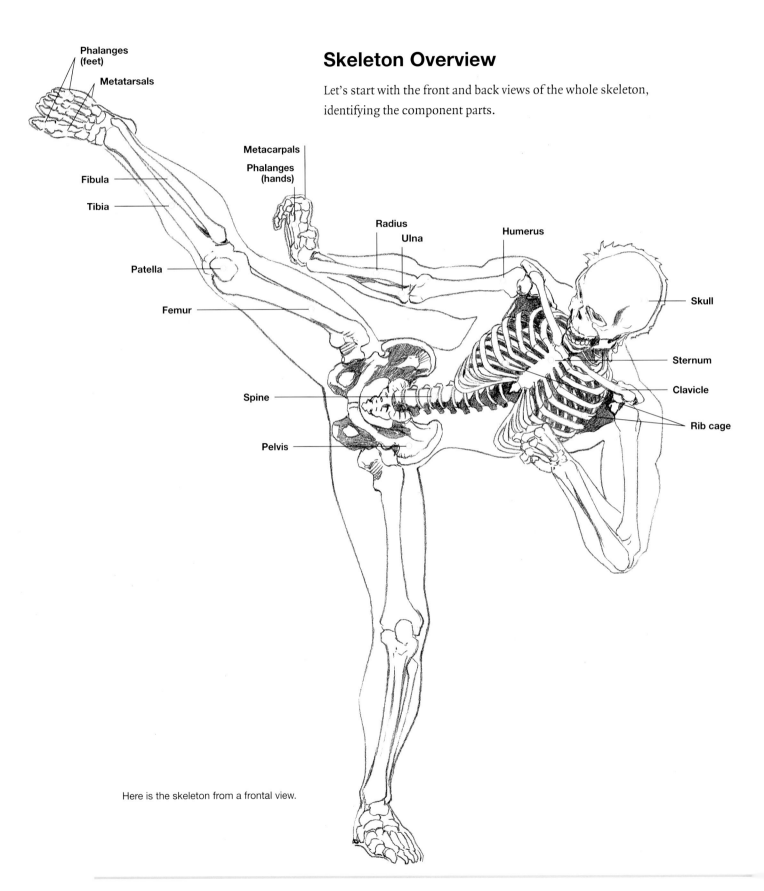

Phalanges
(feet)

Metatarsals

Metacarpals

Phalanges
(hands)

Radius

Ulna

Humerus

Fibula

Tibia

Skull

Patella

Femur

Sternum

Clavicle

Spine

Rib cage

Pelvis

Here is the skeleton from a frontal view.

144

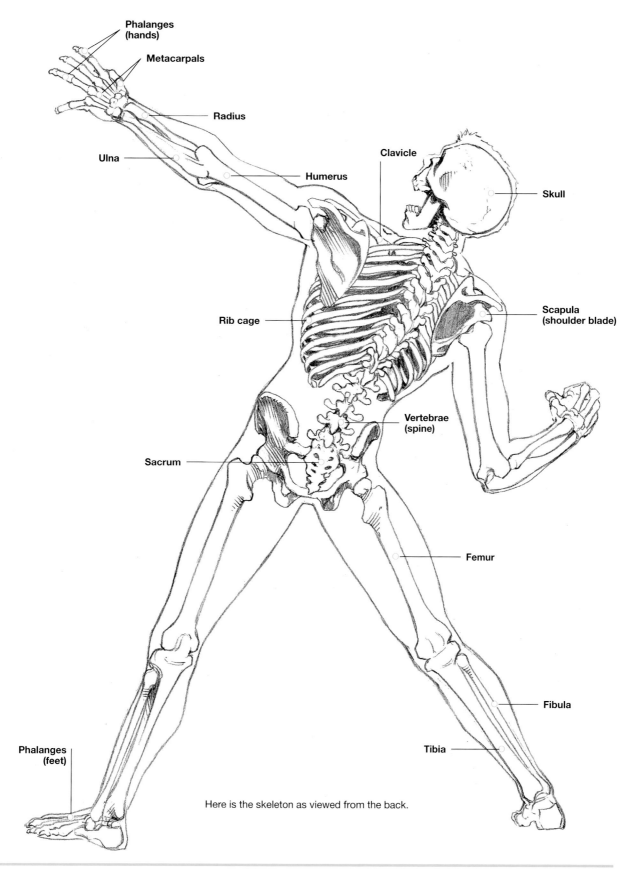

Phalanges
(hands)

Metacarpals

Radius

Ulna

Humerus

Clavicle

Skull

Scapula
(shoulder blade)

Rib cage

Vertebrae
(spine)

Sacrum

Femur

Fibula

Phalanges
(feet)

Tibia

Here is the skeleton as viewed from the back.

## Skeletal Features

Now let's highlight key features of the body's skeletal structure and discuss their visual impact on the fully fleshed out human figure.

In anatomical terms, the region of the upper torso is referred to as the *shoulder girdle* or, alternatively, the *pectoral girdle* and includes such prominent features as the clavicle, or collarbones; the rib cage; and the scapulae, or shoulder blades. Functionally, the girdle is all about how the arms connect to the body and how the skeletal underpinning gives them equal parts strength and flexibility.

The humerus connects to the scapula through a classic ball-and-socket joint (in which a ball-shaped form fits into another,) that is cup-like allowing for a wide-range of movement. However, the scapulae are "floaters." Their only hard connection to the body's "mainframe" (that is, the axial skeleton) comes through the clavicle. This particular joining is called the *process of acromion* (a bone outcropping where the clavicle connects to the top of the shoulder blade) on the scapula's crest. Meanwhile the clavicle's only connection to the axial skeleton is at the sternum. The delicate nature of these contact points allows for a great deal of maneuverability in the upper body. In fact, the shoulder girdle boasts the greatest range of motion in the body. This translates into a wide variety of potential arm positions, including forward and backward, across the chest, up and over, and so on.

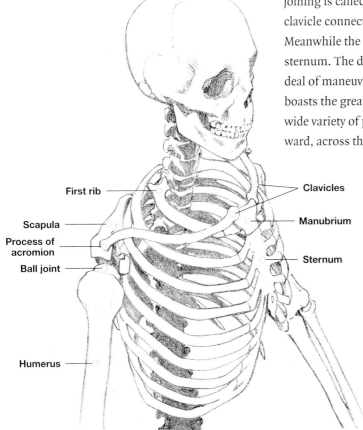

First rib

Scapula

Process of
acromion

Ball joint

Humerus

Clavicles

Manubrium

Sternum

Here is the skeleton's upper body with the shoulder girdle.

## THE SHOULDER GIRDLE IN MOTION

The rib cage's shape is one of the key features allowing for the range of motion in the shoulder girdle. The rib cage is distinctly egg-shaped, with a significant narrowing at its top.

Look at the two images below. When the figure raises his arms over his head, the whole shoulder girdle reacts. The clavicles (collarbones) swing up and the shoulder blades in the back pivot and rise up. The ball-socket joints at the arms also raise up, but move closer together too, narrowing the distance between them.

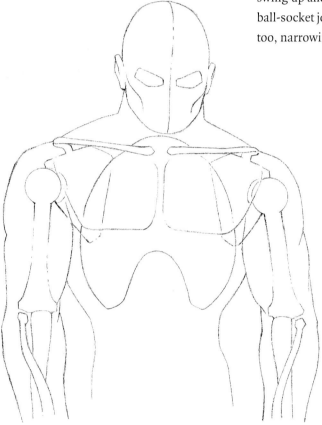

Even a broad-shouldered character like the one pictured here is built around a narrowed structure.

The colored line marks the outer edges of the shoulders from the previous image. Note that the width from shoulder to shoulder changes as the arms change positions. This example shows arms raised above the head.

## A CLOSER LOOK AT THE AXIAL SKELETON

The image of the skeleton in mid-motion to the left shows the complete axial skeleton: the rib cage, spinal column, and pelvis combined. The pelvis, like the skull, is constructed from plate bone. In both cases, plate bones serve the primary function of protecting vital organs. The pelvis is formed by three bones fused together—the *ilium*, the *pubis*, and the *ischium*—along with two additional bones, the *sacrum* and *coccyx*, which actually form the tail end of the spine.

Note how the upper leg bone—the *femur*—connects to the lower third of the pelvis by way of another ball-and-socket joint.

Ilium

Sacrum
Greater
trochanter

Coccyx

Pubis

Ischium

Femur

# The Bones and Joints of the Arms and Legs

The following section focuses on the bones that make up the limbs, with particular attention paid to the joints in both the elbows and knees. Along the way, I'll address notable similarities and differences between the arms and legs.

Two long bones run through the forearm: the *radius* and the *ulna*. While the ulna is broad at the elbow and narrows as it approaches the wrist, the radius is broader at the wrist than at the elbow. The humerus bone of the upper arm widens as it nears the elbow joint and has two knob-like outcroppings referred to as *medial* and *lateral condyles*. Together with the *olecranon process*—a part of the ulna which flares out, forming the knob of the elbow (see diagram to the left)—the condyles form the familiar landmark of the elbow. The femur is the leg's counterpart to the humerus. It flares out at the knee and has medial and lateral condyles of its own. The knee is the body's other basic hinge joint, with a *patella* (or kneecap) and its attached ligament acting as a pulley. As with the forearm, two bones compose the skeletal structure of the lower leg: in this case, the *tibia* and the *fibula*. Unlike their forearm counterparts, these bones do not cross over each other at any time in twisting actions. This reflects the fact that the degree of rotation available to the lower leg is not as great as that of the forearm. The trade-off is a loss of flexibility for strength.

Appreciate the similarities, but respect the differences between the arms and the legs and your drawings will benefit.

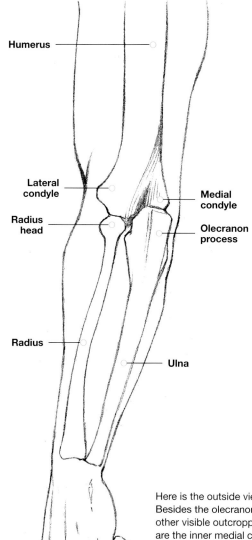

Humerus

Lateral condyle

Radius head

Radius

Medial condyle

Olecranon process

Ulna

Here is the outside view of an extended arm. Besides the olecranon process (elbow), the other visible outcroppings of bone at the joint are the inner medial condyle of the humerus (the funny bone) and the radius head.

Here is the outside view of a bent arm. The ulna acts as the moving part when the elbow is bent. Note the hollow in the humerus in which the olecranon rests.

This inner view of a straight arm features the radius crossing over the ulna. Note as well the changing thicknesses of each bone relative to the other. This angle of the arm shows the relative positioning of all the prominent points of bone that make up the elbow, when the arm is *at rest*.

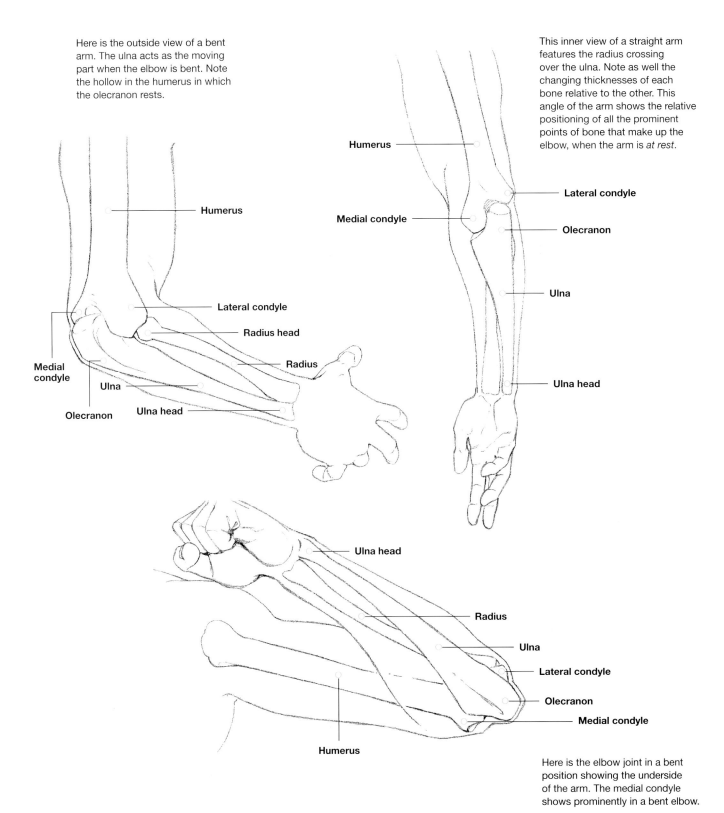

Humerus

Lateral condyle

Medial condyle

Olecranon

Ulna

Ulna head

Humerus

Lateral condyle

Radius head

Radius

Medial condyle

Ulna

Olecranon

Ulna head

Ulna head

Radius

Ulna

Lateral condyle

Olecranon

Medial condyle

Humerus

Here is the elbow joint in a bent position showing the underside of the arm. The medial condyle shows prominently in a bent elbow.

Here is the knee joint with
the leg bent from the outside.
Note the secondary bulging
of the *tubercle*. This is a
small, rounded projection of
the tibia connected to the
patella by a ligament.

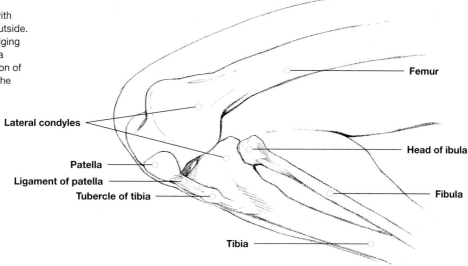

Lateral condyles

Patella
Ligament of patella
Tubercle of tibia

Tibia

Femur

Head of ibula

Fibula

In this inner front view, the knee
joint is partially overlapped by
the tibia; however, the head of the
fibula is still visible on the leg.

The condyles of the femur are not
symmetrical. The medial condyle is a
little smaller than its lateral counterpart.
Note the V-shaped bulge of bone
centrally located on the tibia's head,
capped by the tubercle of the tibia.

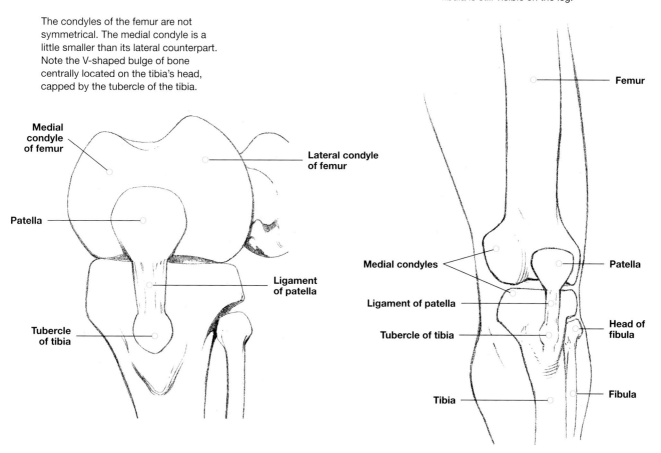

Medial
condyle
of femur

Patella

Tubercle
of tibia

Lateral condyle
of femur

Ligament
of patella

Femur

Medial condyles

Ligament of patella

Tubercle of tibia

Tibia

Patella

Head of
fibula

Fibula

Here's a last look at the bones of the leg. Note the relative heights of the anklebones and that each belongs to a separate leg bone. It's also worth noting the S-curve that runs through the bones.

Greater trochanter

Pelvis

Femur

Patella

Tibia

Fibula

Medial malleolus of tibia

Lateral malleolus of fibula

## EXERCISE: Drawing the Skeleton in Motion

The accompanying image contains two mannequin figures in mid-action. Add your own skeletal under-drawings for each of them.

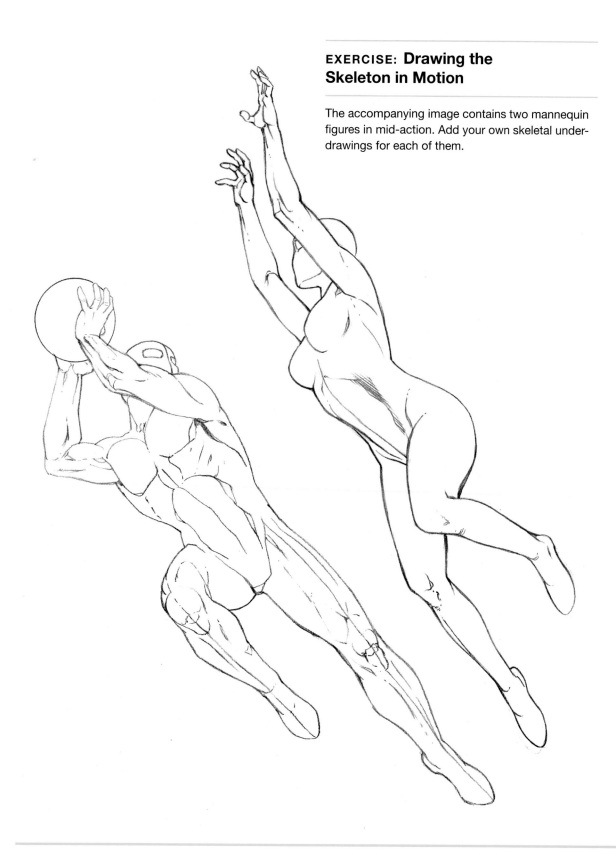

# THE MUSCLES

Now let's focus on examining surface anatomy, combining groups of muscles with bone outcroppings to establish the key landmarks of the human form.

For the student of figure drawing, a more in-depth study of anatomy is recommended. Still, I hope this introduction serves as a visual primer for helping you understand how to draw muscular anatomy. Let's start with an examination of the core of the body: the head, torso, and hips. I will show you front, back, and side views for this purpose.

## Male versus Female Anatomy

In the pages ahead, I've included a comparative look at the visual anatomy of the male form versus that of the female. I must emphasize that these comparisons are based on idealized norms. Such norms are useful as templates. However, be prepared to deviate from these templates, based on the body type(s) of the character or characters you are drawing. That said, the idealized female form is composed of comparatively softer curves and less linear detail than its male counterpart. When too much anatomical definition is applied to the female figure, it looks either too masculine or too gaunt, or appears to be emaciated. Proportionately, the female figure is narrower in the shoulders, but wider in the hips and thighs than the male. The hands and feet of the female figure are generally slimmer as well.

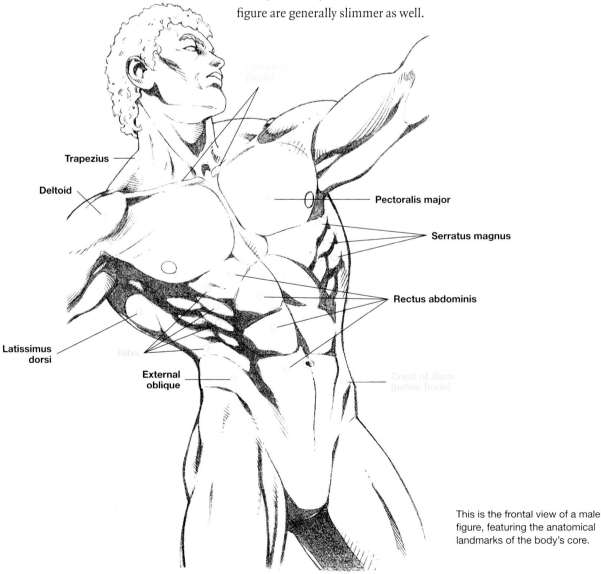

Trapezius

Deltoid

Pectoralis major

Serratus magnus

Rectus abdominis

Latissimus dorsi

External oblique

This is the frontal view of a male figure, featuring the anatomical landmarks of the body's core.

I have purposely omitted the serratus magnus muscles from the frontal view of the female core. While these muscles interweave with the ribs in the same way in a female as in a male, they are typically not visible features on female torsos. For this reason, I have not segmented the abdominal muscles horizontally on the female figures. Too much of this type of linear definition undercuts the figure's distinctive femininity.

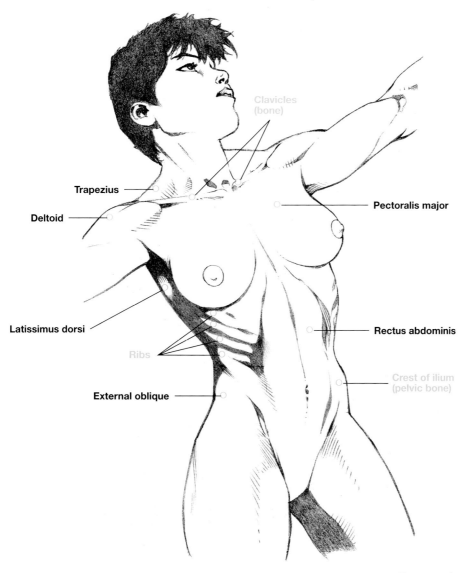

Clavicles
(bone)

Trapezius

Deltoid

Pectoralis major

Latissimus dorsi

Rectus abdominis

Ribs

Crest of ilium
(pelvic bone)

External oblique

For comparison, here is a female figure, featuring the landmarks of the body's core.

Here is a male figure from behind, featuring the anatomical landmarks of the back.

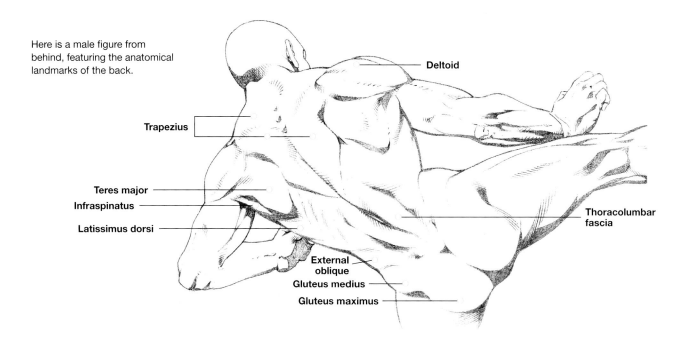

Deltoid

Trapezius

Teres major

Infraspinatus

Latissimus dorsi

Thoracolumbar fascia

External oblique

Gluteus medius

Gluteus maximus

Here is a comparative look at a female figure from behind, featuring the anatomical landmarks of the back.

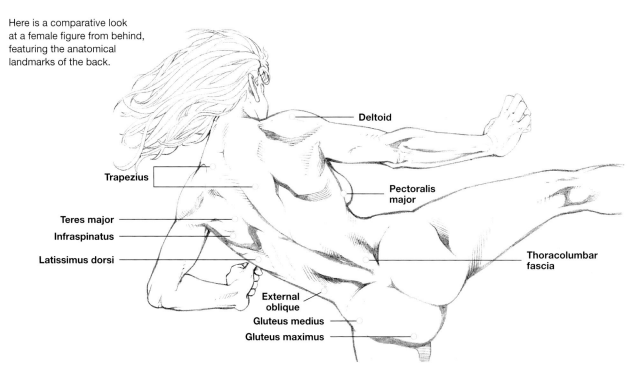

Deltoid

Trapezius

Pectoralis major

Teres major

Infraspinatus

Latissimus dorsi

Thoracolumbar fascia

External oblique

Gluteus medius

Gluteus maximus

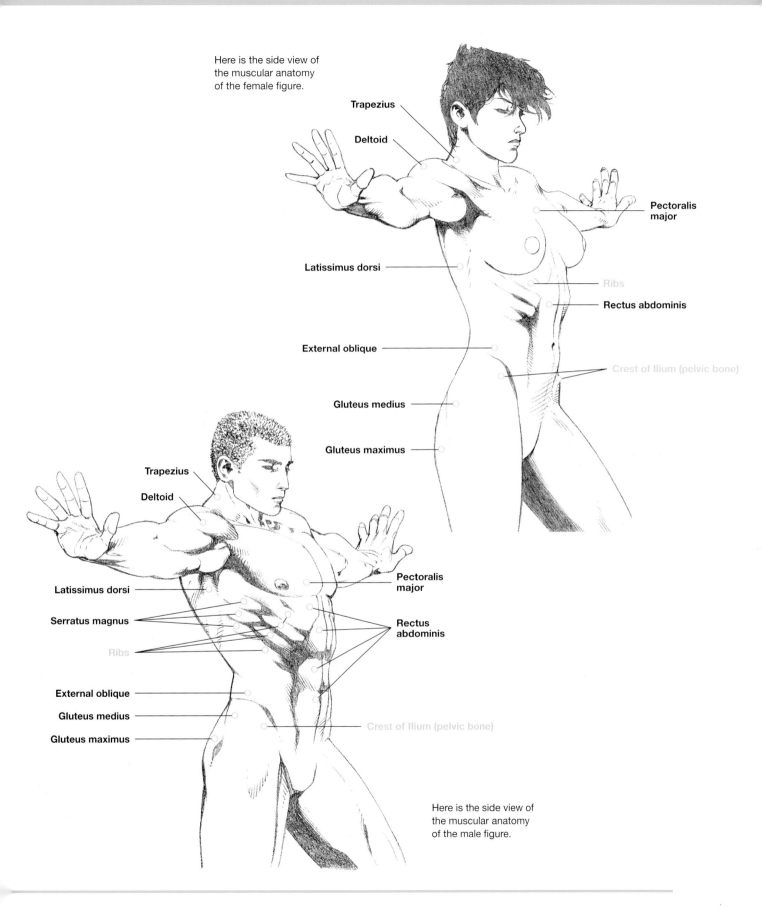

Here is the side view of the muscular anatomy of the female figure.

Trapezius

Deltoid

Pectoralis major

Latissimus dorsi

Ribs

Rectus abdominis

External oblique

Crest of Ilium (pelvic bone)

Gluteus medius

Gluteus maximus

Trapezius

Deltoid

Pectoralis major

Latissimus dorsi

Serratus magnus

Rectus abdominis

Ribs

External oblique

Gluteus medius

Gluteus maximus

Crest of Ilium (pelvic bone)

Here is the side view of the muscular anatomy of the male figure.

## The Armpit

Here is a close look at the armpit, highlighting how the muscles of the arm connect with those of the torso. Note how the latissimus dorsi overlaps the triceps, and how the biceps spreads out over the coracobrachialis muscle. The interweaving of the muscles must be understood in order to draw the underarm region effectively.

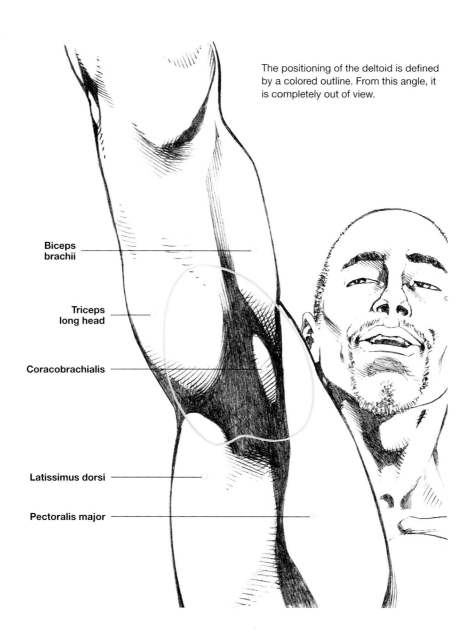

The positioning of the deltoid is defined by a colored outline. From this angle, it is completely out of view.

Biceps brachii

Triceps long head

Coracobrachialis

Latissimus dorsi

Pectoralis major

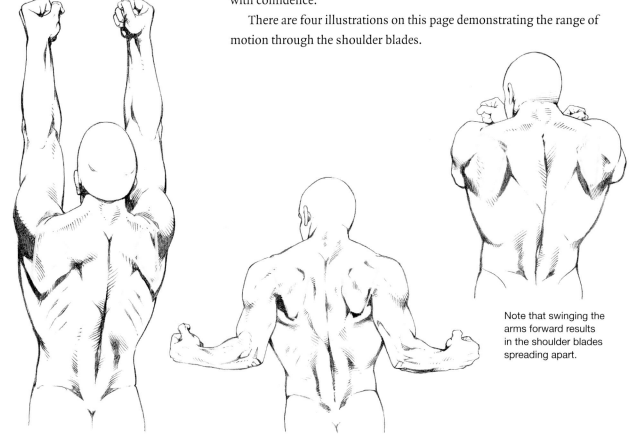

# The Floating Shoulder Blades

One of the most challenging subjects for the freehand figure artist to master is the surface anatomy of the back. In terms of surface anatomy, no part of the body seems as changeable as the back. This is mostly due to the shoulder blades, or scapulae.

The scapulae are unique in that they are major bone masses that have no significant connection to the skeleton, hence the term *floating*. They do connect to the clavicles (collarbones) at a point called the acromion process. The clavicles in turn connect to the sternum at the top of the rib cage, but it is a very delicate, single-point connection. This allows the shoulder blades to have a remarkable range of motion, accommodating the need for flexibility of movement throughout the shoulder girdle and, more specifically, through the arms.

Understanding how, where, and under what conditions the shoulder blades change position, will help you to draw figures from the back with confidence.

There are four illustrations on this page demonstrating the range of motion through the shoulder blades.

Here are the shoulder blades in their relaxed (arms at sides) position.

Here, each shoulder blade pivots, angling out at the bottom. They also rise up as the arms extend upward.

With arms pushed back, the shoulder blades are pushed closer together.

Note that swinging the arms forward results in the shoulder blades spreading apart.

161

## Muscular Anatomy of the Arm

It is time to shift the focus from the trunk of the body to a closer look at the limbs, starting with the arms in various positions. I have chosen to focus on the *surface* or the *visible* anatomy, which includes both the skin and muscles as well as all visible bone outcroppings, which act as useful guides for placing muscles.

Before going further, let's look at some of the terminology used for the muscles, specifically those terms that describe a muscle's function. An *extensor* muscle acts to extend or straighten a limb; a *flexor* muscle contracts to bend a limb at the joint; and a *pronator* muscle helps to rotate a limb.

Here is a frontal view of an extended arm with the hand angling out. Note the muscles of the inside forearm.

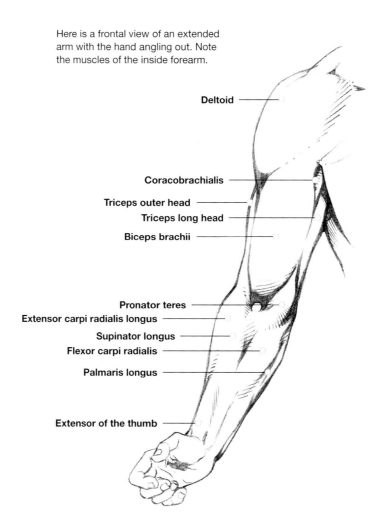

Deltoid

Coracobrachialis

Triceps outer head

Triceps long head

Biceps brachii

Pronator teres

Extensor carpi radialis longus

Supinator longus

Flexor carpi radialis

Palmaris longus

Extensor of the thumb

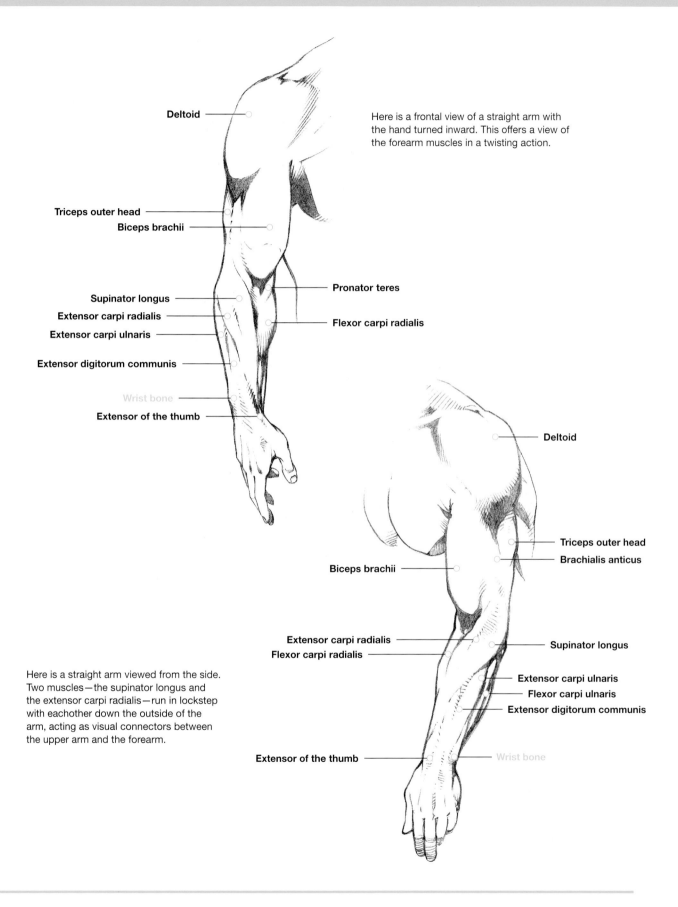

Deltoid

Here is a frontal view of a straight arm with the hand turned inward. This offers a view of the forearm muscles in a twisting action.

Triceps outer head

Biceps brachii

Supinator longus

Extensor carpi radialis

Extensor carpi ulnaris

Extensor digitorum communis

Wrist bone

Extensor of the thumb

Pronator teres

Flexor carpi radialis

Deltoid

Triceps outer head

Brachialis anticus

Biceps brachii

Extensor carpi radialis

Flexor carpi radialis

Supinator longus

Extensor carpi ulnaris

Flexor carpi ulnaris

Extensor digitorum communis

Here is a straight arm viewed from the side. Two muscles—the supinator longus and the extensor carpi radialis—run in lockstep with eachother down the outside of the arm, acting as visual connectors between the upper arm and the forearm.

Extensor of the thumb

Wrist bone

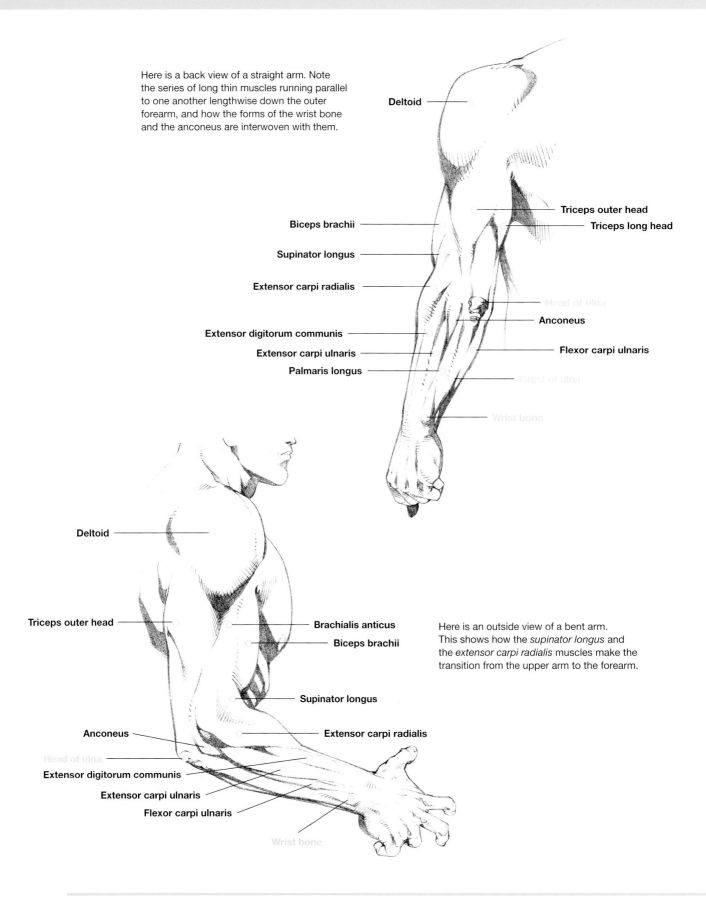

Here is a back view of a straight arm. Note the series of long thin muscles running parallel to one another lengthwise down the outer forearm, and how the forms of the wrist bone and the anconeus are interwoven with them.

Deltoid

Triceps outer head

Triceps long head

Biceps brachii

Supinator longus

Extensor carpi radialis

Head of ulna

Anconeus

Extensor digitorum communis

Extensor carpi ulnaris

Flexor carpi ulnaris

Palmaris longus

Crest of ulna

Wrist bone

Deltoid

Triceps outer head

Brachialis anticus

Biceps brachii

Supinator longus

Anconeus

Extensor carpi radialis

Head of ulna

Extensor digitorum communis

Extensor carpi ulnaris

Flexor carpi ulnaris

Wrist bone

Here is an outside view of a bent arm. This shows how the *supinator longus* and the *extensor carpi radialis* muscles make the transition from the upper arm to the forearm.

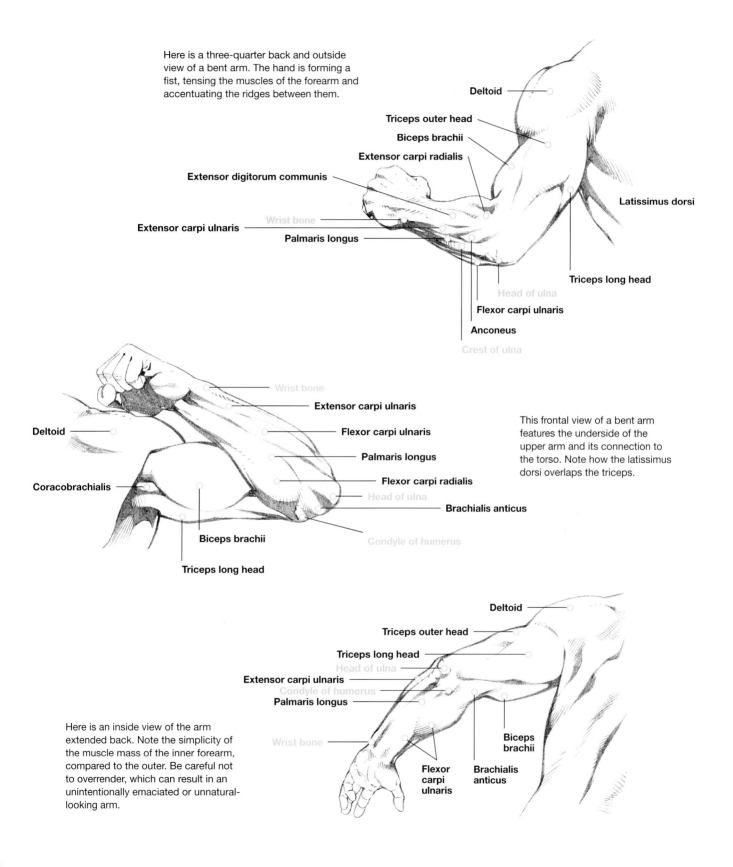

Here is a three-quarter back and outside view of a bent arm. The hand is forming a fist, tensing the muscles of the forearm and accentuating the ridges between them.

Deltoid

Triceps outer head

Biceps brachii

Extensor carpi radialis

Extensor digitorum communis

Latissimus dorsi

Extensor carpi ulnaris

Wrist bone

Palmaris longus

Triceps long head

Head of ulna

Flexor carpi ulnaris

Anconeus

Crest of ulna

Wrist bone

Extensor carpi ulnaris

Deltoid

Flexor carpi ulnaris

Palmaris longus

This frontal view of a bent arm features the underside of the upper arm and its connection to the torso. Note how the latissimus dorsi overlaps the triceps.

Coracobrachialis

Flexor carpi radialis

Head of ulna

Brachialis anticus

Biceps brachii

Condyle of humerus

Triceps long head

Deltoid

Triceps outer head

Triceps long head

Head of ulna

Extensor carpi ulnaris

Condyle of humerus

Palmaris longus

Here is an inside view of the arm extended back. Note the simplicity of the muscle mass of the inner forearm, compared to the outer. Be careful not to overrender, which can result in an unintentionally emaciated or unnatural-looking arm.

Wrist bone

Biceps brachii

Flexor carpi ulnaris

Brachialis anticus

## Muscular Anatomy of the Leg

To complete this study of muscular anatomy, let's look at four varied images of the leg. In these examples I have chosen to pull back the skin for a more detailed look at the leg's musculature. In the leg's anatomy, there are important *shapers* at work below the surface. They are the sartorius, a long, thin curving muscle that runs from the hip, angling down through the inner leg to end just under the knee on the inside and which acts to both flex and rotate the thigh, and the iliotibial tract, which runs down the outside of the thigh to the knee and aids in the sideways rotation of the thigh and reinforces the knee when the leg is extended. Note: The sartorius muscle has the distinction of being the longest muscle in the human body.

Gluteus medius

Tensor fasciae latae

Adductor

Sartorius

Vastus lateralis

Gracilis

Rectus femoris

Vastus medialis

Here is a frontal view of the muscles of the leg. These muscles run down the thigh and terminate just above the knee, aligning along a concave curve, with the vastus medialis ending a little lower than the others.

Patella (kneecap)

Head of fibula

Gastrocnemius

Peroneus longus

Crest of tibia

Extensor digitorum communis longus

Tibialis anticus

Soleus

Extensor of the toes

Malleus of tibia
(anklebone)

Malleus of fibula
(anklebone)

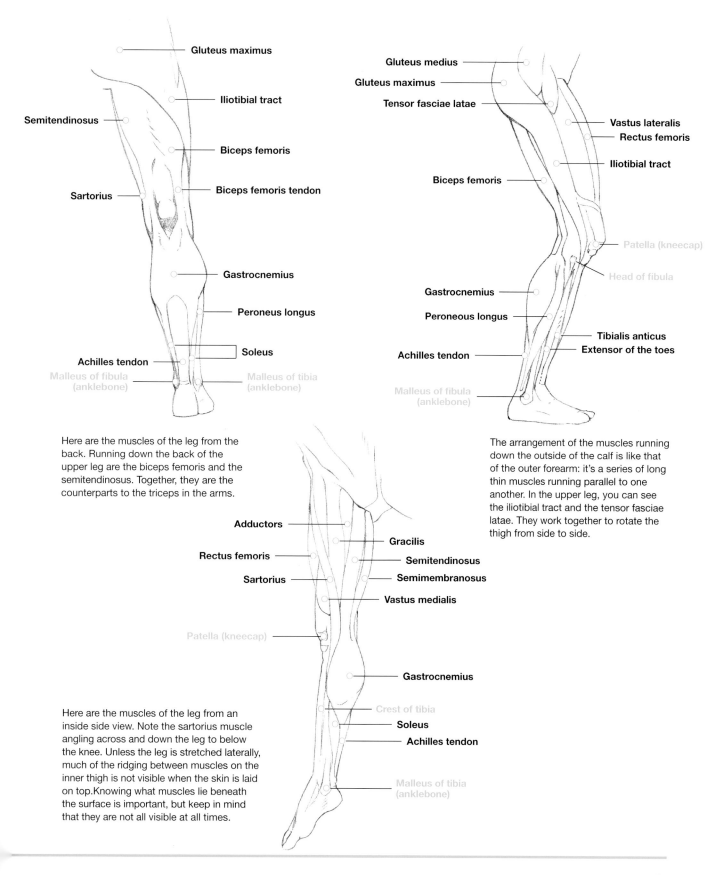

Gluteus maximus

Iliotibial tract

Semitendinosus

Biceps femoris

Biceps femoris tendon

Sartorius

Gastrocnemius

Peroneus longus

Soleus

Achilles tendon

Malleus of fibula
(anklebone)

Malleus of tibia
(anklebone)

Gluteus medius

Gluteus maximus

Tensor fasciae latae

Vastus lateralis

Rectus femoris

Iliotibial tract

Biceps femoris

Patella (kneecap)

Head of fibula

Gastrocnemius

Peroneous longus

Tibialis anticus

Extensor of the toes

Achilles tendon

Malleus of fibula
(anklebone)

Adductors

Gracilis

Rectus femoris

Semitendinosus

Sartorius

Semimembranosus

Vastus medialis

Patella (kneecap)

Gastrocnemius

Crest of tibia

Soleus

Achilles tendon

Malleus of tibia
(anklebone)

Here are the muscles of the leg from the back. Running down the back of the upper leg are the biceps femoris and the semitendinosus. Together, they are the counterparts to the triceps in the arms.

The arrangement of the muscles running down the outside of the calf is like that of the outer forearm: it's a series of long thin muscles running parallel to one another. In the upper leg, you can see the iliotibial tract and the tensor fasciae latae. They work together to rotate the thigh from side to side.

Here are the muscles of the leg from an inside side view. Note the sartorius muscle angling across and down the leg to below the knee. Unless the leg is stretched laterally, much of the ridging between muscles on the inner thigh is not visible when the skin is laid on top. Knowing what muscles lie beneath the surface is important, but keep in mind that they are not all visible at all times.

## EXERCISE: Adding Muscles to Mannequins

Select mannequin figures from any of the previous chapters, and use them as the basis for drawing anatomical studies. Here are some that I have chosen for you to practice applying muscles within.

Be sure to include front and back views in your selection as well as some requiring foreshortening. Challenging yourself is the only way to grow!

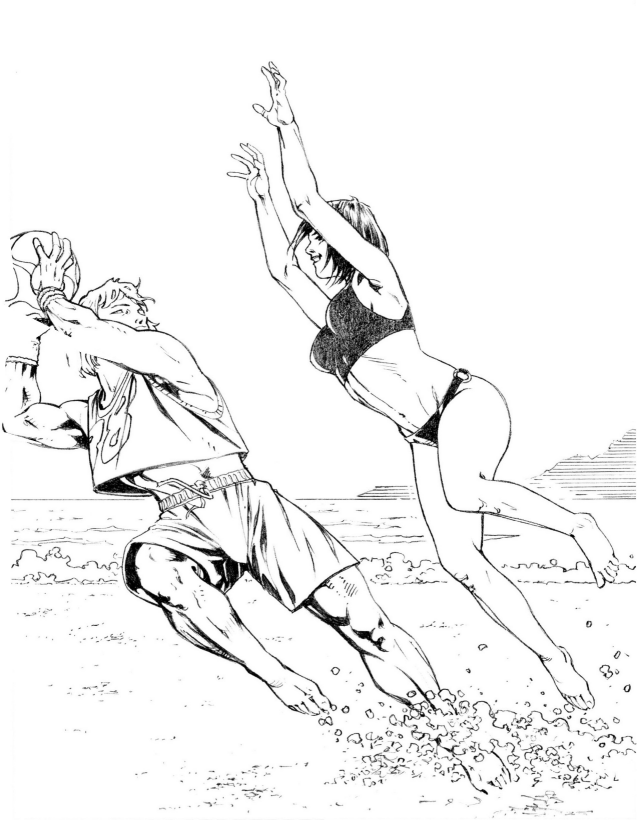

# DYNAMIC ACTION

Let's apply the lessons covered in the previous chapters to the drawing of figures *in action*.

*Dynamic action* is all about drawing your figures mid-motion. Strong tipped lines of balance forward and back come into play. Be prepared to throw your characters off-balance and to shift their centers of gravity out from under their bodies.

*Broad actions*, involving arched backs, stretching limbs, and twisting torsos distinguish these poses. Effective action poses rely on structural considerations, such as accurate proportions and parts that fit together cohesively. However, you must combine these with graphic considerations as well. Action figures must read clearly. By addressing both the structural and the graphic, you will gain the best results.

Before continuing on this topic, however, I'd like to introduce you to a new mannequin.

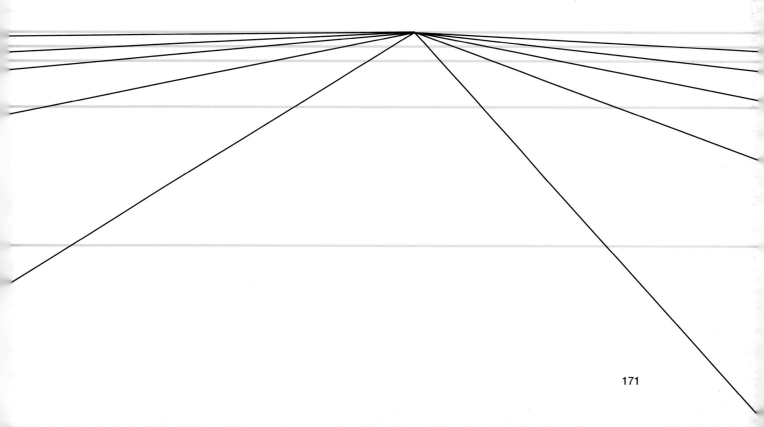

## Advanced Mannequins: Male and Female

Here is a comparative look at the basic glass mannequin and the advanced mannequin. Some anatomical details involving bone prominences, such as the collarbones and hip bones, have been added to the advanced versions with major muscle groups as well.

For both advanced male and female mannequins, your focus should be on smoothing out the transitions between component parts of the mannequin as well as adding some anatomical details.

The basic male mannequin

The advanced male mannequin

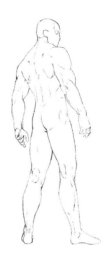

Advanced male mannequin from the back: Note the moderate use of anatomical detailing in this example.

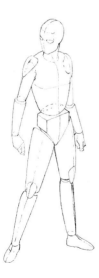

The basic female mannequin

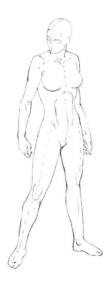

The advanced female mannequin

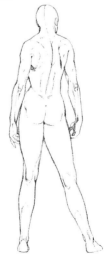

Advanced female mannequin from the back: Again, note the moderate use of anatomical detailing.

# Glass Mannequins versus Advanced Mannequins in Action

The basic mannequins are still semitransparent in this comparative study. That feature plus their simplicity combine to make them ideal for blocking in poses. Foreshortening is more easily visualized, in part due to the simple curves running through the basic mannequin's form. And even with minimal anatomy being added, the mannequin will take on a more organic shape. As a result, the second pairing of figures is more fully formed, with the anatomical detailing.

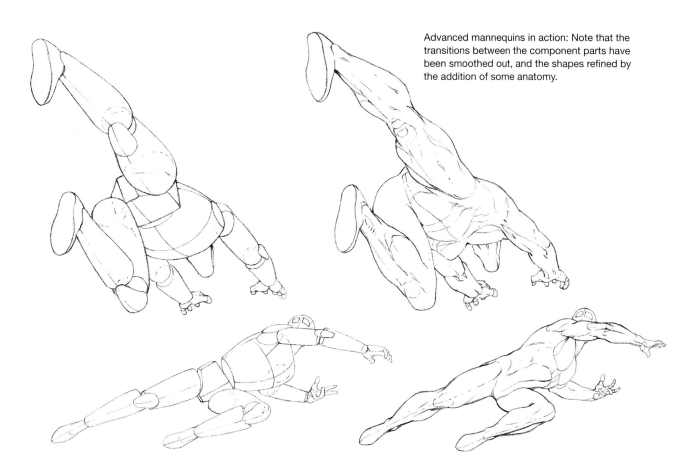

Advanced mannequins in action: Note that the transitions between the component parts have been smoothed out, and the shapes refined by the addition of some anatomy.

Basic glass mannequins in action: Both poses are built on strong stretching actions. Note that the recoiling figure's core is both twisting and bending back. Note as well, the degree to which the component parts of the foreground mannequin overlap one another. He is both foreshortened and being viewed from a low angle.

## Applying Foreshortening to the Advance Mannequin

As you prepare to draw the advance mannequin, I want to revisit the topic of *foreshortening*. In chapter 2, I introduced a simple version of foreshortening using the rotation of cylinders.

When more complex forms are involved, additional techniques are needed to aid in visualizing those forms from all possible angles. Here is a step-by-step demonstration of one useful technique refered to as *cross-sectioning*.

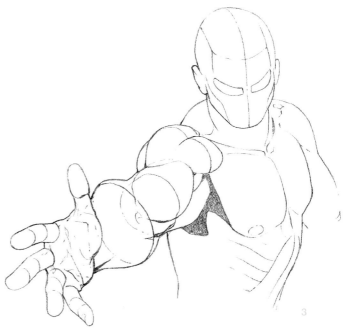

1 Draw cross-sections through key points on the arm; at the mid-point of the upper arm, through the forearm just below the elbow, and at the wrist where the cross-section loses its elliptical nature, becoming more rectangular.

2 Add the basic wedged block of the palm to the wrist. Then extend the cylindrical forms of the fingers along with the thumb. Keep the component parts of the arm transparent as you work. This will aid in both their positioning and scaling.

3 The next step is to smooth out and refine the foreshortened forms by adding some anatomical details such as the deltoids, biceps and triceps.

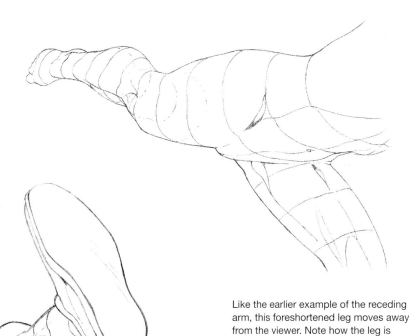

## FORESHORTENING ARMS AND LEGS USING CROSS-CONTOURS

Taking the concept of cross-sectioning one step further, cross-contouring makes use of a greater number of cross-sections to define the surface contours of the subject you are drawing, be it an arm, a leg, or a whole figure. When you apply more subdivisions it becomes easier to define anatomical surface details as they appear in foreshortened perspective.

Here are three examples of extended arms and legs demonstrating how cross-contouring helps to resolve the challenges of foreshortening.

Foreshortening is most often associated with images of big hands or feet dramatically projecting out at the viewer. But it is just as important a factor in drawing receding limbs, such as this arm.

Like the earlier example of the receding arm, this foreshortened leg moves away from the viewer. Note how the leg is becoming smaller in diameter, due to the diminishing perspective.

Here is a classic *kick at the camera* angle. Note how the degree of curvature in the cross-contours reinforces the POV while also defining the leg's surface anatomy.

# The Mannequin in Action: Step by Step

Use a rough sketch to construct a mannequin with a ball. Begin with a loose gestural line to capture the essence of the pose. If you're ready, you can go with the constructive mannequin directly. Either way, it's best to start with the simplest POV (usually eye level)—one that shows off the pose clearly.

Let's look at the step-by-step procedure for setting up poses from any and all conceivable angles. Start with a rough sketch, establishing a specific gestural curve (in this case a C-curve) and a tipped line of balance. A figure in mid-action usually has a strong tipped line—together with a center of gravity that is shifted from its normal position directly underneath.

This pose is also marked by a stretching action along one side of the body. This is a gestural detail that you should emphasize in your own action poses. In the example here, the mannequin torso and hips are at the gestural center of the pose and should be roughed in first. Next come the arms and hands holding the ball. That's because they lead the action. Add the head to establish the figure's line of rhythm.

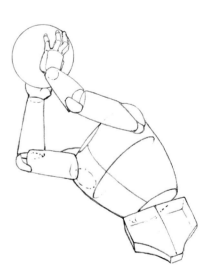

Start with constructing your basic mannequin, with the torso and hips first. Then ask yourself the following questions:

- Should there be a tipped line of balance? If so, to what degree?
- Is there a twist, bend, or curve through the torso and hips?
- Does a natural line of rhythm flow through the pose?
- Is foreshortening at work in this view of the torso and hips? If so, how extreme is it?

What comes next: arms, legs, or head? Take your cue from the pose itself. In this case, it is all about the figure swinging the ball behind his head, so draw the arms, hands, and ball in position right away.

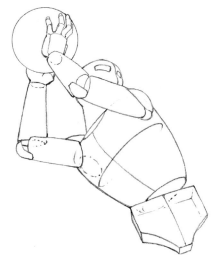

Next, locate the head. Remember, it should flow out of the body and follow the established line of rhythm.

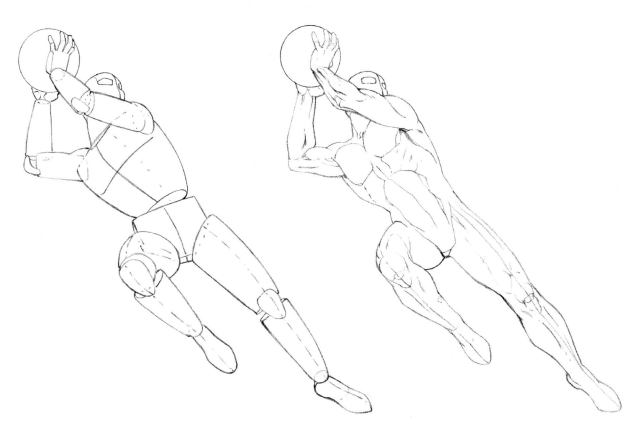

To finish the mannequin, draw in the legs; however, keep the distribution of weight in mind. Due to the figure being in mid-action, the center of gravity has shifted to the left. It is no longer directly under the figure. Mid-action figures need to be drawn off-balance to give their poses the necessary gestural dynamics.

Refine the mannequin by applying some anatomical details to the figure and adding the legs.

## HIGH-ANGLE MANNEQUIN

Below is the mannequin with a beach ball from a high angle. To draw this figure, maintain the same order of steps—drawing the trunk of the "body first. Each component part must rotate in perspective. To accommodate the new POV, you must diminish the legs proportionally at this angle.

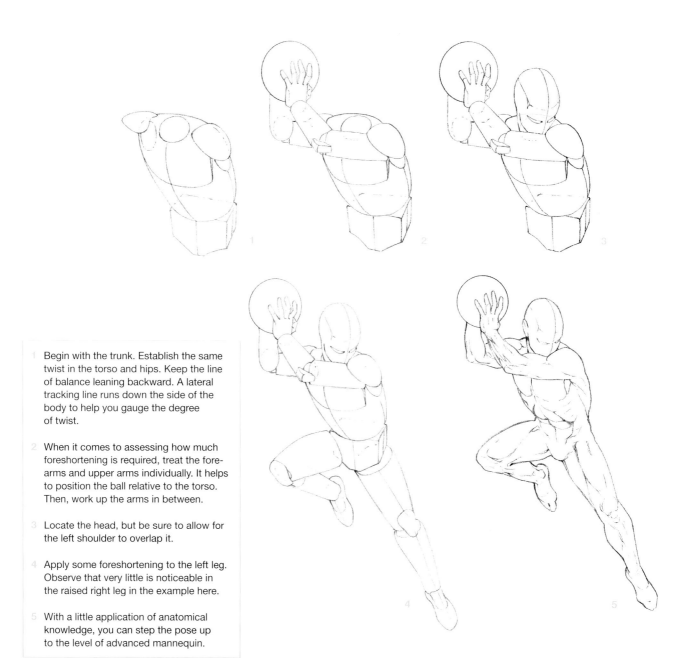

1 Begin with the trunk. Establish the same twist in the torso and hips. Keep the line of balance leaning backward. A lateral tracking line runs down the side of the body to help you gauge the degree of twist.

2 When it comes to assessing how much foreshortening is required, treat the forearms and upper arms individually. It helps to position the ball relative to the torso. Then, work up the arms in between.

3 Locate the head, but be sure to allow for the left shoulder to overlap it.

4 Apply some foreshortening to the left leg. Observe that very little is noticeable in the raised right leg in the example here.

5 With a little application of anatomical knowledge, you can step the pose up to the level of advanced mannequin.

# Leaping Figures

Figures jumping down from great heights have two choices: they can go head first or feet first. In either case, the figures are bound to have strong tipped lines of balance, either forward or back. As the artist, you must make a clear choice at the outset whether the upper body or the legs will lead the action. These poses are typically built around C-curves.

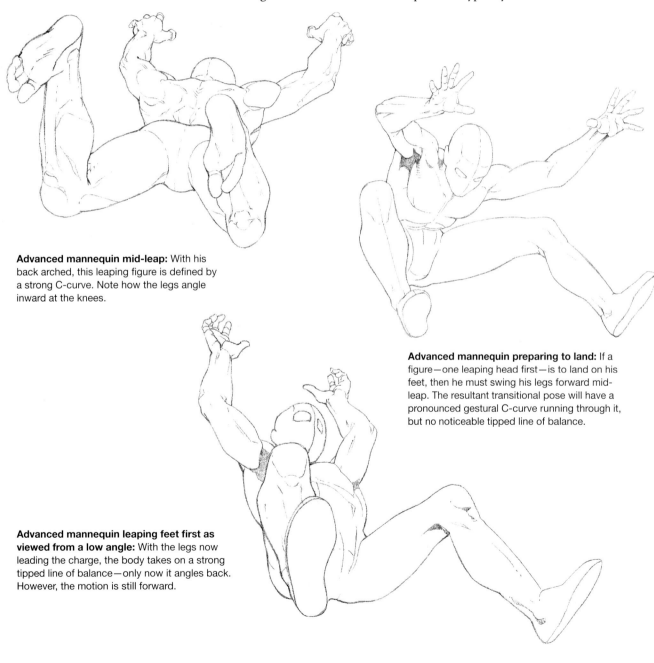

**Advanced mannequin mid-leap:** With his back arched, this leaping figure is defined by a strong C-curve. Note how the legs angle inward at the knees.

**Advanced mannequin preparing to land:** If a figure—one leaping head first—is to land on his feet, then he must swing his legs forward mid-leap. The resultant transitional pose will have a pronounced gestural C-curve running through it, but no noticeable tipped line of balance.

**Advanced mannequin leaping feet first as viewed from a low angle:** With the legs now leading the charge, the body takes on a strong tipped line of balance—only now it angles back. However, the motion is still forward.

## Clarity in Posing

Whether for storyboards, layouts, or comic book pages, it's crucial that your storytelling convey an action or emotion through body language and that you do so with total clarity.

To demonstrate these issues I have chosen the action of a figure just landing after leaping. This first image of the mannequin's action is ambiguous. This could be a character who has just landed. However, there are not enough cues to make it clear. The second image answers that concern. Indicators like the hand placed firmly on the ground (as if to support breaking action) and the other arm trailing behind in the direction from which she has come make the action appear more specific. Additionally, her focus is still down at her point of landing.

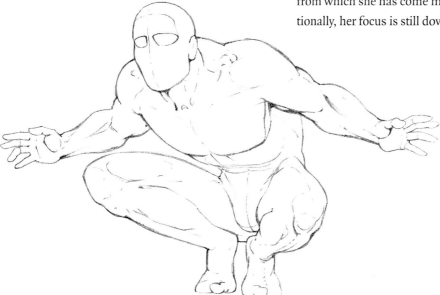

**Landing position A:** This *could* be a character who has just landed. He has a strong gestural C-curve running through his form and his legs are folded under into a crouch position.

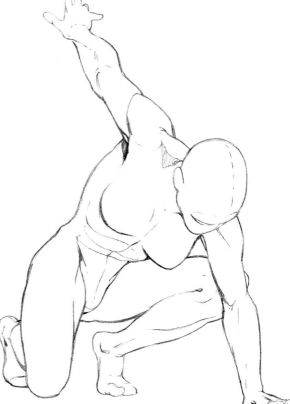

**Landing position B:** In this pose the ambiguity has been removed. The figure shares many of the same gestural traits as the one before, such as the C-curve and folded–under legs. But now there are specific cues to suggest the context of "landing."

# Pulling and Pushing

The actions of pulling and pushing are opposites, but are still closely related to each other. In both cases, the center of gravity shifts away from the figure to accommodate a redistribution of the body's weight. In these poses, the more you shift the figure's center of gravity, the greater its efforts will appear.

**Pulling:** In this example, the center of gravity has shifted behind the figure, as the strong tipped line of balance back suggests. This character would be off-balance except for the support of the rope and whatever mass it is tied to.

**Pushing:** Here the center of gravity shifts ahead of the figure to the degree that if the obstacle were removed, the character would fall forward.

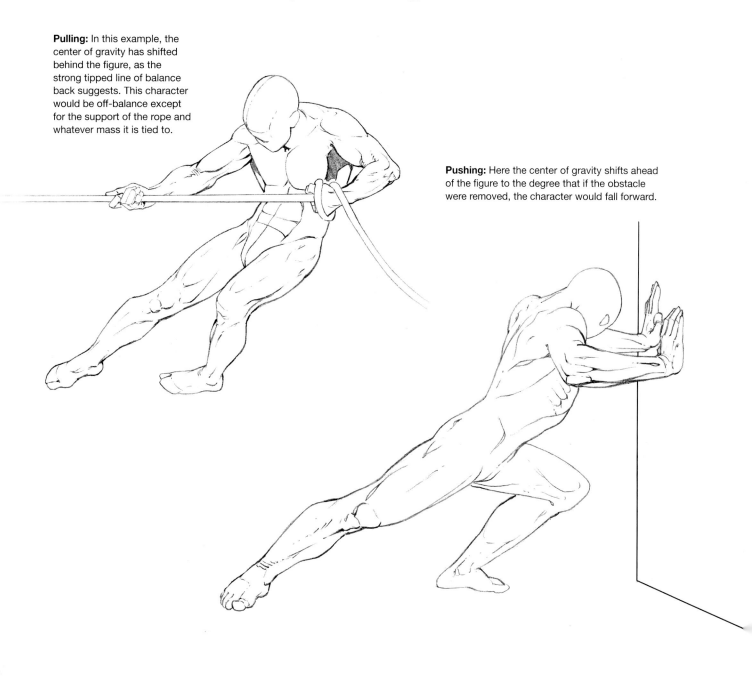

# Taking Flight

Obviously, the action of human flight is a total fabrication. No one can actually "fly" like in the comic books—can they? If there is not a real-world model for an action you're drawing, then you have to take cues from somewhere else. Comic book artists have traditionally looked to swimmers and divers for inspiration when it comes to imagining human flight.

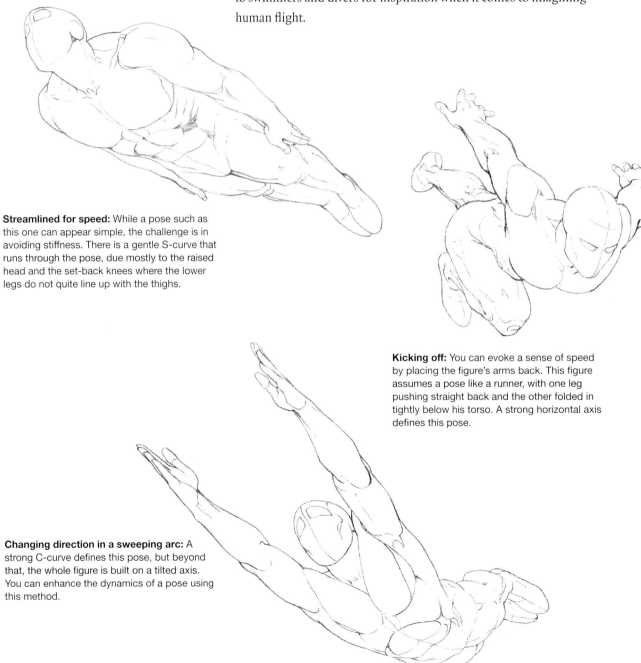

**Streamlined for speed:** While a pose such as this one can appear simple, the challenge is in avoiding stiffness. There is a gentle S-curve that runs through the pose, due mostly to the raised head and the set-back knees where the lower legs do not quite line up with the thighs.

**Kicking off:** You can evoke a sense of speed by placing the figure's arms back. This figure assumes a pose like a runner, with one leg pushing straight back and the other folded in tightly below his torso. A strong horizontal axis defines this pose.

**Changing direction in a sweeping arc:** A strong C-curve defines this pose, but beyond that, the whole figure is built on a tilted axis. You can enhance the dynamics of a pose using this method.

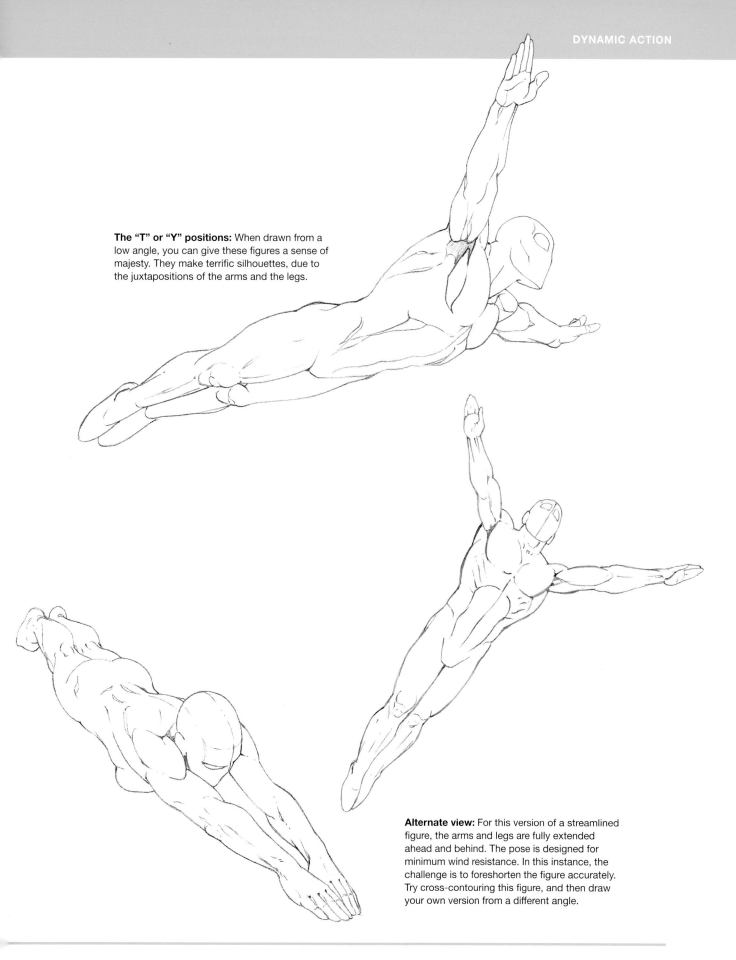

**The "T" or "Y" positions:** When drawn from a low angle, you can give these figures a sense of majesty. They make terrific silhouettes, due to the juxtapositions of the arms and the legs.

**Alternate view:** For this version of a streamlined figure, the arms and legs are fully extended ahead and behind. The pose is designed for minimum wind resistance. In this instance, the challenge is to foreshorten the figure accurately. Try cross-contouring this figure, and then draw your own version from a different angle.

## The Lunging Figure and a Hypothetical Problem

What if you had to portray the lunging pose from a straight-on frontal view? How would you convey those same attributes as the three-quarter view below? The answer is found in the three-dimensional nature of the mannequin itself. By using foreshortening to varying degrees on the component parts (more for torso, less for the hips, etc.), you imply a curvature through the back. The other strong cue is seen in the overlapping of those parts. The stronger the tilt forward toward the viewer, the more the head overlaps the torso and the torso overlaps the hips. See the three-stage example opposite.

The underlying gesture in the lunging position of the figure benefits from the three-quarter side POV. The angle clearly shows a gentle C-curve running through the pose as well as the strong tipped line of balance forward.

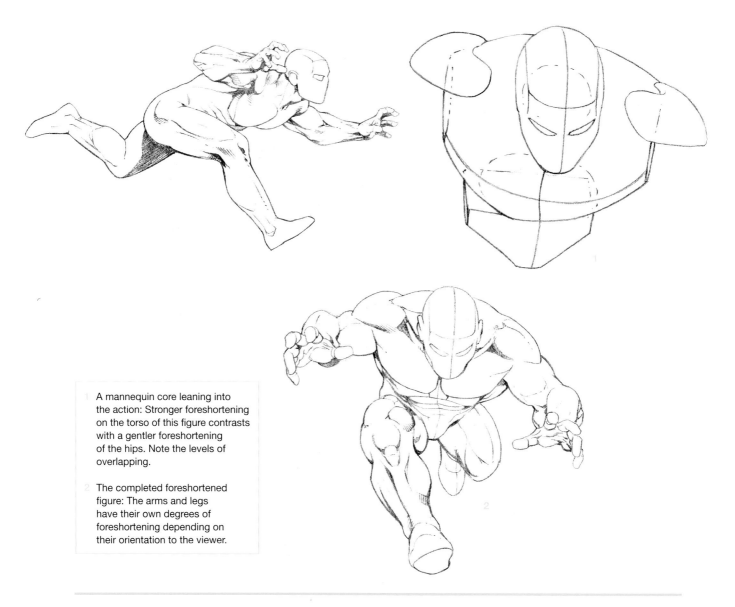

1 A mannequin core leaning into the action: Stronger foreshortening on the torso of this figure contrasts with a gentler foreshortening of the hips. Note the levels of overlapping.

2 The completed foreshortened figure: The arms and legs have their own degrees of foreshortening depending on their orientation to the viewer.

## Finished Figure Moving Forward

This example is a portrait of a male figure's upper body suggesting a tipped line forward in a frontal view showing angered facial emotion. The following three images illustrate the changing relationship between the head and the top of the shoulders as the figure leans progressively forward. One simple way to track it is to compare the brow line to a line running across the top of the shoulders. The farther forward the figure leans, the lower the brow line drops in relation to the shoulder line. As his head lowers and moves forward, his facial expression changes to obvious anger.

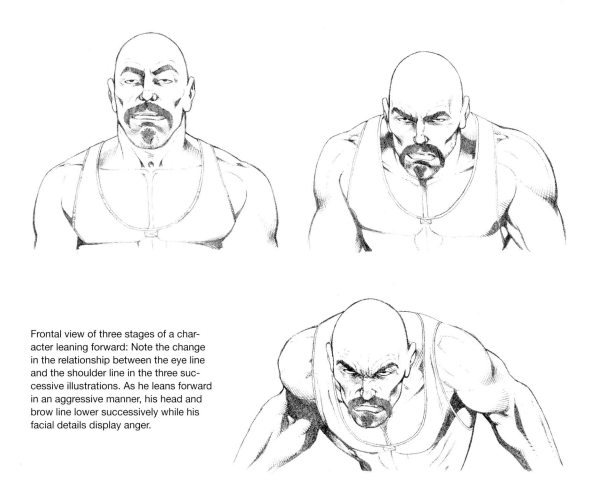

Frontal view of three stages of a character leaning forward: Note the change in the relationship between the eye line and the shoulder line in the three successive illustrations. As he leans forward in an aggressive manner, his head and brow line lower successively while his facial details display anger.

## Conflict Poses

Conflict poses are marked by strong leading actions, such as punches and kicks. For these poses, it is good to block in the leading arm or leg early on. That lead action is the maker of the pose, and all other parts of the body flow out from it gesturally.

Look for strong stretching actions and tipped lines of balance in this category. The faster and more furious the movement of the figure, the more displaced its center of gravity will be. Remember that you are capturing a moment in time when the character is in mid-action. Such poses—when freeze-framed—should appear off-balance. I have paired up some of the figures, since it usually takes a minimum of two to do these particular tangos.

**Close-quarters combat:** Body language is a vital tool for conveying a character's physical condition or mental attitude. The female figure is clearly the aggressor. Her tipped line is forward as she leans into action. The male figure has upraised arms, and his head is hunched down in a defensive gesture.

**Throwing a punch:** Every part of the body must shift in position to accommodate the drawing of the thrown punch.

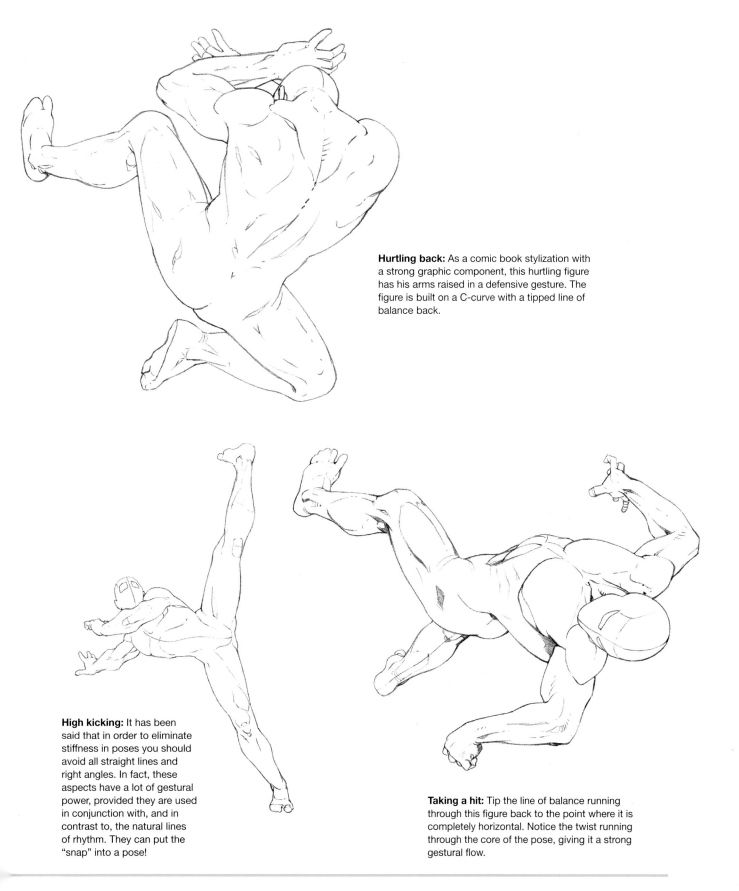

**Hurtling back:** As a comic book stylization with a strong graphic component, this hurtling figure has his arms raised in a defensive gesture. The figure is built on a C-curve with a tipped line of balance back.

**High kicking:** It has been said that in order to eliminate stiffness in poses you should avoid all straight lines and right angles. In fact, these aspects have a lot of gestural power, provided they are used in conjunction with, and in contrast to, the natural lines of rhythm. They can put the "snap" into a pose!

**Taking a hit:** Tip the line of balance running through this figure back to the point where it is completely horizontal. Notice the twist running through the core of the pose, giving it a strong gestural flow.

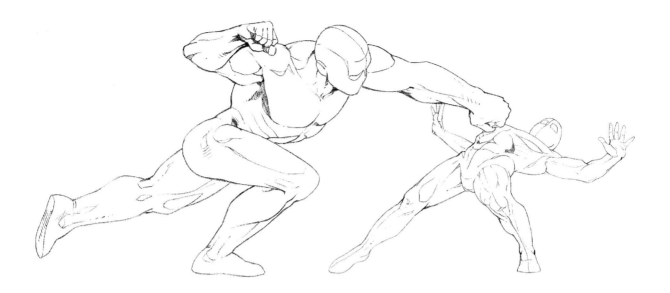

**Punching and ducking:** A strong tipped line of balance angles through both figures. As the aggressive giant moves in a forward line, the ducking figure angles back.

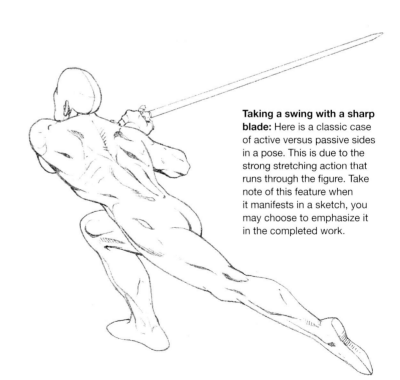

**Leaping straight upward:** While this figure leaps above the opposite figure's sword slash, her body language is not defensive. She is leaning into the action and toward the threat. The arms swing back as a counterbalance to the forward tipping.

**Taking a swing with a sharp blade:** Here is a classic case of active versus passive sides in a pose. This is due to the strong stretching action that runs through the figure. Take note of this feature when it manifests in a sketch, you may choose to emphasize it in the completed work.

## Taking a Hit

Here are four examples of figures reacting to being struck. In most circumstances, these figure drawings involve tipped lines backward, as the figures pull away from, or are thrown back by, the force that has struck them. These figures are typically off-balance.

These poses also employ outstretched arms and hands as characters try to regain their balance or reach out for external support.

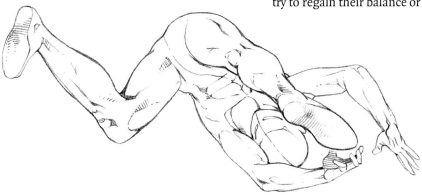

**Tumbling "head over heels":** Build this type of pose around a strong C-curve. Note how the legs curl forward, overlapping the body while still flailing in different directions. It is important to create the impression of a character that is not in control of his or her limbs.

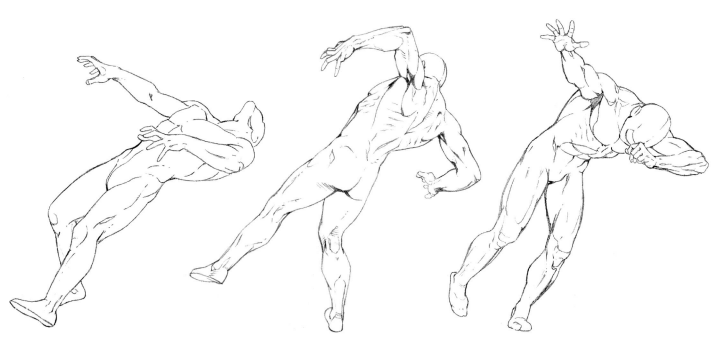

**Reeling back:** This image shows a character who has just been struck. With his head flung back, he has a strong tipped line of balance back. The outstretched arms are typical of any off-balance pose.

**Recoiling:** This is a figure avoiding a sudden threat. He is pulling his arms back, out of harm's way, along with his whole upper body. With one foot off of the ground, he also appears off-balance. In fact, his center of gravity has shifted back, far enough that the pose is now unsustainable.

**Dazed and stumbling:** Hallmarks of this pose are the outstretched, grasping hand, and a shifted-forward center of gravity—reflected in the tipped line of balance, a lowered head, and feet that curl inward a little.

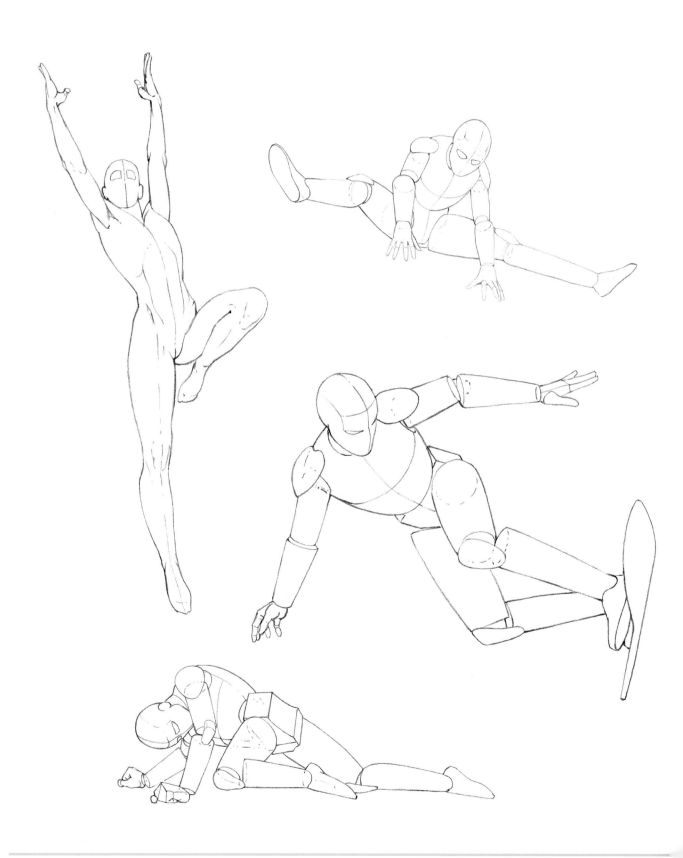

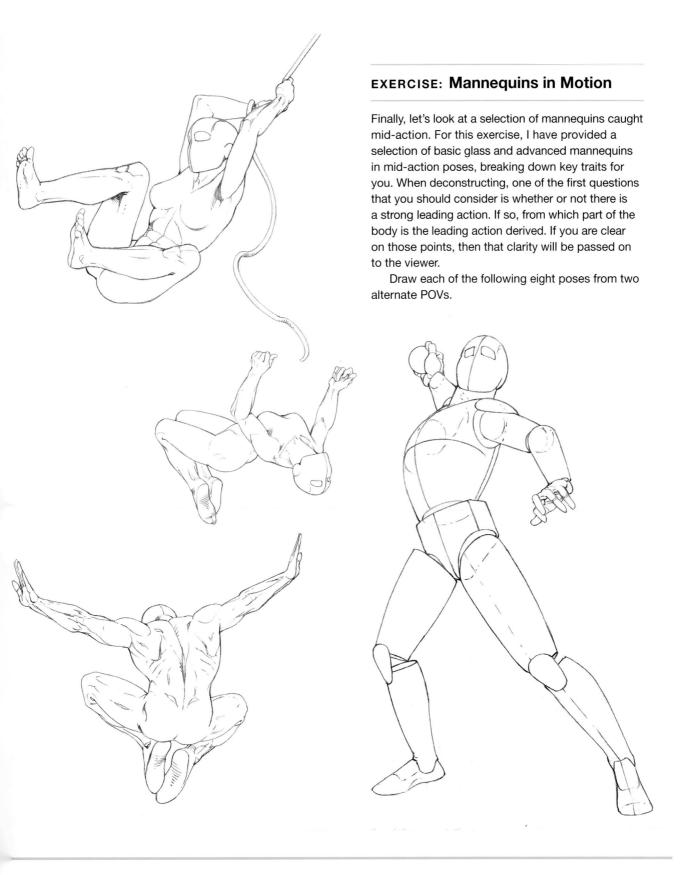

### EXERCISE: Mannequins in Motion

Finally, let's look at a selection of mannequins caught mid-action. For this exercise, I have provided a selection of basic glass and advanced mannequins in mid-action poses, breaking down key traits for you. When deconstructing, one of the first questions that you should consider is whether or not there is a strong leading action. If so, from which part of the body is the leading action derived. If you are clear on those points, then that clarity will be passed on to the viewer.

Draw each of the following eight poses from two alternate POVs.

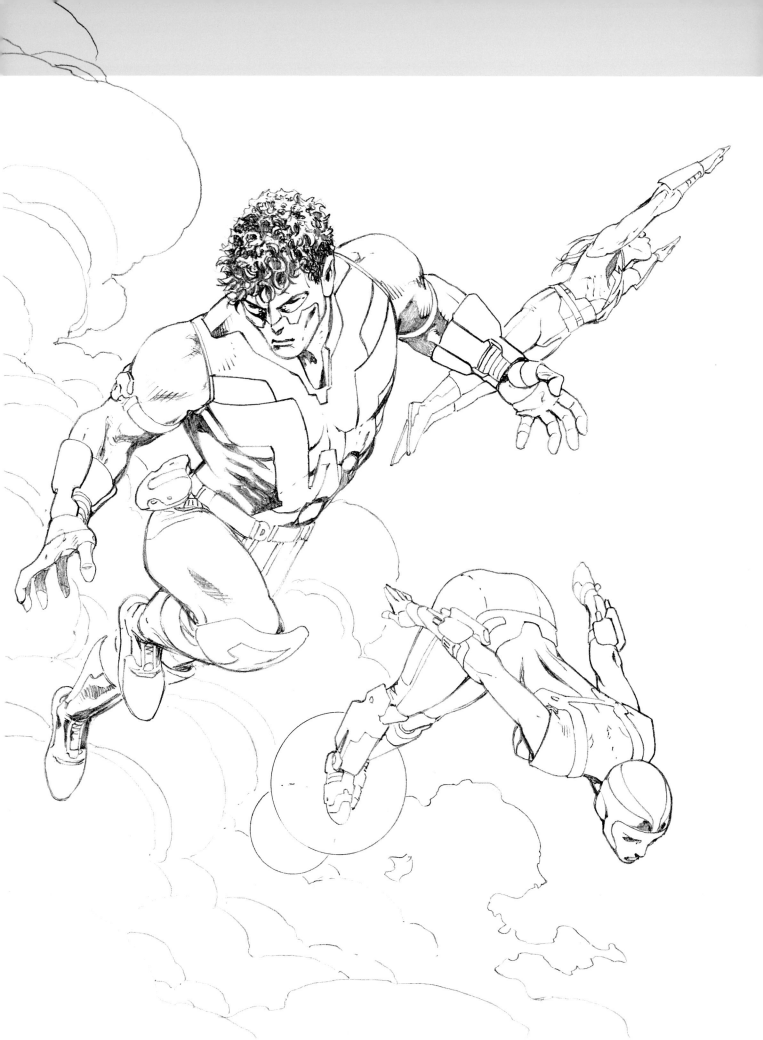

## CONCLUSION

*Freehand Figure Drawing for Illustrators* outlines a specific approach to mastering the human figure in drawing, without the need of a live model.

The instruction presented in this book is designed to give you a solid foundation in figure drawing that will serve you well, regardless of what your own art style may be. The use of basic and advanced mannequin underdrawings, awareness of the gestural lines of rhythm that are so useful in posing, the importance of tipped lines of balance for figures in motion, and understanding the hows and whys of foreshortening—these, along with the study of anatomy are the fundamentals that form the bedrock of freehand figure drawing.

While this book offers direction and guidance, ultimately, it is you who must supply motivation. In this discipline, the learning process can and should be a lifelong endeavour so that growth and refinement of your abilities do not stagnate.

Like an actor, you must make a study of human body language and gestures. Beyond that, your ability to observe and mentally record what you see will play a vital role in the development of your freehand drawing skills. So, never underestimate the importance of observation along with experimentation and repetitive practice, focused on your drawing challenges.

Almost as important as the drawing skills you develop, is the ability to be self-critical. I don't mean you should be negative, but rather that it is vital that you nurture a clear understanding of your strengths and weaknesses in order to concentrate your efforts where they are needed most.

Do not practice avoidance. Those areas in which you feel that your drawing is the weakest are the ones to tackle head on. The payoff is in seeing your skill levels grow and your versatility expand to the point where anything you can imagine you can draw.

# INDEX

## A

Action poses
    basic vs. advanced
        mannequins in, 173
    clarity in, 180
    in conflict, 186–89
    foreshortening and, 174–75
    step-by-step procedure for,
        176–77
    *See also individual actions*
Active vs. passive sides, 139, 188
Anatomy, knowledge of, 2,
    143, 155.
        *See also* Muscles; Skeleton
Armpit, 160
Arms
    behind back, 59
    bones and joints of, 149–50
    folded, 60
    foreshortening, 174–75
    muscles of, 160, 162–65
    raised, 147
    at rest, 49, 51

## B

Bags, figures carrying, 62, 73
Binoculars, figure with, 61
Bird's-eye views. *See* High angles
Bottle, hand holding, 131
Boxes
    building figures within,
        17–21
    drawing, 16
    figure carrying, 73
Briefcases, figures carrying,
    63, 72

## C

Camera angles, 6
C-curves, 48
Cell phones, figures with, 61,
    72, 129
Clean line art, 101
Clothing, adding, 69, 73
Conflict poses, 186–89
Core
    definition of, 33
    drawing, 33
    joining head to, 40–41
    in motion, 33
    *See also* Hips; Torso
Cross-contouring, 100, 140, 175
Crosslines, 10
Cross-sectioning, 174
Crouching figures, 81, 82–85, 91
Crutch, figure with, 61
Cup, hand holding, 130

## D

Deltoids, of mannequins, 42
Drawn mannequins. *See* Glass
    mannequins

## E

Ears
    anatomy of, 98
    from different POVs, 98, 99
    placement of, 94
Elbow joint, 149, 150
Eye-level views
    definition of, 6
    ears from, 99

eyes from, 97
feet from, 134–35, 138, 140
head from, 95, 113
in one-point perspective, 8
Eyes
    anatomy of, 96
    detailing, 96–97
    from eye level, 97
    from high angles, 102,
        103, 111
    from low angles, 104, 105,
        107, 108, 109, 110
    placement of, 34, 35, 94, 97

## F

Feet
    anatomy of, 132–33
    approach to drawing, 115
    cross-contouring, 140
    from eye level, 134–35,
        138, 140
    from high angles, 137,
        138, 140
    from low angles, 136,
        139, 140
    in motion, 139, 141
    of running figures, 74, 77
    of walking figures, 70, 74
Female figures
    anatomy of, 156–59
    basic vs. advanced
        mannequins for, 172
    hairlines of, 112
    hands of, 122
    physical characteristics
        of, 43

poses of, 43
Fingers
    angling, 120
    curving arcs of, 117
    *See also* Hands
Finish line, running figures at, 79
Fists, 121
Flying figures, 182–83
Forced perspective, 11
Foreshortening
    advanced mannequins and,
        174–75
    basic principles of, 28–29
    definition of, 6
    in lunging figures, 184
Freehand process, outline of,
    24–25

**G**

Gestural lines, 24
Glasses, hands holding, 131
Glass (drawn) mannequins
    advanced vs. basic, 172–73
    benefits of, 1, 23, 26
    examples of completed, in
        motion, 44
    exploded view of, 27
    male vs. female, 43
    transparency of, 1, 26
    as visualization tool, 1
    *See also individual body parts
        and poses*
Gridded space, 6
Gun, figure with, 62

**H**

Hairlines, 112
Hands
    anatomy of, 116
    approach to drawing, 115
    constructing, 118
    cupped, 126, 129
    curving arcs of, 117, 119
    in a fist, 121
    gestural, 124, 127
    on hips, 59
    holding objects, 129–31, 141
    male vs. female, 122
    in pockets, 58
    reaching, 123, 125, 128
    views of, 116
    of walking figures, 72
    *See also* Fingers
Head
    back view of, 112
    constructing, 95, 101–12
    cross-contouring, 100
    drawing, 34–35
    from eye level, 95, 113
    hairlines on, 112
    from high angles, 36, 39,
        102–3, 111, 113
    joining, to torso and hips,
        40–41
    from low angles, 37, 38,
        104–10, 113
    planar, 113
    proportions of, 93–94
    *See also* Ears; Eyes; Mouth
High angles (bird's-eye views)
    action poses from, 178

    definition of, 6
    ears from, 99
    eyes from, 102, 103, 111
    feet from, 137, 138, 140
    head from, 36, 39, 102–3,
        111, 113
    in one-point perspective, 9
    standing figure from, 53–55
    in three-point
        perspective, 15
Hips
    drawing, 32
    hands on, 59
    offset, 59
    in sequential rotation, 32
    *See also* Core
Horizon line (H-Line)
    definition of, 6
    in one-point perspective,
        8–9
    in three-point perspective,
        14–15
    in two-point perspective,
        10, 12–13

**I**

Image area, 7

**K**

Kicking, 175, 187
Knee joint, 149, 151
Kneeling figures, 86, 87

## L

Landing figures, 87, 179, 180
Leaping figures, 179, 188
Legs
    bones and joints of, 149, 151–52
    foreshortening, 175
    fully extended, 52
    muscles of, 166–67
Low angles (worm's-eye views)
    definition of, 6
    ears from, 99
    eyes from, 104, 105, 107, 108, 109, 110
    feet from, 136, 139, 140
    flying figures from, 182–83
    head from, 37, 38, 104–10, 113
    leaping figures from, 179
    in one-point perspective, 9
    standing figure from, 56–57
    in three-point perspective, 15
Lunging figures, 184

## M

Male figures
    anatomy of, 156, 158–59
    basic vs. advanced mannequins for, 172
    hairlines of, 112
    hands of, 122
    physical characteristics of, 43
    poses of, 43
Mouth
    open, 106
    placement of, 94
    width of, 94
Muscles
    adding, to mannequins, 168–69
    of arms, 160, 162–65
    of back, 161
    of legs, 166–67
    male vs. female, 156–59

## N

Natural lines of rhythm, 48
Natural perspective, 11–13
Neck hole, 30

## O

Observation, importance of, 193
One-point perspective, 7–10
Optical mid-point, 17

## P

Pail, figure with, 73
Pectoral girdle. *See* Shoulder girdle
Pelvis, construction of, 148
Perspective
    definitions of terms relating to, 6
    forced, 11
    importance of mastering, 5
    natural or unforced, 11–13
    one-point, 7–10
    three-point, 14–15
    two-point, 10–13
Planar studies, 113
Point of view (POV), 6
Pole, hands holding, 130
Props
    hands with, 129–31
    standing figures with, 61–63
    walking figures with, 72, 73
Pushing vs. pulling, 181

## R

Reclining figures, 81, 90
Rib cage, 146, 147, 148
Running figures
    eight-step cycle for, 76–77
    feet of, 139
    at the finish line, 79
    opposing action in, 65, 74
    tipped line of balance in, 66, 74, 75, 78
    variants on, 78
    walking figures vs., 74

## S

S-curves, 48
Self-criticism, 193
Shoulder blades, 161
Shoulder girdle
    anatomy of, 146
    in motion, 147
Sitting figures, 81, 88–89
Skeleton
    arms and legs, 149–52
    axial, 148
    back view of, 145
    feet, 132
    frontal view of, 144
    in motion, 148, 153
    shoulder girdle, 146–47

with arms folded, 60
classic poses for, 58–59
from high angles, 53–55
legs in, 52
from low angles, 56–57
with props, 61–63
viewer's proximity to, 57
weight distribution of,
49, 50

**T**

Three-point perspective, 14–15
Tipped line of balance
backward, 67, 71, 88
in conflict poses, 186–89
in crouching figures, 91
forward, 185
importance of, 65–66
in running figures, 66, 74,
75, 78
sideways, 67
in sitting figures, 88
in walking figures, 66,
71, 74
Toes, 133, 139. *See also* Feet
Torso
drawing, 30–31
joining head to, 40–41
neck hole on, 30
in sequential rotation, 31
*See also* Core
Two-point perspective, 10–13

**U**

Unforced perspective, 11–13

**V**

Vanishing points (VPs)
definition of, 6
distance between, 11
left and right, 10
nadir and zenith, 14
in one-point perspective, 8
in three-point
perspective, 14
in two-point perspective,
10–13
Viewer, proximity of, 57

**W**

Walking figures
with active/occupied
hands, 72
adding features and
clothing to, 69
carrying weight, 73
eight-step cycle for, 68–69
feet of, 70
front view of, 70
opposing action in, 65, 70,
72, 74
with props, 72, 73
running figures vs., 74
tipped line of balance in, 66,
71, 74
Worm's-eye views. *See* Low angles

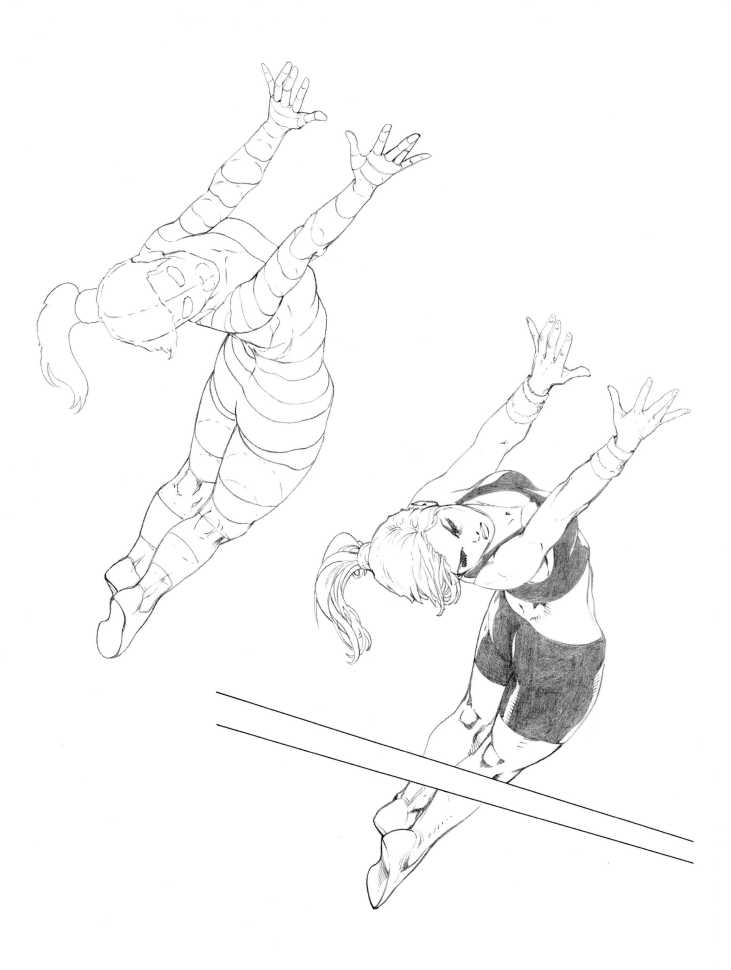